LIFE ON MAR'S

Creating Casual Luxury

MAR JENNINGS

LIFE ON MAR'S

Creating Casual Luxury

MAR JENNINGS

ROSEBROOK GARDENS

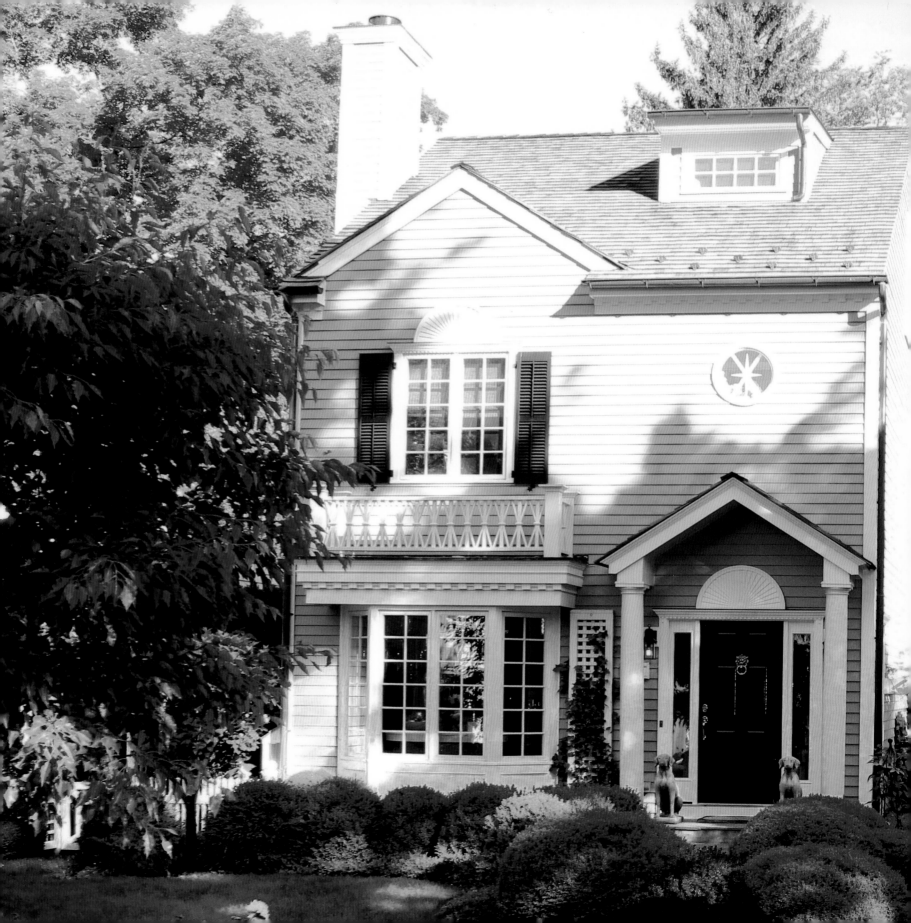

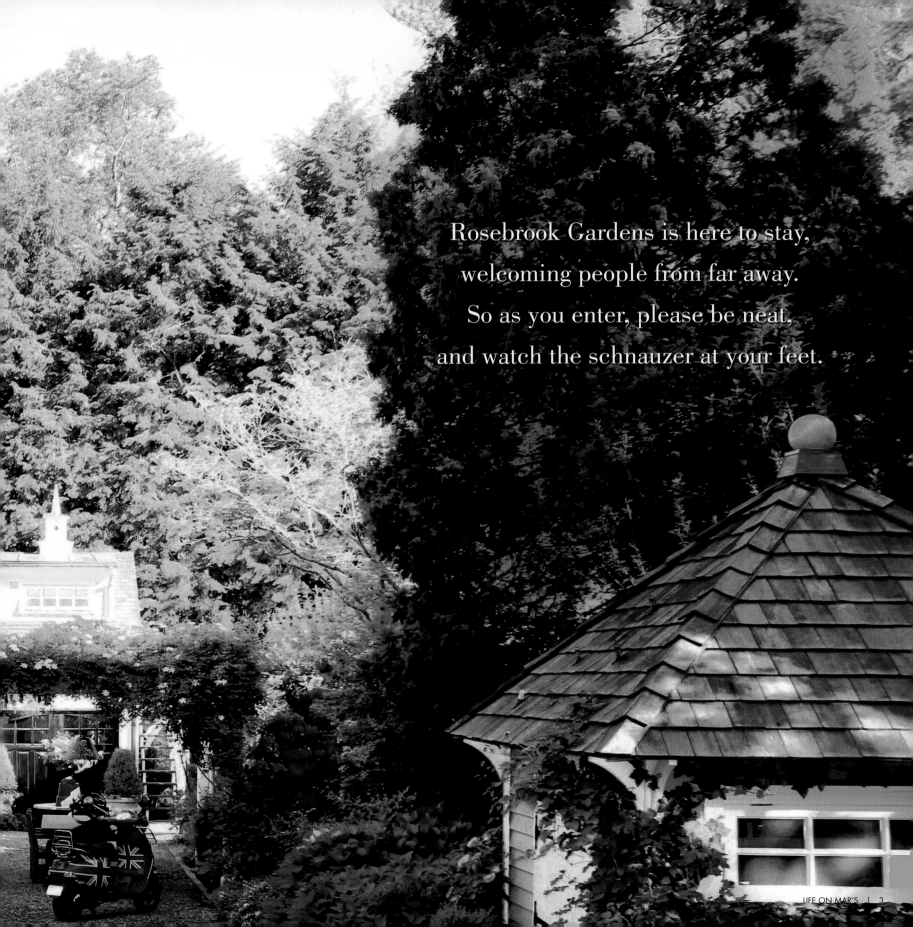

Rosebrook Gardens is here to stay,
welcoming people from far away.
So as you enter, please be neat,
and watch the schnauzer at your feet.

Casual Luxury is the cure for all design dilemmas. My six principles will work in your home regardless of its size, your personal style, and in any room. *Casual Luxury* has no boundaries.

Acknowledgements

Many people dream of doing what they love and loving what they do. I've learned that you cannot achieve the dream alone, so I must acknowledge all of those who made it possible for me. You know who you are: my friends, my fans, my followers—my family. You have traveled this journey with me, and your letters, e-mails and involvement in *LIFE ON MAR'S* have inspired me like nothing else. You have shown me the rewards of taking the risk of believing in myself, and reinforced my belief that anything is possible when you find the passion and commitment to follow your heart. I'm so grateful to have my **MAR**tians! I also have to thank the corporate environments I've been part of; they have allowed me to dovetail this passion with career work, thus making it mutually productive. Thank you.

I dedicated my first book *LIFE ON MAR'S: A Four Season Garden* to the incredible contribution of the unforgettable Edward R. Smith—my mentor, devoted friend, and confidant who has forever changed my life. This book would also be incomplete without a dedication to this wonderful man. Although many years have now passed since his death in 2005, more than ever I continue to feel his essence in the work I do, and in the platform I have created for my *Casual Luxury* brand. Rosebrook Gardens provides me the foundation for my inner strength to bloom, and no matter how far I may travel I return home feeling grateful and blessed, as everywhere I look there is something that transports me back to our wonderful place in time together.

To Paul Darcy Mitchell, also my friend and confidant, who now continues to make me better, both personally and professionally. His wonderful love and incredible family have extended *LIFE ON MAR'S* to a whole new universe.

This book is dedicated to those who we love, and the power that comes from within our hearts when we have loved, lost, yet love again. And to all those who are working to acknowledge their journey, embrace their passion, and connect to their future.

S&J MULTIMEDIA LLC, WESTPORT, CT 06880
LIBRARY OF CONGRESS CONTROL NUMBER: 2013913696—ISBN 978-0-578-12082-9

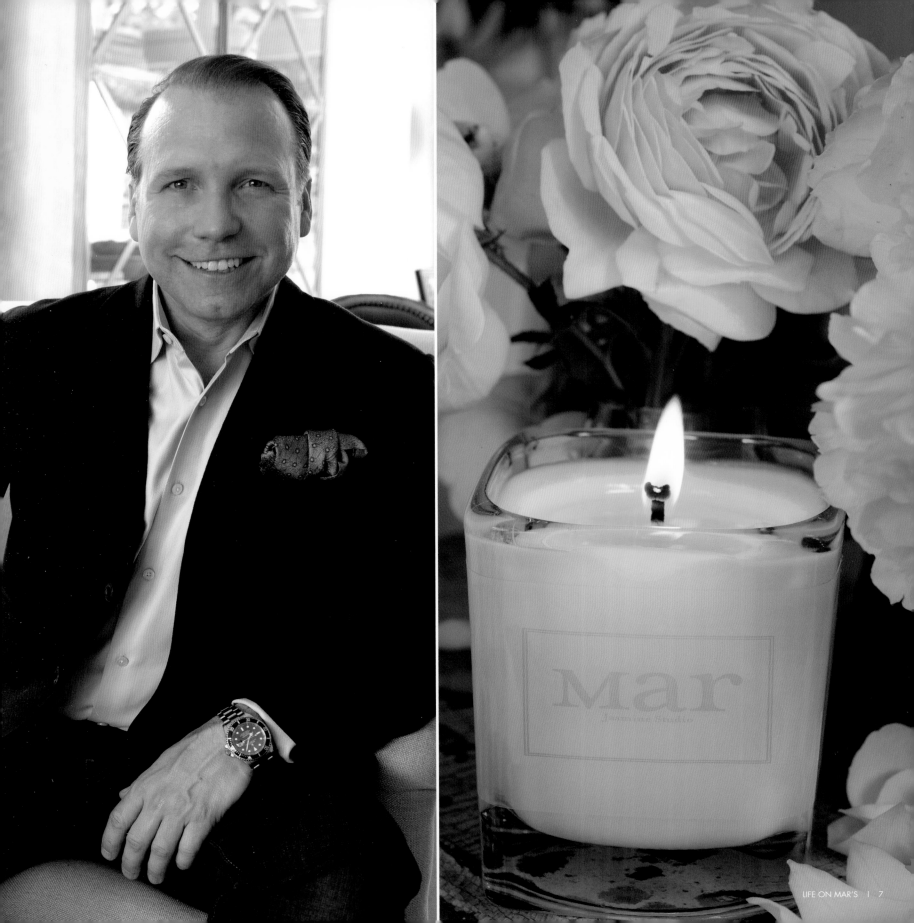

LOUIS VUITTON

Casual Luxury embraces
both the old and the new,
blurring the lines of time. "

Contents

Introduction

Unlike other decorating books, truly this one is structured as a tour of my home.

I want you to imagine that you have been transported here to spend an afternoon with me, but you're not getting a standard tour; you're getting a guided tour that shows you how my design aesthetic *Casual Luxury* comes to life.

Because of that, I have written the book as if personally escorting you through every room in my house—and yes, it includes the outdoor living spaces for entertaining and dining—and have devoted a chapter to each room. Once inside, I'll walk you through in detail, just as I would if you were here. Then I'll pause to share tips plus in-depth background information on some of my favorite pieces of furniture. Finally, before we move to the next room, I'll highlight lessons you can apply to a room like it in your home. I call these my s**MAR**t Tips.

Once we have finished the house tour, I have even more for you: how to start translating *Casual Luxury* for your home. I'll share my own insider process that will help you solve any design dilemmas and apply *Casual Luxury* to any room. It's the next best thing to having me visit.

Ready to let me show how *Casual Luxury* can be made simple and s**MAR**t?

Let the tour begin!

Chapter One
Creating a *Casual Luxury* Home

I'm quite sure you are asking yourself "What is *Casual Luxury*?" And perhaps wondering, "How does it apply to everyday living?" This book is designed to help you discover, understand and embrace *Casual Luxury*, to show you how it easily creates a look of sophistication that suits today's lifestyles, and to teach you how to easily create *Casual Luxury* in your own home. This book illustrates these concepts using my own home, Rosebrook Gardens, as an example.

I created and developed *Casual Luxury* as my own personal style, but quickly discovered that others love it, too. The descriptions they give fall into two themes: people talk about how timeless and beautiful the rooms look, but also how livable and comfortable they feel—exactly my intent. It is really the reason *Casual Luxury* stuck with me as a term, because it summarized their responses.

What intrigued me, however, was that people from all walks of life, regardless of age or gender, have similar reactions to—and make nearly identical comments about—the rooms I design. Although skilled fellow designers are among the fans of my work, it became obvious that people didn't need to be schooled in formal design principles to "get" my rooms. I came to the conclusion that people were having a natural, organic response to the rooms as a whole. I may have formulated the way to bring it all together as a design, but I was tapping into something that, to quote one of them, "just felt right."

Let me be clear: I believe that *Casual Luxury* resonates with so many people because everyone has the basic building blocks of *Casual Luxury* instilled within them. Put more poetically, everyone has the ingredients to create it, but perhaps lacks the recipe.

I define *Casual Luxury* as a combination of six core principles:

1. Representing Mother Nature inside the home using items normally found outside.

2. Embracing natural light and reflecting it throughout the space.

3. Taking inspiration for color and materials from Mother Nature's palette and textures.

4. Rethinking, repurposing and redesigning—from furniture to rugs to lamps.

5. Creating a cohesive look with repeated patterns and shapes.

6. Selecting the right scale of furniture and decorative objects.

I also believe that to make design livable you need a healthy dose of reality: it has to be attainable. That makes it more fun to create your home space. And to be creative should also mean getting inspiration from

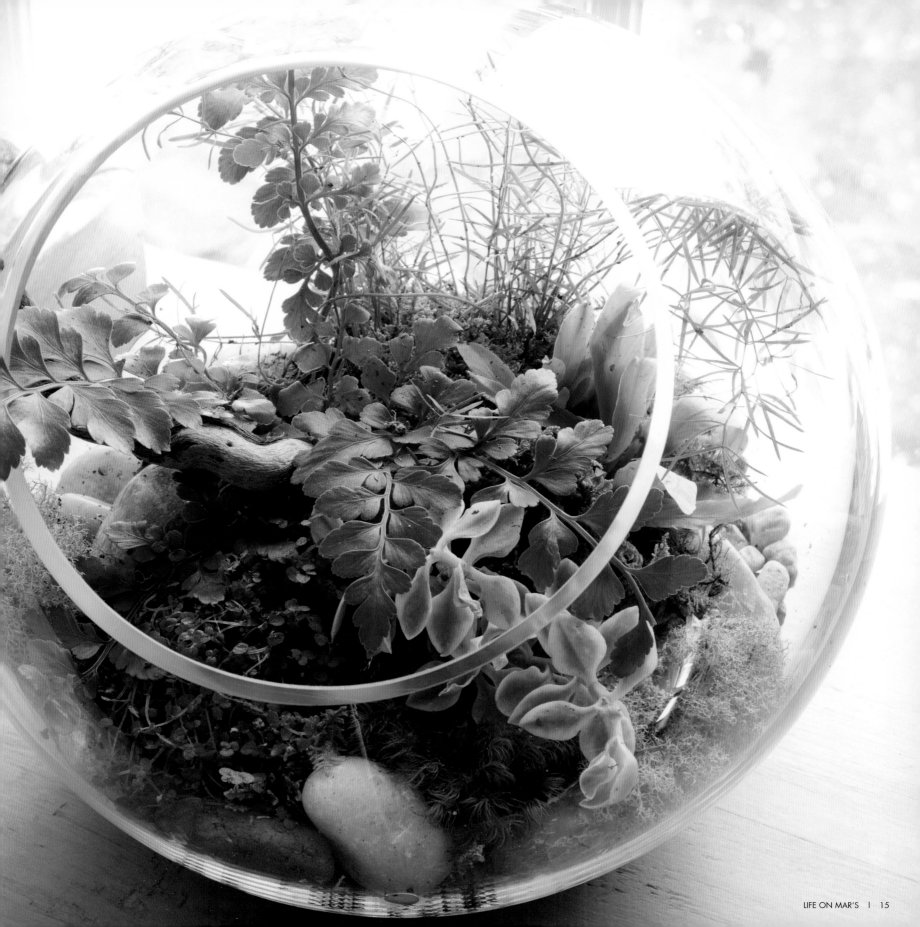

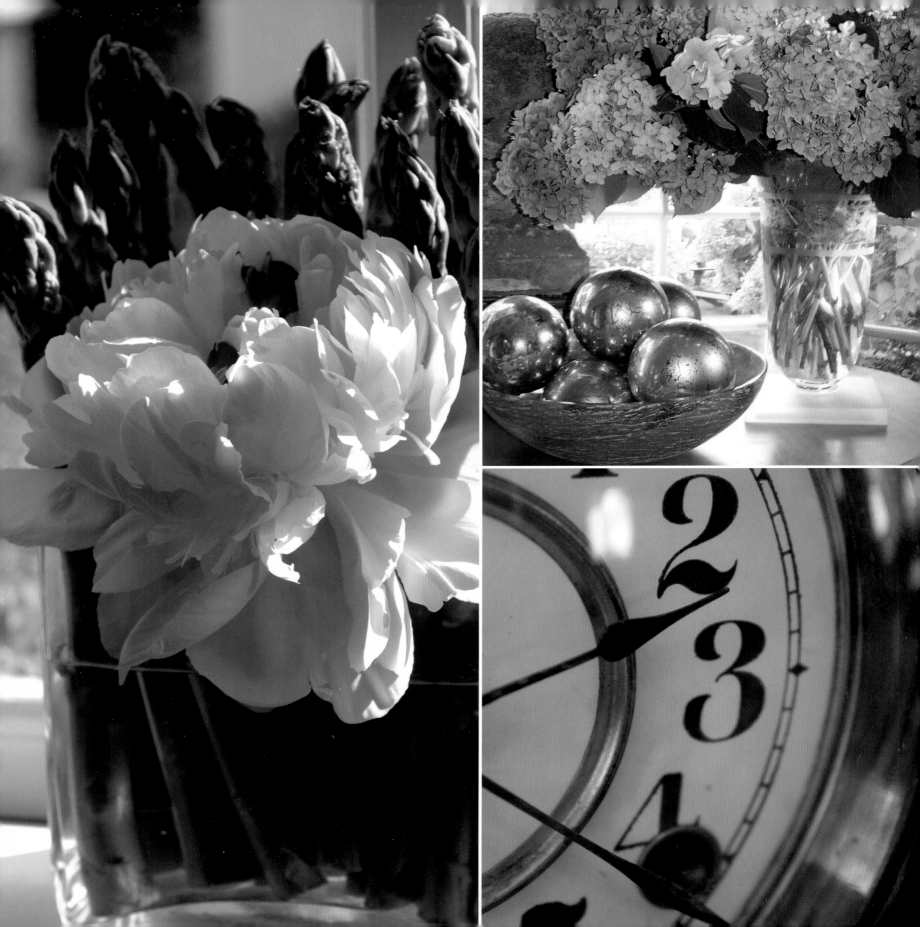

all the resources available—not just traditional home decorating stores. So another reason I call it *Casual Luxury* is because when it's applied to home design, it becomes both beautiful and livable.

As you reflect on these principles yourself—and as you learn more later in this chapter—you will understand how I believe they have their roots in the very essence of what it means to be part of the human experience. Sounds lofty, but hear me out: people the world over respond the same way to these stimuli. The colors and textures of nature subconsciously signal health and vitality. Repurposing triggers the concept of the importance of heritage. Light symbolizes energy and open spaces, while repeated shapes and patterns prompt our need for harmony and order. And proper size and scale—when the contents of a room are the perfect size—echo our natural judgment of whether something does or does not belong. Combined, these elements automatically signal a desirable space. Because these responses have been with us for thousands of years, they are now deeply subliminal. I think this is why a *Casual Luxury* room seems so right to so many: its elements are already established in our subconscious.

LIFE ON MAR'S: Creating Casual Luxury uses my home as an example to help deconstruct *Casual Luxury* and to provide you with a winning formula that can be applied to any room, space or design scheme. You will see that it truly is that simple.

But before you begin your journey room to room, I want you to know a little more about me. My home, Rosebrook Gardens, is the example and inspiration for this book; it is a snapshot of my soul, and nothing gives me greater pleasure than to share my home with others. One visit will take you to a deep part of who I am. But my affair with my surroundings began early in life, as I have always been in tune with my environment.

In addition to being the baby of the family, my father referred to me as a "spirited child." I am not exactly sure if this was because I was a competitive figure skater who was very aware of his costumes,

the gardening I did, or the fact that I liked to draw cartoons, so I assume it was a combination of the three. Back then my paternal grandmother made all of my skating outfits, and looking back today at photos of all those sequins it looks as though Liberace had designed the costumes. Truthfully, there are enough skating stories to warrant another book. Regardless of my extracurricular skating and love of coloring, I have always been drawn to and felt organically connected with Mother Nature.

In my first book, *LIFE ON MAR'S: A Four Season Garden*, I mention staying home from school claiming to be ill so I could revamp the living room when my parents were out. Let me share another Mar moment from my childhood, but this time I'm turning the clock to the late seventies, when I was nine years old.

My mother underwent six surgeries in six months to remove a tumor from her knee. Each was performed in a hospital an hour away in New York City. When she returned to Connecticut to recover, she was a handicapped woman. Being the youngest of three boys, I remember feeling helpless during that dreadful year. As Mother was dealing with excruciating pain she was medicated, and many times seemed unaware of her surroundings. It was as though she slept through the months.

I longed to do something useful, so I took it upon myself to pick flowers from the garden for her nightstand. I did this religiously every couple of days, regardless of the season. When flowers were not in bloom, then interesting foliage and branches became the centerpiece of my designs. The local neighbors invited me to forage in their gardens as word got out that I was picking flowers for my mother. When guests brought flowers, I arranged those, too, and many times infused the local gardens' resources into the store-bought bouquets.

Recently, I was speaking with my mother about this new book and she reminded me how when she awoke during those dark days, the beauty and the fragrance of the seasonal flowers gave her tremendous hope and joy. Years later, she suffered

the loss of her right leg as a result of that bone cancer, but today my mother is cancer-free and a survivor! She never forgot that year of flowers and often teases me when she calls from her home in North Carolina: "Why don't you do that for me now?"

Back then, flowers provided me with nurturing comforts to get me through the difficulties of life. Today, nature continues to serve me as divine inspiration; its colors, textures and light became the key ingredients of my recipe for a room.

As I grew I became wiser and more in tune with all of Mother Nature's beauty. *Casual Luxury* reflects that, but I have realized over the years that it was becoming so much more than a design palette; rather, it is a way of life that embraces resources and creativity while maximizing the endless opportunities with colors, textures and light.

Applying *Casual Luxury* is simple, but first you need to assess your room. No matter where you live or what your style may be, I encourage you to begin any design by focusing on what you love about the space. What you cherish might manifest itself in many places: it could be the windows, the fireplace mantel, the floors, the high ceilings, the wood moldings, or the openness and natural light. Once you identify what you love, then the next step is to maximize the beauty of the space and personalize it by applying my *Casual Luxury* design principles.

I'll show you how *Casual Luxury* can work in your home regardless of its size or the spaces within it; *Casual Luxury* has no boundaries. From giant mansions to condos to historical homes, my principles can be successfully applied to all. And my promise remains that it is so easy. Let's proceed!

Six Principles of *Casual Luxury*

My *Casual Luxury* has six basic principles.

1 Represent Mother Nature
The objective is to blur the lines between indoors and out by representing the outdoors somewhere in each room. Incorporate something alive and/or fresh: a plant, bowl of fruit, cut flowers—or anything that offers a fragrant aroma. Nature-inspired artwork, prints, and fabrics work wonderfully. Apothecary jars are a must-have for any room: fill them with moss balls, shells, or even birch branches. These vessels also reflect light while allowing you to capture pieces of nature for all to enjoy.

2 Embrace Light and Reflection
Natural light is free and available, so should be used as an important design element. The feeling of open vistas that natural light gives creates dimension and expands a room's visual interest. Help light expand into the space by creating reflection. Reflection in turn creates more light, light creates energy, and energy creates a special ambiance to any room. A silver trophy filled with candy, a mirror placed at an angle, a glass tabletop, are all examples of ways to reflect light beautifully.

3 Use Natural Materials and Colors
The simplest rule of thumb for colors: the primary shades in your walls and furniture should be shades found in nature. Variations can be introduced in accessories, if at all. If a shade is not found in nature, don't use it. Think about natural materials as inspiration for texture, texture, texture! You do not need color to provide all of the variety in a room: a monochromatic theme can be beautiful when it is presented in a variety of textures. In fact, it's how to achieve a more luxurious and professional look. Wicker, rope, distressed wood, stone and metals such as iron, brass or chrome offer ways to vary textures and finishes while staying within specific color palettes.

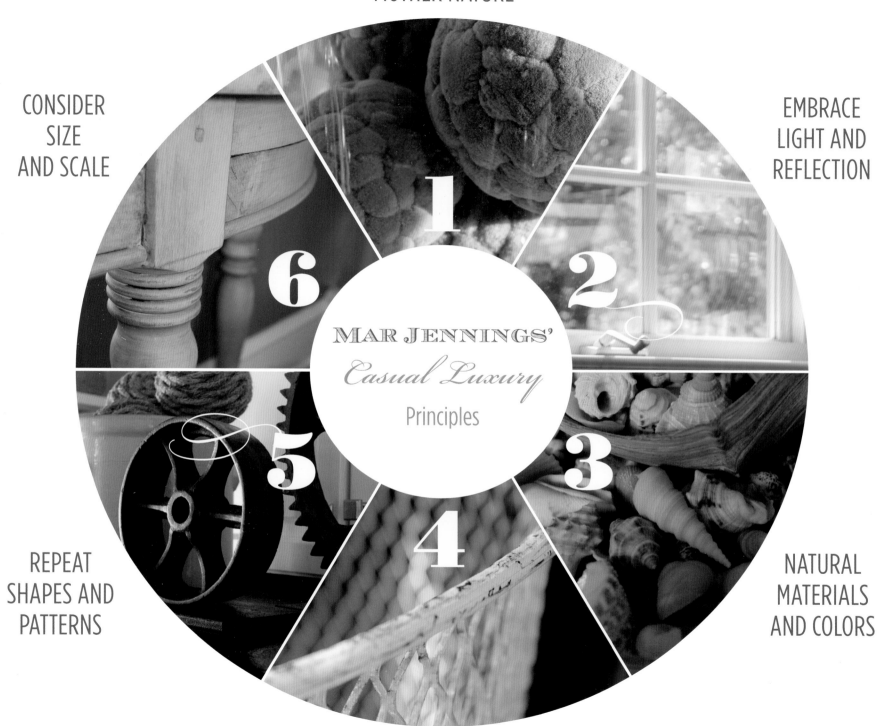

REPRESENT
MOTHER NATURE

EMBRACE
LIGHT AND
REFLECTION

NATURAL
MATERIALS
AND COLORS

REPURPOSE

REPEAT
SHAPES AND
PATTERNS

CONSIDER
SIZE
AND SCALE

MAR JENNINGS'
Casual Luxury
Principles

1

2

3

4

5

6

Repurpose

I love it when something old becomes something new. Flea markets, tag sales and grandmother's attic are excellent resources for treasures that have sentimentality and history. This is a must in the design of any room, as you truly cannot complete a *Casual Luxury* room with new stuff alone! This is not just about furniture; repurpose something unexpected as an accessory or decoration. An old mirror makes a great cheese tray, an old book makes a great platform for a small statue, and so on.

Repeat Shapes and Patterns

There is no better way to creative a cohesive look than by repeating patterns and shapes, as nature is full of this type of symmetry. For example, a round coffee table can be complemented with circular shapes on a textile, in artwork, or lamps. An angular sofa can benefit from right angles in hutches and tables—even when it is paired with curved armchairs. Whole rooms need not be dominated by the shapes you choose; you simply need enough repetition for it to be picked up subconsciously.

Consider Size and Scale

Nothing makes a room feel "off" more noticeably than when the furnishings look too cramped or too minimal. You should never have to jump over or squeeze by something in a space. Scale can be confusing, as it's also about understanding how to mix objects of different size together. When something is oversized for the space it's called overscale. Something oversized can work if you know how to balance its bulk. Whenever you go large you need to introduce a balance of smaller items as well. I recommend using one oversized item in every room; they are great pieces around which to build a room or to create focus. Each item in your home has a scale value; small should be mixed with large, so long as the result is balanced. Have you ever walked into a room and felt overwhelmed? Well, that is an over-weighted room. Then there are the rooms that feel empty, or under-weighted. The best scale comes from balance combined with flow—not all the items concentrated in one area. As you read this you may be recalling rooms where you felt scale was not working; if so, you can avoid these mistakes more easily in your rooms. And the good news is that you can apply the same concept to artwork on walls and decorative objects on tables, mantles and so on.

And there you have it. These six *Casual Luxury* design principles probably seem simple, and even logical, right? That's why I like to say that I'm all about "*Casual Luxury* made simple and s**MAR**t."

One final note: I don't expect you to copy my home. My goal is to help you learn to apply *Casual Luxury* to your own environment. You need to make this your own. To do so, you need to identify what you like regarding colors, textures and shapes in general. Let's say you love shades of green, wood finishes, and rounded corners versus hard edges. Let's also acknowledge that your favorite "look" may change over the years—for example, you may describe your favorite type of designs as traditional, Sante Fe, mid-century modern, or rustic—the list goes on. But even when your favorite "look" changes, your core likes and dislikes will not. You will still gravitate to greens, wood finishes, and rounded edges, and I believe that you should incorporate them no matter what your current style may be. It personalizes the look. Once you home in on these basic "must-have" elements of your own *Casual Luxury* esthetic, building and matching your style is easy. So yes, you can create a Sante Fe room with *Casual Luxury* principles; you can create a post-modern one, too, if you so desire.

As you create your rooms, it's always best to have an excellent resource book on hand; it will provide inspiration and an incentive to stay on track. Many of us have a binder filled with tear sheets of images from favorite magazines. Still waiting to create one? Hopefully this book will serve that purpose for awhile and be an incentive to start one!

Your own *Casual Luxury* designs are within your reach, and your affinity for the principles is already within you—you may have simply needed help combining the ingredients. *Casual Luxury* is my recipe to help you do just that.

Now let's see how it all comes to life, with my home as the ideal case study.

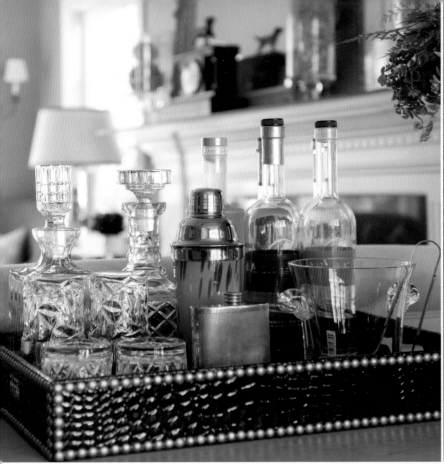

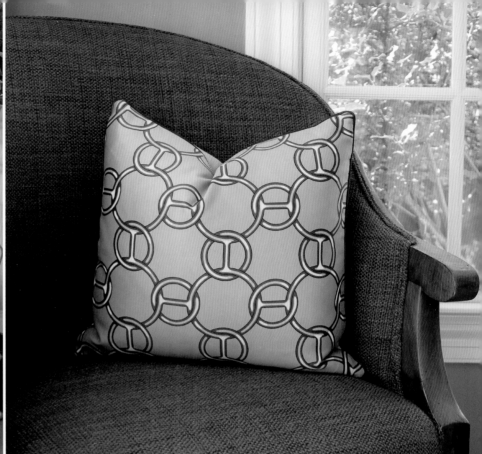

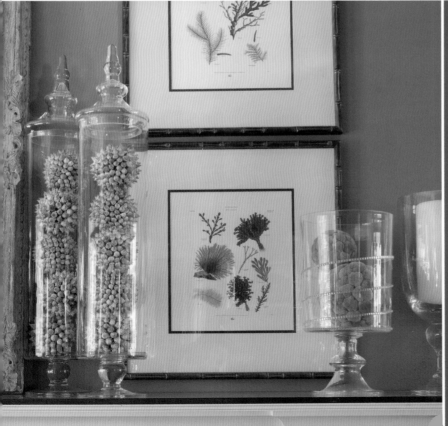

"This house is my design laboratory. Frank Lloyd Wright also used his Chicago home as a testing ground, each room an experiment in varying architectural styles and looks. Fortunately, my design experiments are easier to translate into your own!"

Casual Luxury colors and shades are inspired by what is visible in nature.

Here is a quick, at-a-glance overview of my favorite *Casual Luxury* shade palette. You will see these throughout my home.

 Clean Whites
From bright cloud to smooth bone

 Soothing Greens
From delicate olive to lush grass

 Calming Blues
From watery aqua to cerulean sky

 Earthy Browns
From washed tan to rich chocolate

 Natural Stones
From sheer sand to deep slate

Choose accent colors—or seasonal pops of color—inspired by flowers and fruit, from pastel to vibrant.

To narrow it down for your room, the jumping-off point should be something from your overall furnishing scheme. For example, a sofa fabric, a bedding collection, or a favored piece of artwork.

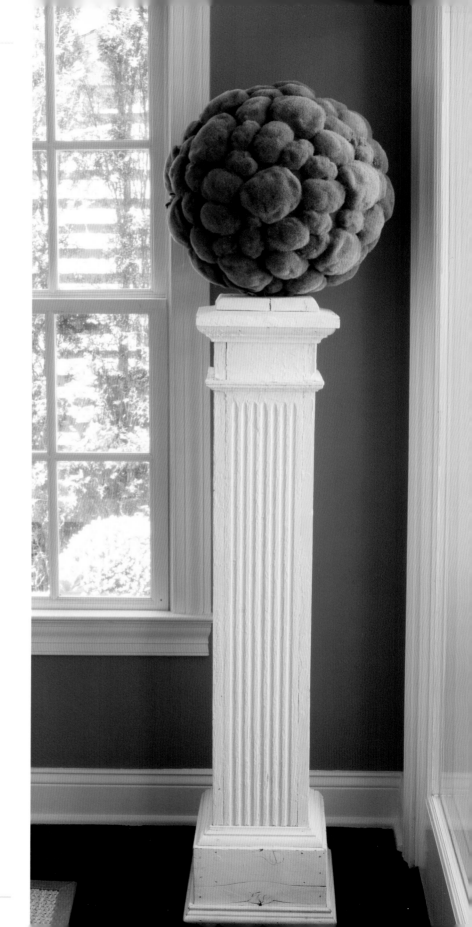

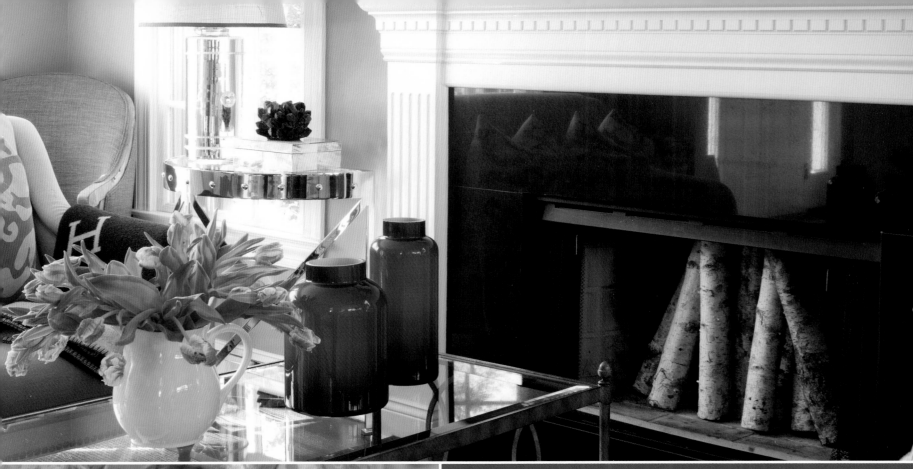

LIFE ON MAR'S requires no passport – and no extra luggage!

> "Some of the biggest design tricks lie in the smallest details."

Chapter Two
The Journey to Rosebrook Gardens

You may not know this, but my first success was not as a lifestyle expert, it was as a competitive figure skater.

In 1992 & 1993 I won gold medals in both regional and sectional championships. Already in my twenties—too old by today's standards—it was time to retire and focus on what my future would be.

In 1994 I landed a fantastic opportunity as a Manager at a new branch of Citibank that was to open in my hometown of Westport. What I lacked in banking skills I made up for with my personality and dedication, and by leveraging what I knew about the market as I was a longtime Westport resident.

The joke at the branch became that there were credit champions, mortgage champions and online champions—to name a few types—but I was the only "skating champion." I definitely had something to prove and, not having an MBA, I had to work extra hard to show that I could do the job just as well if not better. I focused on reading and learning everything I could about the business, tapped into my sales skills, and did a ton of local networking—including becoming the head coach for the Town of Westport's "Learn to Skate" program. It wasn't long before I was told that I was rivaling the best performers in not only Connecticut but also New York, New Jersey and Pennsylvania.

At the time I was living in Westport, on Washington Avenue, in a cute but small cottage that I named the "Love Shack" because although it was small I loved it so much. It was a postage stamp of a studio cottage above a garage, but with the best amenities: close to work, to the town's beach, near a fabulous park and within walking distance to great restaurants and shopping. What it lacked in size was well offset by the amenities as well as the private garage, a large backyard and the ability to have a dog.

My landlords, Mr. and Mrs. Fink, quickly became new friends when I moved in that fall of 1994. Andy Fink, who at the time was the Town Attorney, was a man who could give you a hug and show you he cared. His wife Helen was a schoolteacher in the adjacent town of New Canaan.

Shortly after I moved in, Helen told me she thought I had a great deal of style and wonderful energy that was just waiting to be released. She encouraged me to make this tiny space my own, keep my receipts and deduct it from the rent.

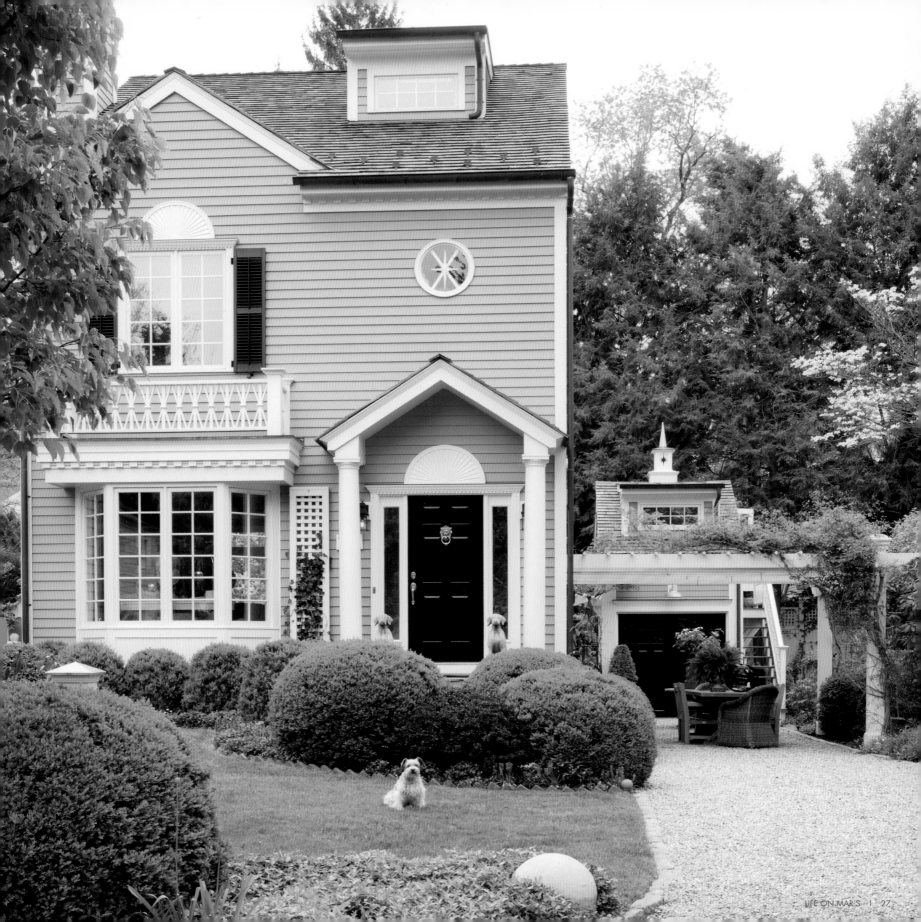

Feeling encouraged, inspired, and needing to be frugal, my *Casual Luxury* design concept began to percolate. Paint, wallpaper and new furnishings would maximize the efficiency of the cottage while creating a sense of space and purpose. I reused and distressed old, worn shutters, added new lighting fixtures, redesigned the closet and transformed the bathroom to rival their own main house. I was house proud and even more delighted that I was appreciated for the work I was doing. I was happy to be their tenant and they were just as happy to have me live there.

In less than three months it became a real showplace—and so did the surrounding gardens. The Finks were known for their "First Friday of the Month" parties.

They often took this time to show off whatever latest transformation I had made. "Look what he has done," they would beam. Many people often thought I was a designer of sorts and, when told I was a banker, the reply was always the same: "Wow, most bankers have to hire someone to get their place to look this good."

The Love Shack became the creative springboard I needed, and it was only a matter of time before I was ready for something bigger and better.

I was eager to establish roots, stop paying rent and give Corky—my miniature schnauzer—a backyard of her own. Having saved my pennies over the years and working hard at the bank, I felt it was finally time to jump into the hot real

estate market as prices were climbing and deals were still being had. I pulled the trigger in the spring of 1997: I jumped into the crazy Westport real estate market. My criteria were pretty simple: A house, not a condo; to stay in town and be in the vicinity of the downtown village; extra bedrooms to accommodate overnight guests; enough room for entertaining; and finally, a yard that did not require a staff to maintain.

So the hunt began and after seeing 20-plus houses on a rainy Saturday in June, I was taken to a home built by a very desirable, high-end builder in town. His name is Rick Benson of R.B. Benson & Company.

The house, built in an old neighborhood, was constructed on one of the very few undeveloped lots available. The lot—less than a quarter acre—was created by a subdivision in 1921 but left untouched until 1995 when the builder purchased the land and started construction the following year.

The brochure read: "New Home! Seven room, four bedroom home with 2 ½ baths, clapboard façade in walking distance to town. All amenities, granite countertop in kitchen, third floor master suite with whirlpool bath, central air. Road and driveway will be paved."

When I first read "four bedrooms" I though it may be too big, but "What the heck," I said, "Lets take a look at it."

I walked up to the newly built three-story colonial house knowing it had to be mine—even though it was painted a peachy-pink. I did not let on how interested I was. I happily entered, only to have the realtor yell at me about wiping my feet and taking off my shoes. I guess she was tired and perhaps thought I was wasting her time. This house offered 2,000 square feet of living space.

This quirky pink house was destined to be mine, but first I had to enter a bidding war with three other interested buyers. It was tense not knowing if my offer would be accepted, but soon enough I got word that I was to officially become a homeowner. I was packed and moved in within 30 days.

It is still my home. Ever since I can remember I have dreamed of a place that would protect me, make me feel whole and inspire me to be me. I never fully anticipated the role this house would play at the center of my story, but I knew that it would be an important part of my finding the voice and expression of my passion. The signs were there early on, and shortly after moving in I knew my house needed a name. I've always felt that names give houses a feeling of belonging. I named it Rosebrook Gardens, drawing inspiration from the rose bushes I was in the midst of planting and my home's proximity to a gentle brook.

> "Giving your home a name allows its journey to begin."

This house felt like a gift to me, and it is my responsibility to share it with the world, as I have enjoyed doing with those who have come to visit, those who have learned here, and those who simply come to be inspired. Rosebrook Gardens is a place that offers all things to many people and I have the pleasure to serve her up with great style.

Whatever became of the little "Love Shack" cottage I lived in? In 2003, the Finks retired and sold their home to a builder who tore it down to built a 5,674 square foot single family home. In August 2004 the property changed hands and sold for $1.8 million. The cottage? It was saved by the wrecking ball and remains, connected to the new footprint.

Who knows, maybe it was my early *Casual Luxury* touches that saved it.

Welcome to Rosebrook Gardens

Chapter Three
Friendly Foyer

Welcome to Rosebrook Gardens. Come on in!

The foyer of a house is like an appetizer: although it must be functional, it also must be cohesive within your overall design. The foyer should flow smoothly to the adjacent rooms.

This space no doubt is a high traffic area and might even be the main point of entry to your home. I recommend you celebrate the opportunities to design the space, regardless of its size. Your energy (along with your budget) should be allocated to this space just as you would to any other room in your home. A foyer, regardless of size, should not be confused with a "mudroom" unless it is your only access into your home. Only then do I recommend a combined space.

When possible, a rectangular landing area should be created right inside the door using a different material than the rest of the flooring—think of it like the mirror image of the welcome mat outside, but larger and

permanent. I love a light natural stone, like granite, limestone or honed marble. This is common in larger foyers, but sometimes removed during a build-out due to budget restraints. I can't tell you how many million-dollar homes skimp out on this important detail. If you can do this, never sacrifice natural stone for faux stone in a foyer.

In my home, an antique area carpet grounds the entrance area while picking up the color theme of my overall design. The dark hardwood floor visually works to "frame" the carpet, and offers continuous flow throughout the house.

Beginning in this room the hardwood floors run through the entire first floor, including the kitchen, and I had them stained and finished in a dark ebony color. If you have pets that shed you do not want to go with a dark color floor as hair will show. Go with something more forgiving in a mid-tone which is better for disguising the evidence of pet ownership. Since I own a schnauzer that has hair rather than fur—and with so much natural light throughout the house—I could afford to create a contrast with a darker, richer floor color.

Large foyer or small, one should always focus on length, height and width to dictate budget. Reassign dollars for higher-end details. This is an excellent opportunity to offer elements and solutions that embrace all who enter as well as provide a positive representation of and create order for those who live in the home.

My foyer, although hardly grand in size, did have many positive features going for it: nine-foot ceilings, a large

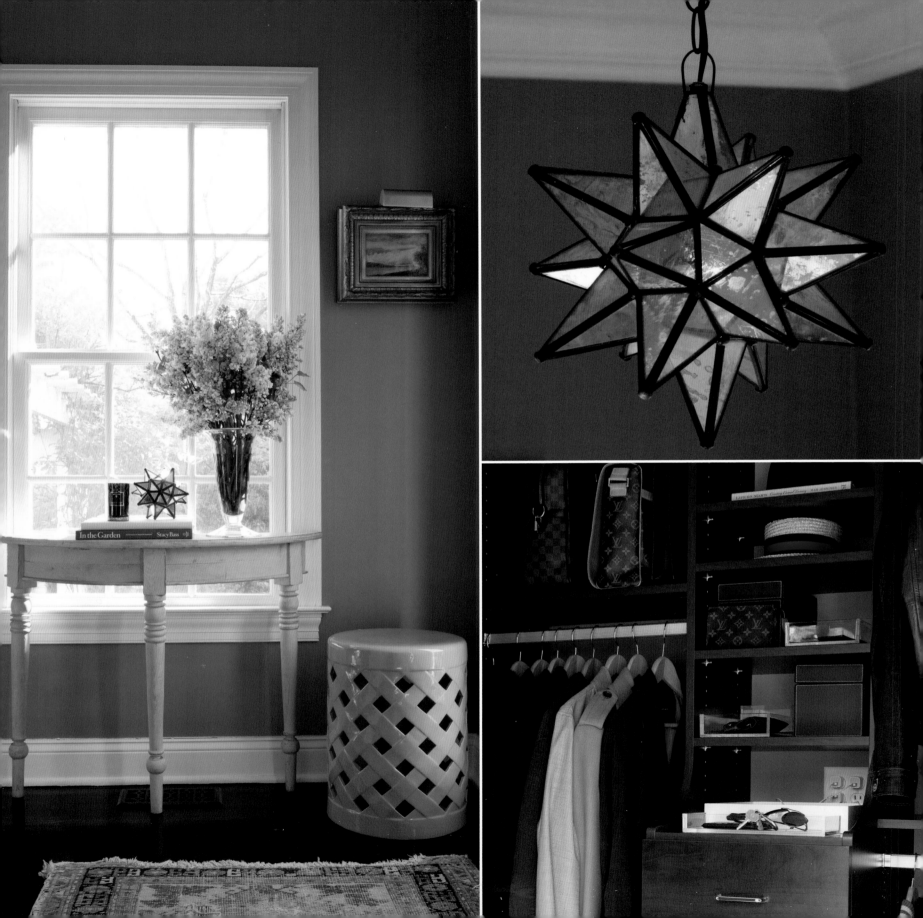

window and a closet conveniently located opposite the door.

Any foyer needs three essential components: a place to sit, a closet and/or storage area, and proper lighting. Once you address these practical issues you can expand on decorative touches such as tables, artwork and accessories. I firmly believe that fresh flowers are a key ingredient for any main entrance area. Vases on walls or shelves work perfectly in tight spaces or apartments. If fresh flowers aren't practical, then incorporate any type of plant.

This home offers all of the elements above, plus the added bonus of Mother Nature's natural lighting. From my foyer one can take in the sights of the pergola. My guests arrive to a vision of beauty in the form of the views of the ever-changing garden vignettes. In the spring, the delicate purple wisteria flowers cascade their blooms, seeming to dance in the air as the breezes of the season embrace their beauty. The lush summer days offer yet another vision as the silver dollar-sized white clematis flowers begin their splendid display. In fall, the leaves turn color and are some of the first to fall, their fluttering motion catching the eye. And in the winter the entwined wisteria stalks contrast with the straight lines of the pergola itself, a formation enhanced all the more when highlighted by snow.

Underneath the window facing the pergola sits a small, antique Swedish demilune table. Demilune tables take their name from their half-moon shape. This table offers the perfect place for an intimate flower arrangement and a candle. I have several tables like it; they are so versatile, and perfect for areas that have high traffic as there are no sharp corners to worry about.

My closet space has been revamped from its traditional, cookie-cutter hanging system. This new custom closet system provides the maximum storage opportunities keeping coats, hats, briefcases and umbrellas organized and perfectly stowed. And should I need to take away and store something a guest might be carrying to fend off the weather, now it can be tucked away in a highly styled space that is both practical and functional.

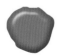

Nine-foot ceilings
9x6
Paint
Benjamin Moore
Van Courtland
Blue

As a bonus, drawers were added to the closet for gloves, hats and scarves. A tray on top makes a perfect drop-off station for keys and more, keeping them out of sight when the doors are closed. One of the best closet features is a "valet" rod, which extends out from the shelving to accommodate airing out wet articles or to keep items close at hand for short-term visitors. I love this feature as coats are easily identified, rather than being mixed up into my own ever-growing collection of outerwear, prompting my friends to ask, "How many coats does one person need anyway?"

Today, guests arrive and are greeted with "Welcome to Rosebrook Gardens; may I take your coat, bag and phone?" Yes, this year I added a bonus feature to the closet: a charging station. Over the years I have collected many battery chargers: from Blackberry to my most recent iPhone and everything in between. Not wanting to be wasteful, and seeking a way to reuse something old, I called my professional electrician to add four new outlets right above the drawers. They act as charging stations not just for me but for my guests as needed.

A licensed electrician can easily install a new outlet and even add dedicated circuits for your more high-end electronics. They can move or install additional outlets practically anywhere in your home, so why not into the main foyer closet? It has become the perfect solution for easy drop-off and pick-up, and it's all out of sight in a moment. Guests focus on their visit and I get to have their undivided attention.

Lastly, look up. A more decorative lighting source was needed, so it was updated with a star shaped, antique, hanging light with bronze finish. I love this look and chose it as one of the shapes that I repeat; throughout my home you will see this fixture reused in multiple styles and finishes.

Altogether, regardless of the season, this foyer may be small in scale, but large in function. I've been told it feels warm and inviting to all. Including myself, who never gets tired of that feeling when I walk through the door.

Chapter Four
Living Room

Today's modern families hardly live in the living room. They have moved, en masse, to the family room or great room.

Unlike it's neighbors the kitchen, bathroom and bedrooms—where the function still reflects the room's name—the proper living room is an unclear and sometimes undefined space.

This poses many design problems, thus making it harder to decide what to put in the room. Through history, you see that the name given to this room has evolved—from reception room, drawing room, parlor or telephone room to finally the "living room." Regardless of its official title, the one thing that remains the same is the need for family and friends to come together somewhere a little less casually than in other rooms. Therefore, it leans towards more

of an entertaining space. I believe that if you apply *Casual Luxury* principles to such spaces, they are not only great for entertaining but become rooms you want to live in, too.

Over the years I have designed many living room spaces for clients, from low-maintenance minimal spaces to the opulent, over-the-top types (yes, including silk window treatments and custom furniture designs.) But the money you spend does not determine a room's success. Regardless of the client—including myself—there are three guidelines that must be addressed: Function, usage and visibility to anyone who visits. These three will help you identify the purpose, the key furniture pieces and the allocated budget requirements.

Your living room no longer has to define your wealth and social status; rather, it should be a place to retreat to and enjoy. As a child, the living room in my home was off-limits to the children and pets. The carpet was white, the furniture uninviting, and the drapes were heavy and matched the furniture. We had to walk past it on the way to our bedroom stairs every night. You could see the "museum collection" living room as you passed, but you never had tickets to enter. My parents would entertain in the space before and after dinner, but we kids were never allowed in. The age requirement that my father set followed the state's liquor law!

It was not until my parents divorced that this space got a makeover. Rugs were removed to expose the original hardwood floors and a baby grand piano

Nine-foot ceilings
17x11
Paint
Benjamin Moore
Van Courtland Blue

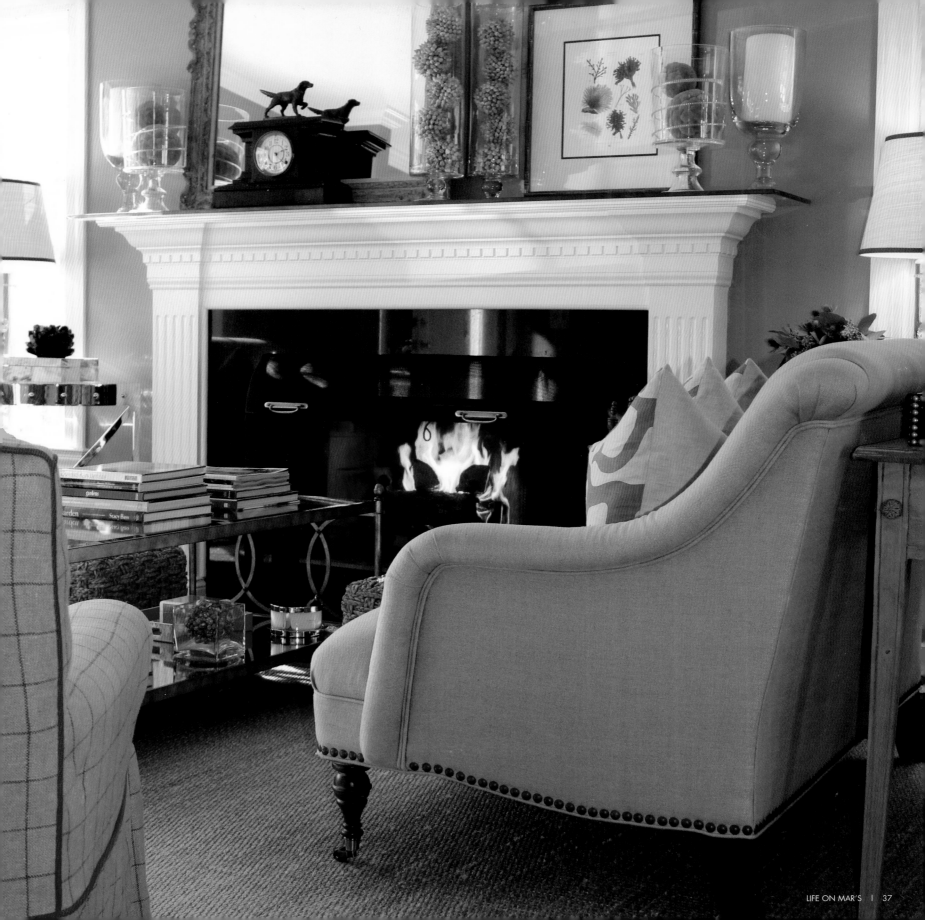

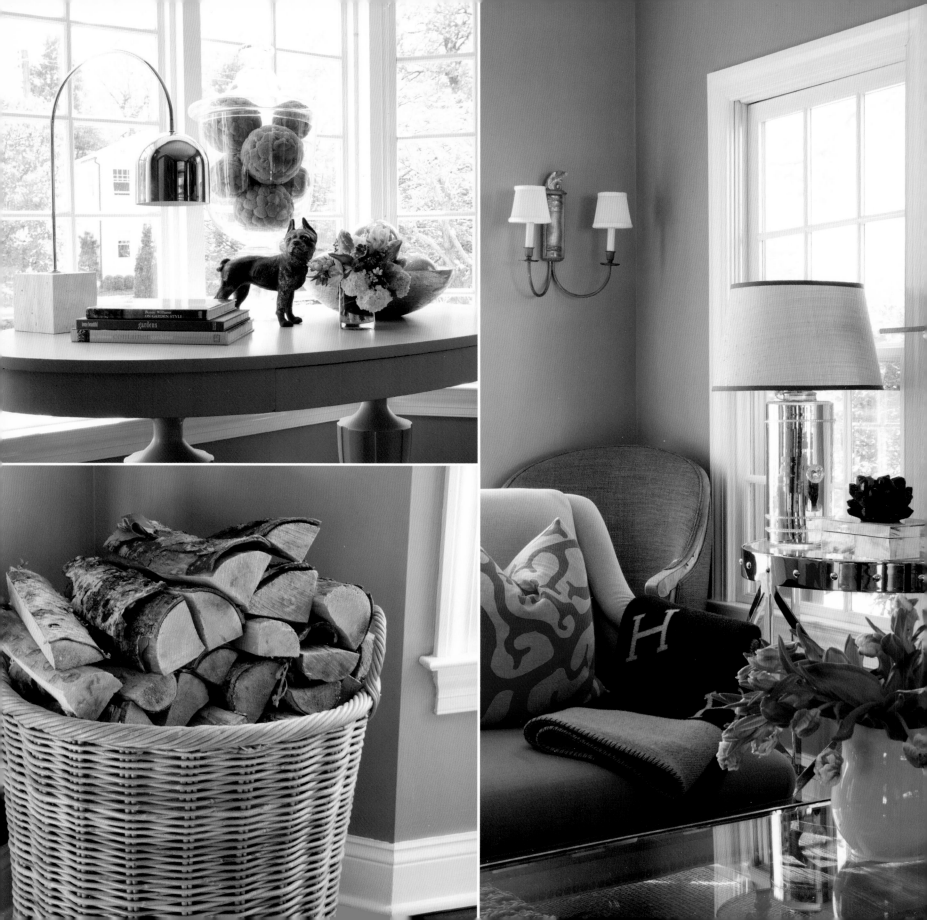

was purchased so my mother could reconnect with her passion for music. I designed the space to suit the function, thus helping it become my mother's music room/sitting space. Finally the once uptight living room was reborn with a new purpose that reflected the homeowner's true passion.

You see, once you identify how you want to use the space you'll understand the usage, allowing you to know how much you need to invest to create the look you want. Forgo a sofa if a chaise is more in tune with your style and needs. There are no rules to break as to what a room must be. Don't be constrained by the traditional limitations and be open to the possibilities for really usable space.

Designing my living room at Rosebrook Gardens was all about entertaining and flow. I knew it was where I wanted to receive guests and so I worked to create a cozy, comfortable room. Eight guests can be seated in this room at any given time. Chairs are interspersed throughout the room and become part of the overall décor when not in use. As you look you will notice the use of scale of the seating; I did not find it all at once, but it was worth waiting to get the right sizes. But there are many things to learn from this space, everything from furniture placement, design details to "zero space" furnishings.

Here is a quick first lesson: Every room should have at least one focal point. In my living room I have two: the fireplace as well as the art collection directly across from it. Both are very different types of focal points.

Focal point number one: the fireplace. I have one simple request regarding fireplaces in a home: if it is your only fireplace it should be a wood-burning one. Nothing connects you to the outdoors as elementally as a real burning fire. Should you be lucky enough to have more than one in your house, then by all means convert the others to gas or any other heat-saving resource. Truth be told, one of my very first expenses after purchasing my home was dealing with converting the then gas-burning fireplace to a wood-burning fireplace.

My fireplace mantel has a cohesive look and feel that matches my colonial style home. Retaining the look was my jumping off point when redesigning it. I replaced the original tiles with a new black granite façade. The style of the fluted columns is repeated on the pergola outside, so the dentil molding was also included to match the same trim of the exterior of the house. These renovation details were worth every penny and best of all, were completed before I moved in.

This is what I created rather than following common, traditional designs. Fireplaces come in a wide variety of styles and finishes. These range from Federal to Tudor to Edwardian to Empire to Art Deco proportions. They can be ornamented with garlands, figurines, urns or classic columns. They might have mantels made of wood, stone, or mirror. The fireboxes vary from brick to cast iron to stone. With so many choices, I believe you should infuse the elements that you love in a fireplace design to create a unique focal point you call your own.

Today, not one season passes that my fireplace is neither styled nor in use. In warmer weather, a collection of white birch logs, vertically placed, offers an interesting and unexpected surprise in the hearth. In the height of the winter season, piles of birch logs are perfectly stacked in an oversized wicker basket, placed near the doorway. I did this to maximize that dead space, and avoid crowding the spaces at either side of the fireplace itself.

In my home I prefer to burn only birch logs, as they are light to carry, produce a romantic ambience with tall flames, are easy to light and, although they do not give off much heat, they are perfect for creating a great atmosphere. Nothing sets a cozy mood like a wood-burning fireplace; the smells, colorful flames and the crackling noise can't be beat.

As for the décor above the fireplace, rather than creating symmetry as one would normally do, I focus on creating balance as a way of making the wall interesting. On one side of the mantel sits a large mirror to offer reflected light, while on the opposite

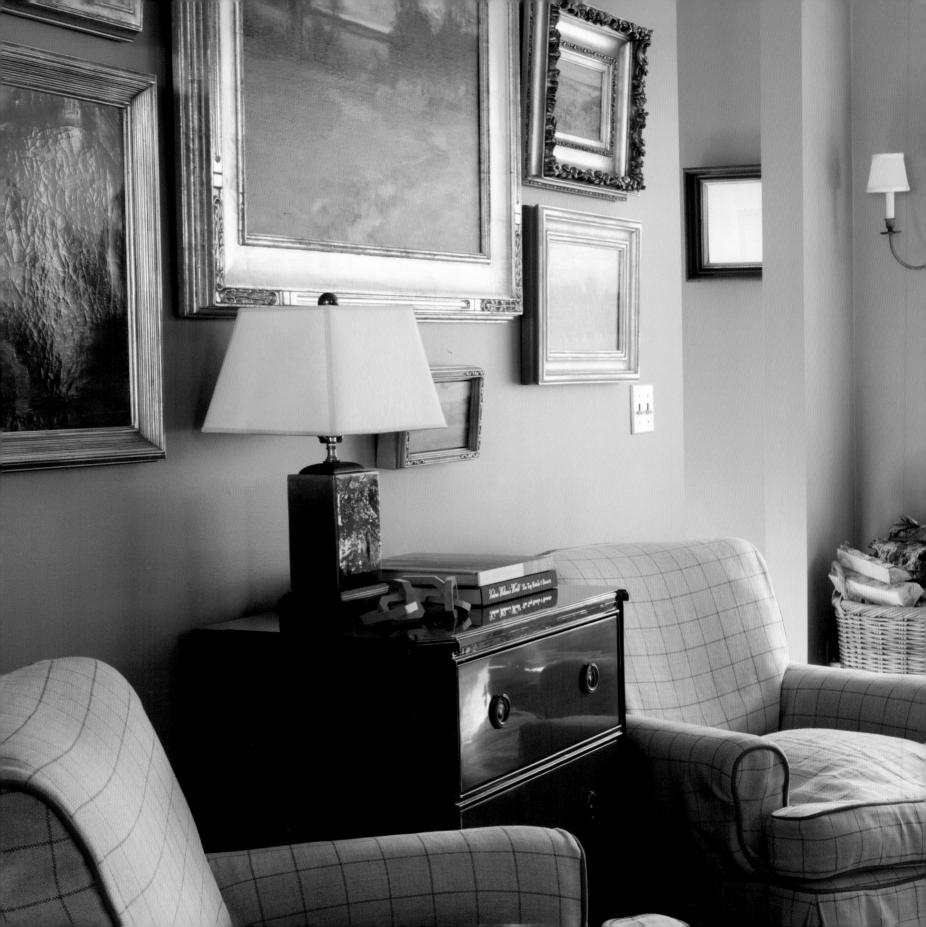

side two coral prints are displayed, each in a bamboo frame. These two different elements are united by their color and scale: the mirror is balanced by the stacked art, thus giving a cohesive flow from side to side. The mirror and prints together create a focal point, while staying in scale to the fireplace.

Another design trick was to increase the surface area of the mantel without any construction. I laid a half-inch-thick clear glass over the existing mantel; it is cut to overlap the mantel underneath by three inches to the front and three inches to each side. I'm not afraid to renovate, but I didn't feel I needed to here: building out the existing mantel would have made it overscale for the fireplace. I incorporated the principle of "zero space": the glass subconsciously seems to disappear, so I was able to create a larger surface without it looking heavy.

Two windows flank the fireplace; they have no window treatments to block the light or views of the gardens. If you have views and are not concerned with privacy, then I say "Dare to go bare!" Remove the window treatments and invite the light in. Window treatments are overrated and expensive when there is no need for privacy.

The lack of window treatments can blur the lines between the interiors and exteriors spaces, creating a rhythm of constant flow and appeal.

All the windows on the main floor are without window treatments of any kind. Through the two flanking the fireplace, the arbor provides a beautiful backdrop. In addition, views

of the boxwood parterre garden and the magnificent lilac topiary offer both a fragrant delight in the high season as well as structured form and elegance.

Focal point number two: The art collection feature wall. To visit Rosebrook Gardens is to experience the elaborate gardens and the ever-growing beauty of the maturing landscape designs. These colors are infused in my home, and there is no better way to embrace the colors of the gardens than these oil on canvas works painted by several favorite artists. I'm attracted to mid-19th century Hudson Valley landscape paintings, and think of myself as an art lover more than a true connoisseur. Truthfully any beautiful landscape painting can easily make its way into my ever growing collection of art. Rosebrook Gardens offers three floors of art. However, the pride and joy of my collection has to be the large Dennis Sheehan painting in the center of the collage.

It's named "Brookside." Living next to a brook and on a street called Brookside, the moment I set my eyes on this magnificent painting I knew it needed to be mine—just like when I saw my home for the first time. I spied this shortly after I bought the house, and since then I have collected many other works by Mr. Sheehan; just like this sunset landscape they, too, reflect my love and passion for planet earth.

Art need not be expensive to be loved, so regardless of what you've invested in your pieces of art, here is some sMARt advice you can "hang" on to for keeping the scale in check and show off the art to its best. When hanging over furniture—such as a

sMARt tip

No-Trip Rugs

Do you worry that your area rugs could become trip hazards? The most elegant and easy way to eliminate the problem: use a decorative upholstery nail head to secure the corners. Because these nail heads are relatively flat they work perfectly, and can be chosen to match your carpet or décor. These are available online or at your local fabric store. Make sure you buy large enough tacks to secure your area rugs. I find I'd rather make a little nail hole in my floor than have someone trip on my carpet.

sofa—it should not be longer than the width of the furniture; better to stay no larger than 75% of the width. For more formal spaces, hang art in symmetrical groupings. For casual spaces like mine, I prefer to use collage groupings. Use frames that don't match for a playful twist. Space artwork one to two inches apart. Make sure the center of the group is at eye level.

Now that I've shared the two focal areas of the room, let's look at the other design details.

Beneath the art wall are two slip-covered chairs divided by a small bureau. Each offers a comfy, down-filled seat cushion. (Yes, they get "poofed" after every sitting; never leave a cushion looking deflated.) My first schnauzer claimed one of these chairs as her basket, so I had an extra two yards of matching fabric cut and edged to cover her favorite spot; it could be whisked away when company came over. My new schnauzer, Violet, has yet to discover that her daddy is willing to accept this behavior. Let's keep it a secret, shall we?

Finials—larger versions of the shapes used to top banister posts—are designed for indoor use. It's an outdoor shape that adds drama and an unexpected touch to your home. I use them on tables as objects, as a doorstop, or even in a bookshelf as a stand-alone item or a bookend. The older and mossier they are the better I love them. Try this whimsical touch in your home.

When you have an open concept between the living room and the dining room—as I do—you don't necessarily need to use one wall color throughout,

although I did. You have the freedom to change it up as you move from room to room. The key to your success is to have a linking element between them, and use of color is the simplest way to pull the rooms together. This can be done with upholstery, carpet, coffee tables and artwork.

Designing the living room space was done by infusing colors and shapes across it as well as the dining room and foyer. Repeating patterns is one concept, but repeating shapes is another, and I've already hinted that you see this type of design idea throughout my home.

In a corner you will find an antique Empire chair recently covered in a Belgian linen fabric. The sculptural lines in the chair mimic the half circle demilune table from the foyer. A matching grey and cream Hermès pillow combines the two colors with a wonderful circular textile pattern. The painted oval urn table located in the bay window repeats the soft lines. I love this table—it even has a top drawer to tuck away a pad and pencil.

An area carpet is the best way to define and ground a space. I anchored the living room with a 100% all-natural sisal carpet with a one-inch thick, deep chocolate trim. Rules I adhere to when using an area rug: keep at least two legs of each piece of furniture on the carpet, and never have an area carpet just under a coffee table. Always order carpet based upon this information and you'll never go wrong with size and coverage.

A set of Odette loveseats by Mitchell Gold + Bob Williams offer a modern twist on a traditional style. The oversized nail

sMARt tip

Curtains or Not?
In order to embrace natural light, do not put up curtains or other window treatments unless you don't have a pretty view or there is a need for privacy. If you must install something, just make sure you do not match the carpet with the drapes, the drapes with the furniture and the furniture with the pillows. Yikes! Where do I begin to explain why this is a design no-no? Decorating like this is tantamount to painting by numbers: too contrived and merely copying someone else's design concept! Any great room design comes to fruition through patience and the investment of time to find pieces that work together. Live, learn and experience the space before jumping into buying window treatments on impulse.

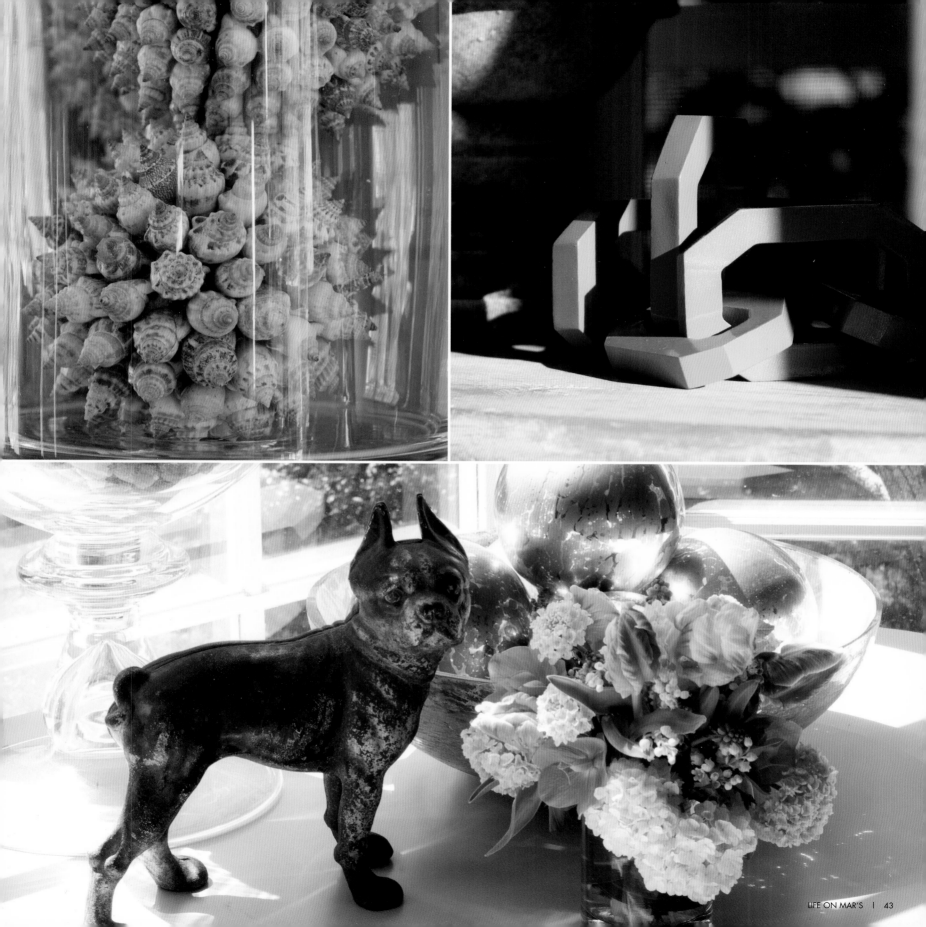

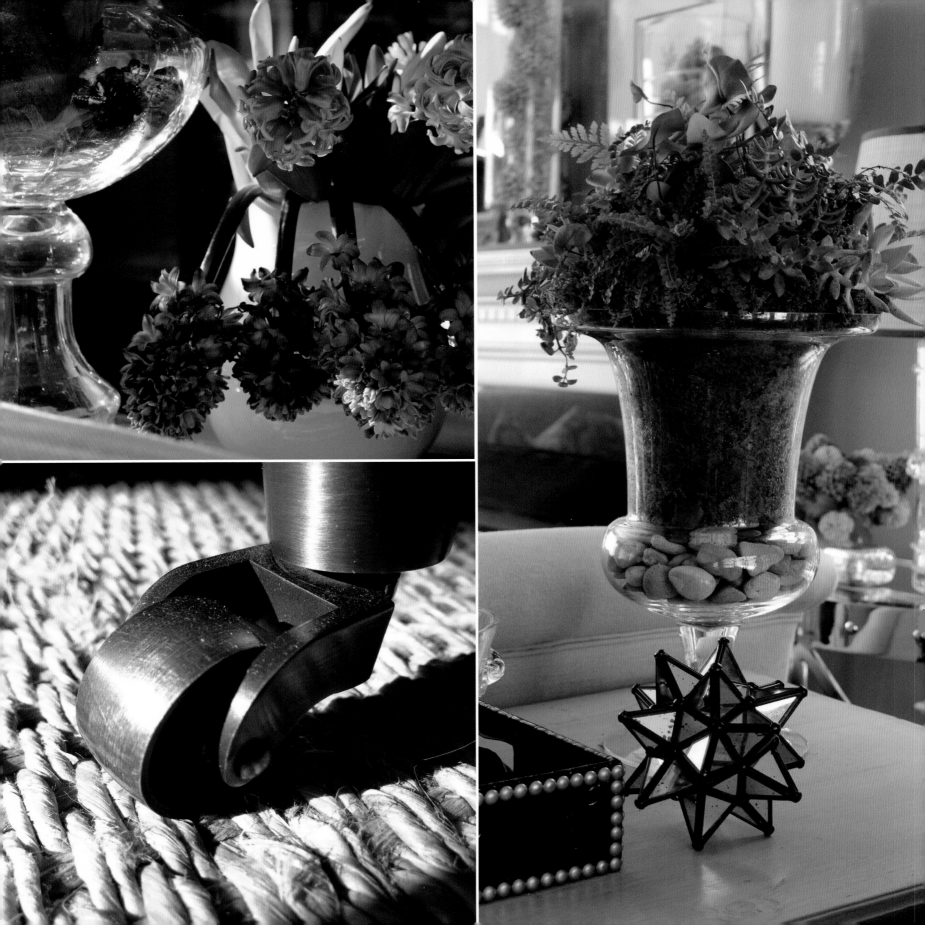

head trim around the base offers masculinity to the soft curve design. I chose this set due to the dimensions: 54" wide by 36" high. Add the great, slim arms and you have a wonderful sofa that does not clutter the space. The arms have an English curve and the turned legs have brass casters. Casters on furniture offer a wonderful decorative detail—not just to the furniture but to your home as well. I love the look, style and convenience. Whenever possible I try to select furniture with this design detail. As someone who films at home quite regularly, casters are practical and an essential element of *LIFE ON MAR'S*!

The coffee table and silver-glass end tables are other items that benefit from the principle of "zero space," allowing your eye to focus on the openness of the room. Try for yourself, imagine three solid pieces of furniture in their places. "Zero space" is a great way to add extra surfaces in a room without the heaviness of a solid piece of furniture.

When working with an open floor concept and an adjacent room, consider how you can use furniture to break up the space. A set of chairs, a small scale sofa or—in smaller spaces—a beautifully upholstered day bed can become the perfect room divider. By keeping furnishing heights low, your spaces stay open, allowing light to fill the room while you are still creating boundaries.

A Swedish desk with carved details sits in the perfect place for a bar, creating a transition from the living room to the dining room. An antique chair upholstered in black leather has wonderful nail head details and it slides right under the desk. The desk and chair serve two purposes: style and function. (If inspired to try a desk as a bar yourself, don't buy a matching desk and chair—you don't want it to look like a home office.) The drawers offer storage for both rooms. One drawer is for bar supplies: a bar towel, cocktail napkins, additional stirrers and extra coasters. The other doubles as a silver chest so my flatware is at-hand for the nearby dining table. No room for such a desk in your home? You can also create a bar in the hutch of a breakfront or on a shelf of a bookcase. Any place that will hold a tray is suitable for a bar, I say.

This room is flooded with lots of natural light during the day, and when sunset occurs the accent lighting has its chance to shine as an important part of the design in this room. As a matter of fact, each room on the first floor—the foyer, living room, dining room, kitchen and even the powder room (which I call the cloakroom) has art lamps on the portraits. Most rooms also have glorious wall sconces. But there is no need to run around the entire floor to turn any of them on or off, as they are all conveniently wired to one switch. It was easy for my electrician to drop all the wires below and connect them onto one master switch. The switch is also on a dimmer, so the lighting can be adjusted for the best effects for any time of day.

There is even more lighting by the way of four three-way table lamps. If I'm to own a lamp it must accommodate a three-way light bulb. I'll admit it, I'm somewhat of a lighting control freak. Even my recessed lights are on a dimmer switch. You might not see the need to vary the lighting in your home, but it allows you to change the mood. It is an easy alternative to candlelight, and everyone and everything looks great in softer lighting.

No living room would be complete without some beautiful fresh flowers or even a plant. Terrariums are my go-to solution for year-round longevity and beauty. No matter what your style may be—from country to modern and everything in between—a terrarium is a wonderful way to bring Mother Nature indoors, as well as lift your spirits. And so easy to care for. In fact, they add an element of *Casual Luxury* to almost any room. I love the ones from the experts at Terrain; theirs are beyond compare. I decided to learn how to assemble them myself and think mine are "**MAR**nifique," too!

I have so enjoyed evolving my living room to be comfortable, inviting, and a reflection of who I am. Applying these *Casual Luxury* principles makes it easy for you to do the same.

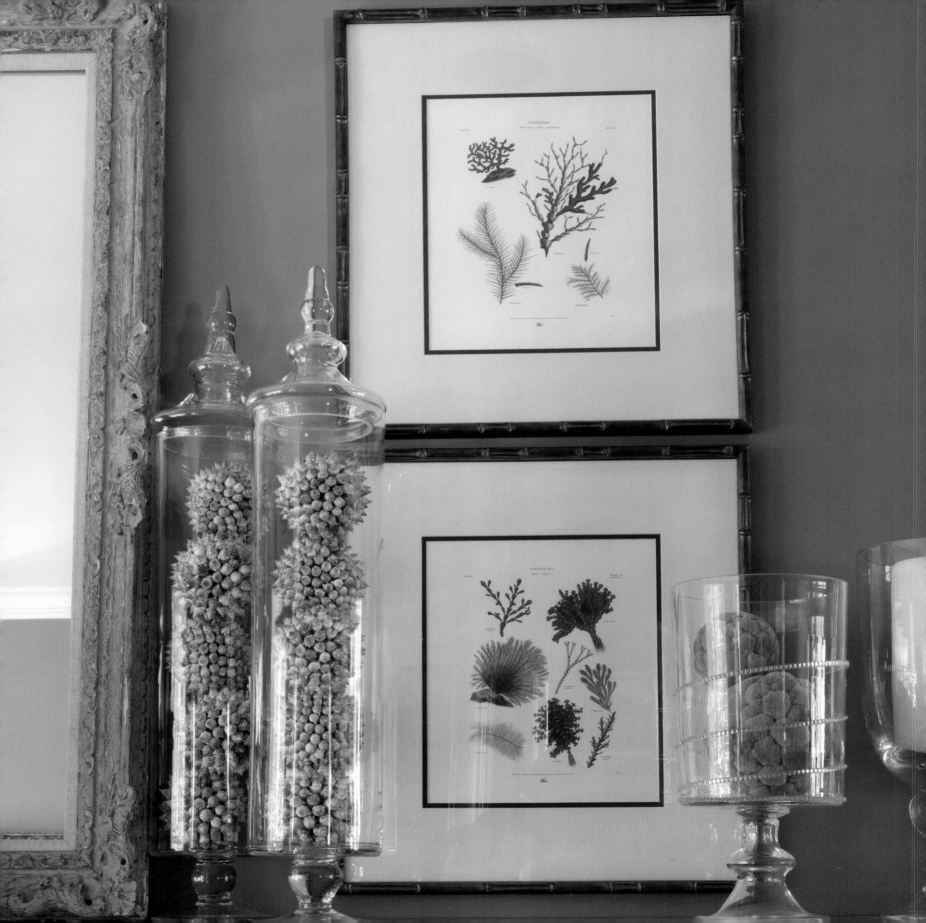

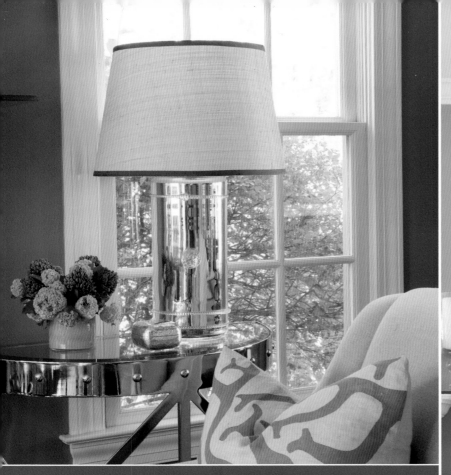

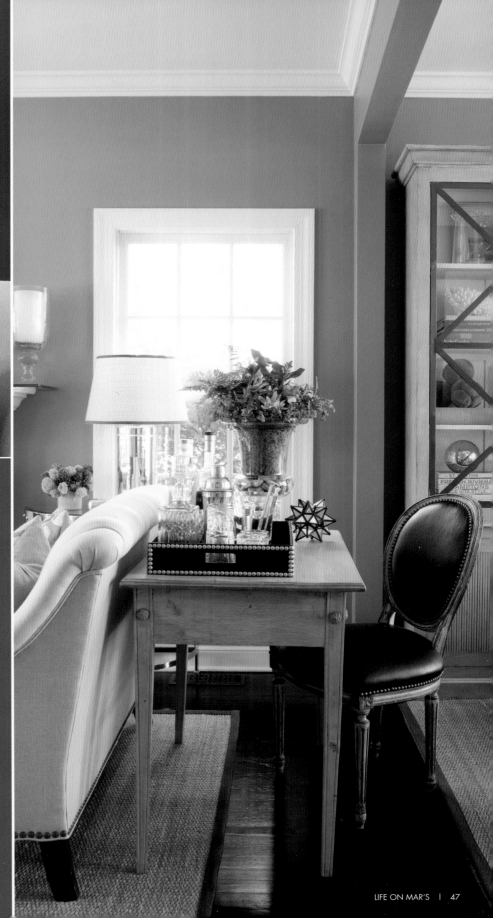

"Much more than simply placing furniture in a room, *Casual Luxury* adds warmth, personality and a feeling. Suddenly, it's a home— not a showroom."

Chapter Five
Dining Room

Today's open concept spaces offer easy access and flow between rooms, such as kitchens, dining rooms, and family rooms.

My dining room is open to the living room. This open concept allows for a harmonious blending of the two spaces. However, I wanted to avoid having the overall impression of one large and narrow room.

When designing an open floor plan, it is important to separate spaces. My philosophy is to create zones to identify each individual area within the open space while keeping them cohesive in their design. This concept can be applied to smaller, intimate rooms, too. To do it successfully, divide the space into areas defined by their purpose first, then decide on the unifying design elements you will use, such as the use of color and patterns.

Start by defining spaces from the ground up. The ebony color hardwood floors continue throughout the main floor and matches the color and texture of the one in the living room.

One of the principles of *Casual Luxury* is to repeat shapes and patterns. It creates a cohesive look throughout a home, and in open concept areas it is critical because it creates a subconscious connection between the adjacent areas.

An example of this is the glass-topped wrought iron sideboard. The circles and "x" design reference the patterns found in both the living room coffee table and end tables, also in metal.

This sideboard is also an example of my "zero space" concept. The openness of the room is visually reinforced by the fact that one can see through the grillwork. When observed from the living room, the open pattern allows your eye to travel freely through the room to a view of the gardens. Originally, the iron base was a balcony railing from a London home— beautifully repurposed here. The sleek, frosted glass top is another part of the "zero space" concept as it is visually clean, and adds a modern touch. Hanging above this sideboard is an original work by artist Carol Leslie, commissioned to further tie in the colors and textures of the living and dining areas.

When selecting a dining room table, select one that has enough surface area to accommodate a place setting for everyone in the home while leaving enough space for a tablescape and other décor. My 42" circular table is circa 1950 and was purchased

Nine-foot ceilings
12x10
Paint
Benjamin Moore
Van Courtland Blue

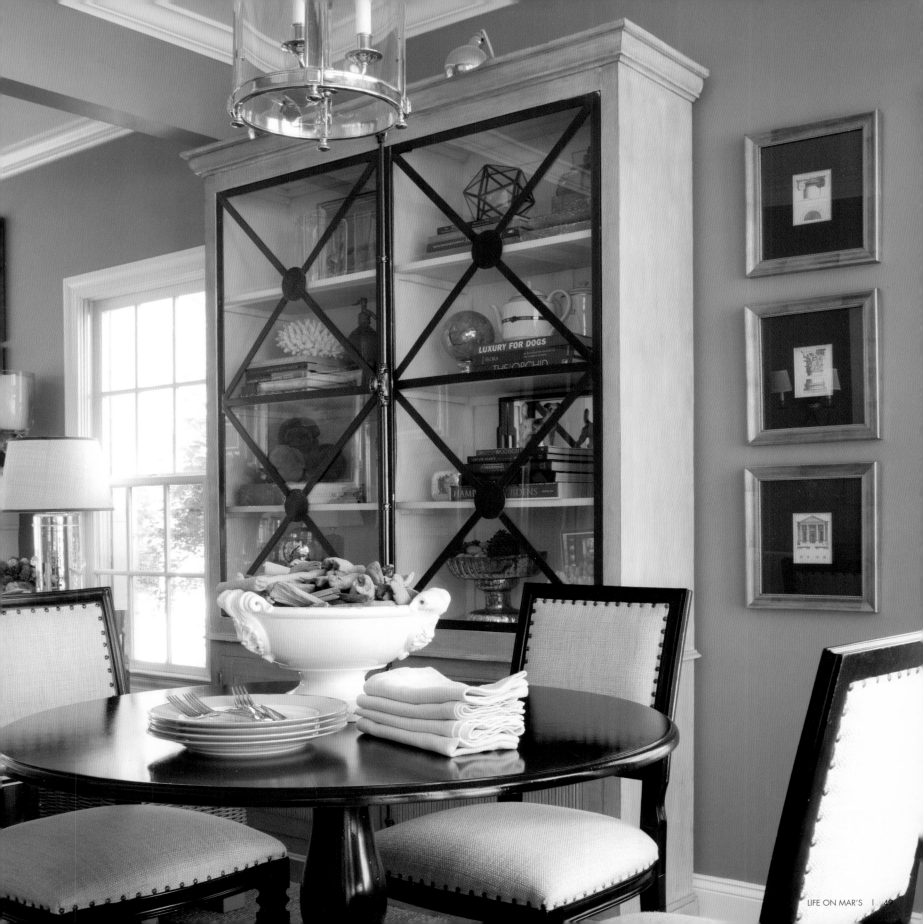

while on a business trip in Miami, Florida. When it arrived at my home several weeks later it was badly scratched, so the only option was to refinish it. Refinishing wood is a great way to teach an old item a new trick, but in this case I opted to revive it with a coat of paint. A high-gloss black finish was selected to complement the wrought iron sideboard and the metal details on the china cabinet. This dining table is perfect for intimate dinners for two to four people. The barn table originally in this room seated six and was oversized for the room.

Four armless dining chairs, also black, perfectly accent the table. They were acquired for a house tour that happened right after the launch of my first book. Only recently were they reupholstered in a fabulous cream colored woven Belgian linen. The nail-head tacks were added both as wonderful accent detail and as a repetition of the similar tacks on the living room sofas.

Lighting needs to be addressed just as you would any other layer of design.

When selecting a chandelier, make sure it is not wider than your table's dimensions. A chandelier's width should never extend beyond the sides of the table. In fact, the table should be a few inches wider on all sides.

How do you know what height to hang a suspended lighting fixture? The average dining room ceiling is eight feet high. My rule of thumb is that the base of the fixture—including chandeliers—should be about a yard above the table. If the ceiling is more than eight feet high, raise the lighting fixture about six inches for every additional foot of height, which keeps the dimensions in scale. Another reason to raise the fixture is for a bowl style—or anything that you cannot see through.

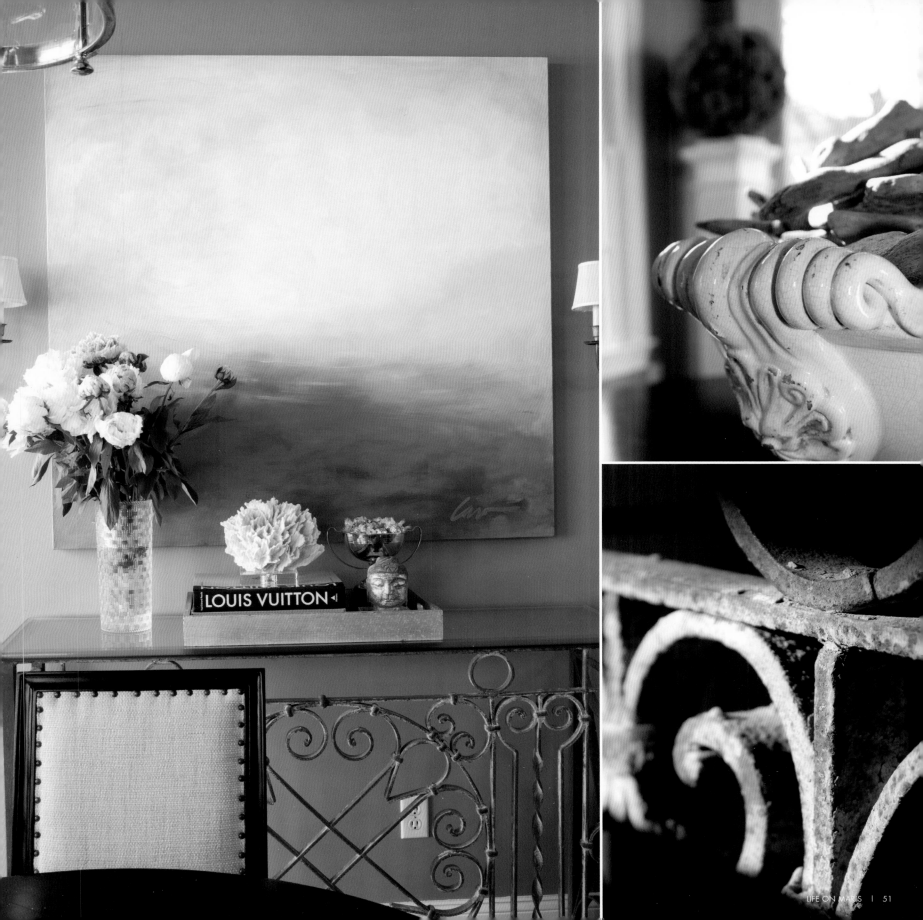

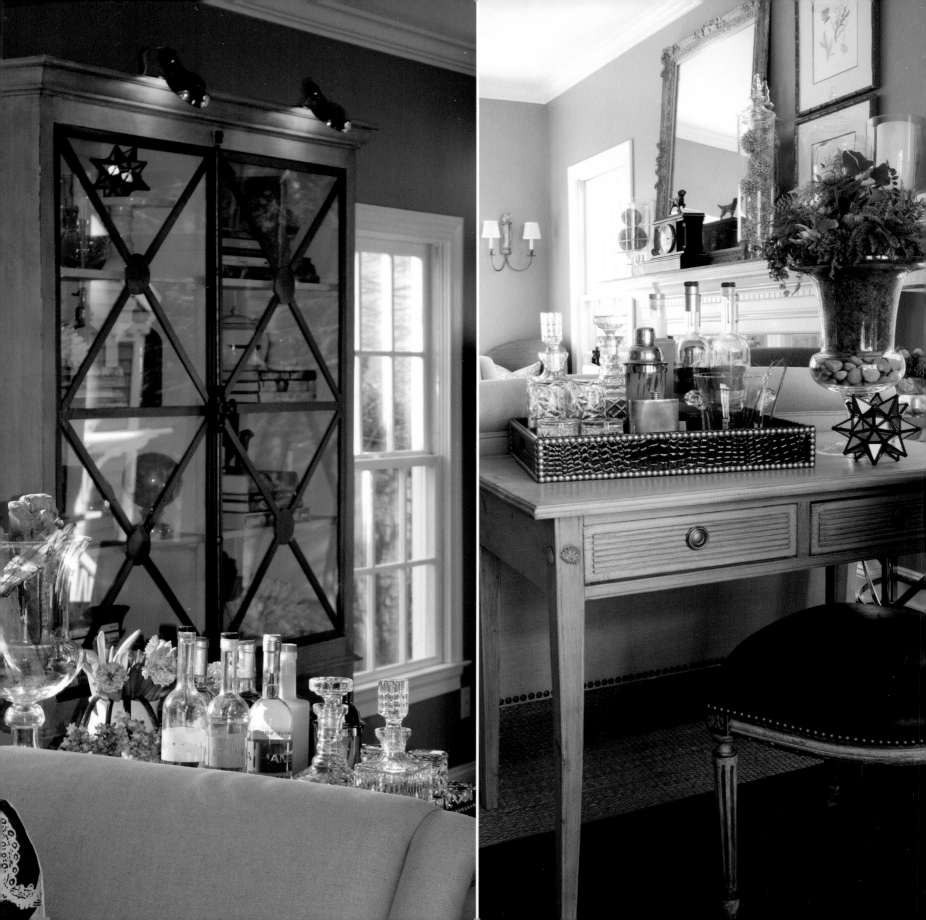

I selected a nickel finish pendant lamp. Nickel or silver is a wonderful material to incorporate into a space as an accent, however if overdone it can make a room feel cold and unwelcoming. The exact opposite of my *Casual Luxury* philosophy, so use reflective metals sparingly.

The china cabinet was added to the room recently, creating even more storage and a strong focal point. The moment you enter the living room it's hard not to notice this piece in the adjacent dining room. It has a great height and width that mirrors the dimensions of the fireplace, but is also shallow, making it the perfect scale beside the dining table.

The metal bands on the glass doors repeat the "x" design, connecting the piece to the overall design with both the pattern and material.

Selecting items to fill the shelves was driven by the location of the cabinet. If shelving is visible from multiple rooms it should be devoted to housing items related to both rooms. Therefore, because this cabinet is visible from the living room as well, my china is safely stored below, except for a few favorite pieces. The shelves contain decorative items such as books, artwork and collectibles in addition to pitchers and tea sets. Mixing these items allows the design to repeat patterns and colors across the two rooms. For example, you will notice the color orange, outdoor elements like brackets, dog imagery, and reflective pieces, all of which can be found elsewhere in the house. It is important to balance the visual weight of the items across the shelving. When placing a transparent glass object make sure to add something solid behind it. This avoids the look of empty space.

For lighting, two small-scale desk lamps were placed on top of this cabinet to bring attention to the piece's height and to highlight the items displayed. These lights are on the same dimmer switch as the artwork, making it incredibly easy to turn on and off. I hate seeing electrical cords, so the electrician was quickly called into action for these quaint lamps. In one afternoon an extra outlet was placed out of sight on the wall behind the cabinet.

The nickel finish of the lamps is picked up by the color tones of the sconces on the opposite wall. They were created from a single old finial, which was sawn in half, wired and attached to bracket arms. These are one-of-a-kind. They are a good example of how, when designing a space, light features never need to match throughout a room. Rather, they should simply have similar elements, such as color tones, materials or patterns.

Next to the cabinet are three framed vintage images. In a narrow space like this think of stacking artwork, especially next to such a large piece of furniture where a single picture would be off scale. Pages were repurposed from an antique architectural book. They are framed with an extra large black matte to pick up the table color and to add an element of sophistication.

In front of the china cabinet are two natural washed rattan cube ottomans. I found them at Dovecote, and chose them because they are perfect as extra seating anywhere, and in a pinch they also can be used as a side table. They easily hold large platters and serving trays that otherwise would not fit on the table, and are within easier reach than the sideboard.

In the dining room you will notice that, once again, no window treatments are hung. Just as in the living room, the dining room windows offer plenty of privacy due to a well planned landscape design. (For all the resources and secrets to maximize this for yourself you will have to read my first book!)

The moss ball is a real conversation starter. It was placed in the corner to bring the organic elements of Mother Nature right into the dining area. To make the moss ball easy to care for, it's made from a terrific synthetic. It sits atop a former porch banister, which was carefully cut down to the perfect level. The fluted column design also subtly references the design on the fireplace. This duo of moss ball and pillar represent a great combination of almost all of my *Casual Luxury* principles, including elements of Mother Nature's colors and textures, repurposing, and repeating patterns and shapes.

The column comes from a grand era of design when millwork and design details were taken even more seriously. Unlike the design details you expect to find in charming older homes, today's modern homes offer little in the way of structural design details. It's very rare to find a newly constructed home with moldings, carved details, or architectural elements. Something as simple as reclaimed wood can offer color tone inspiration for creating your own unique color palette in a room. Metals and vintage fabrics can infuse a room with character and interest by adding details that are one of a kind.

> **Windows allow us to embrace the views. Doors allow us to blur the lines between indoors and out.**

Discovered over a decade ago in the dumpster, today this column continues to stand tall in the dining room and reminds me and all who visit the importance of the "little details" that make a house a home. Recycling these treasures whenever possible reminds all who dine in this space that great design inspiration can come from the most unexpected places.

The back wall offers floor-to-ceiling windows that extend the openness of the space with no visual interruptions. A glass door provides the opportunity to easily embrace the outdoor living room, located in the heart of the backyard gardens. This oasis is visible year-round, but is only a hint of what makes the grounds of Rosebrook Gardens so special.

You may have noticed that nothing in this dining room is matchy-matchy or forced to work together. As a matter of fact, absolutely nothing in this room was ever purchased together or as a set. However, when you take each element (the desk, the china cabinet table, dining chairs, ottomans and sideboard), you will notice a harmonious feeling to the overall room. Repetition is the key to mixing distinct materials together. For example, having the same wood tones creates a sense of unity. The wood finishes of the desk and the china cabinet are repeated along with the dining table and chair legs. It looks as if it was premeditated and purposely intended to be this way from the start.

I advise people that when they are first starting to build a *Casual Luxury* room they are better off collecting the right pieces over time, from different stores. Your wallet can breathe, your mind can explore, and your soul will discover resourceful pieces that normally would not have been an option. Steer away from trying to achieve instant results; instead, focus on pieces that offer elements you love while coordinating shapes, color tones, and textures. The best rooms don't come from a catalog but rather from a plan of action!

As you can see from this room, matching colors is not the only formula for creating cohesion. Rather, repeated tones, shapes and materials can open new opportunities for design. Glass and "zero space" furnishings can make rooms feel larger than they appear. Your dining room can go beyond basic function and contribute to your overall *Casual Luxury* ambiance.

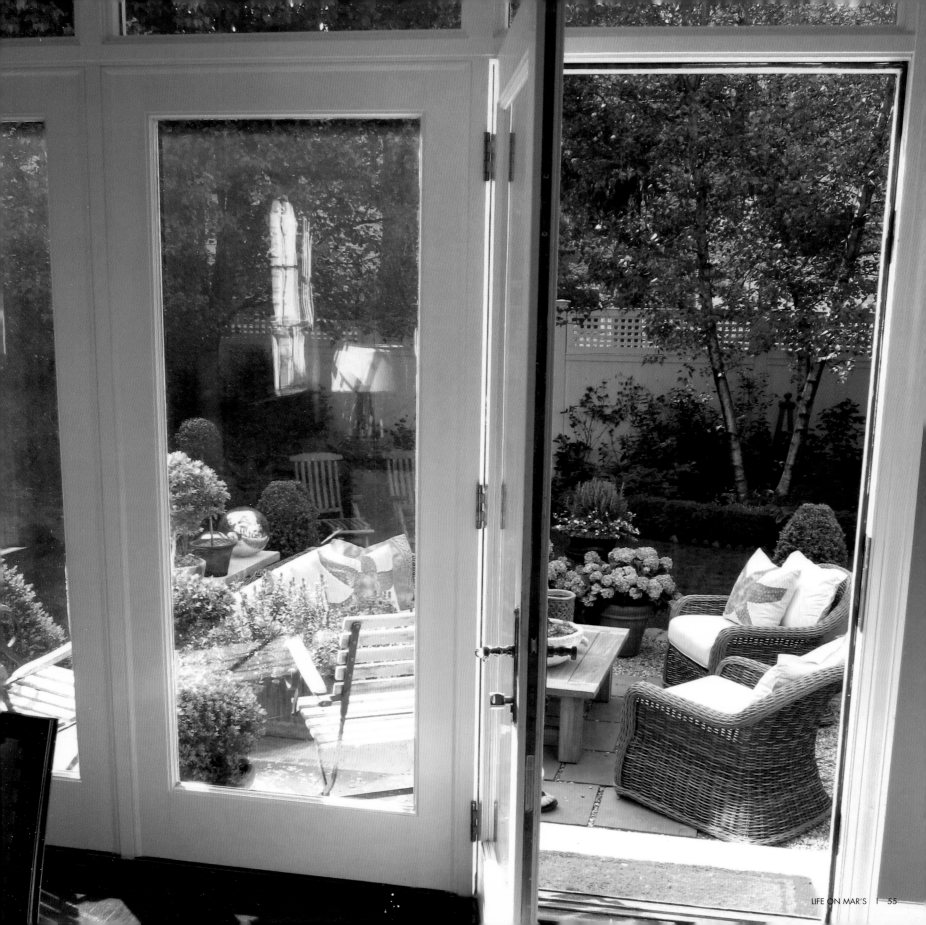

Kitchen

Kitchens have long been referred to as "the heart of the home," so it's no wonder we are tempted to spend so much money and time on the overall look and feel.

Your kitchen is usually the one place to spend some big upgrade dollars because we all love the idea of making it a personalized space.

Kitchens have also grown into something that we continue to dream about. Extra large kitchens have become expected as the perfect grand accessory to a well-designed home. Today, most large kitchens have lush spaces to lounge, sit, eat and be merry, and

generally open into a den or family room, making them perfect for entertaining. But what if you don't have a kitchen like that? Can you capture the same feeling and achieve all of these functions in a more traditional space? That was my challenge.

Outfitting your existing kitchen can be done in ways that provide both visual and practical solutions. Renovating an entire kitchen may not be within the budget. The answer comes by way of improvements that focus on upgrades, design elements, color and textures as well as using the unexpected.

When I first moved into my home the kitchen housed all the necessary appliances to cook and clean. However, what they offered in function they lacked in style. They were all white and too stark for my taste.

The cabinets were a dirty cream color while the hardware had a faux gold finish. The black granite countertops were apparently where the money was spent. There was not much going on in the way of design, but I appreciated that it was a good-sized, eat-in kitchen.

I did love the extra large, true divided light windows facing the back yard which allowed tremendous natural light to flood into the room. The fabulous nine-foot ceilings had crown molding. There was a deep sink. A second window over the sink offered more views, this time of the side garden. The cabinetry was sturdy, had solid construction, and provided plenty of storage opportunities.

Nine-foot ceilings
10x12
Paint
Benjamin Moore
Conventry Gray

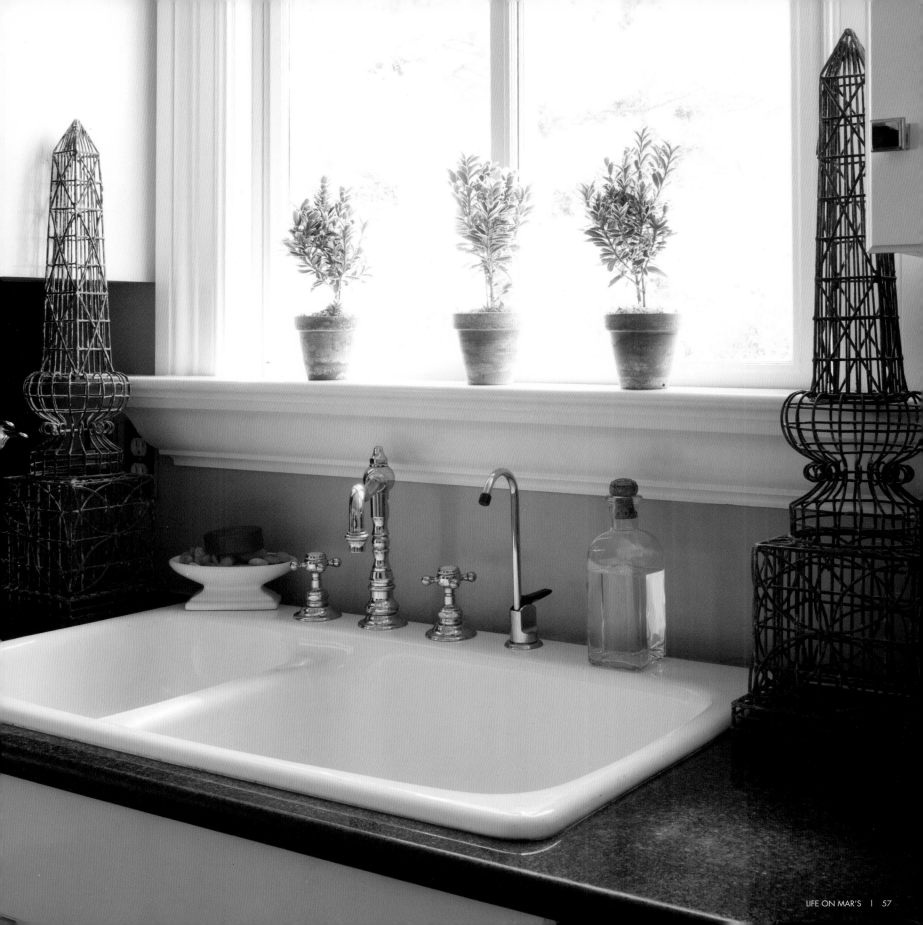

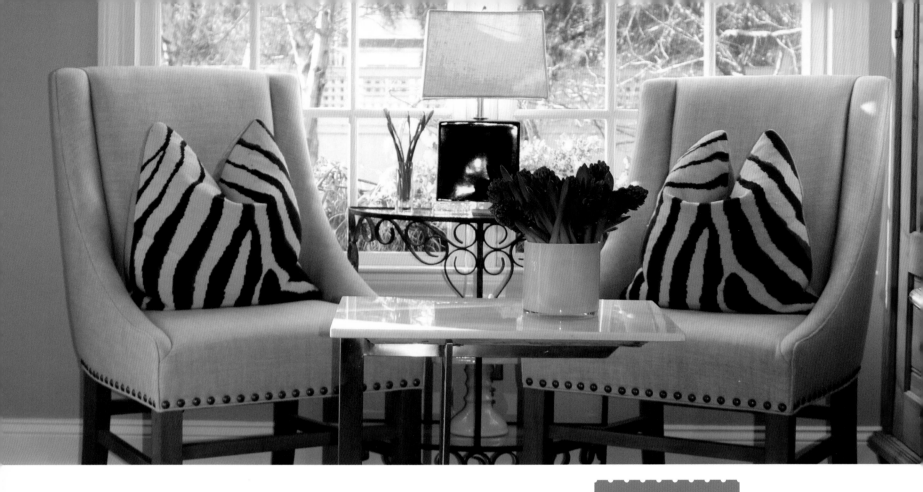

My kitchen evolution happened over a number of years. First, the walls were painted. I then used the space intended for a kitchen table to place a rustic, reclaimed barn wood armoire as well as a small scale farm table and four English pine chairs. A trip to Home Depot provided me with the items necessary to replace the gold cabinet hardware. To help direct one's eye to the gardens outside, window boxes were installed outside and filled with dwarf English boxwoods. Over the eating area a star shaped hanging antique bronze light was added, to mirror the one in the foyer, but in a much larger scale.

For the rest of the kitchen I focused on updates and upgrades.

Knowing the countertops would remain black, I began by brainstorming with an artists' color wheel, pulling the samples of colors that would complement it. I decided on shades of grey for the walls to make the space feel united. White would be the cabinet color, completing the overall color theme. I decided that color accents would come from the appliances, artwork, and the views of the garden.

Investing in high-end appliances that fit into existing spaces is an inexpensive way to update a kitchen. Your return on investment is huge and immediately showcased in an updated kitchen.

sMARt tip

De-Clutter
Clear counter surfaces. Don't park the microwave, coffeemaker and toaster on the counter if space is limited and you rarely use the appliance. If you don't use it every day, put it away. Alternatives to counter storage are a movable cart, an open shelf or the pantry. Clutter is contagious, so edit as often as you can. Less is more.

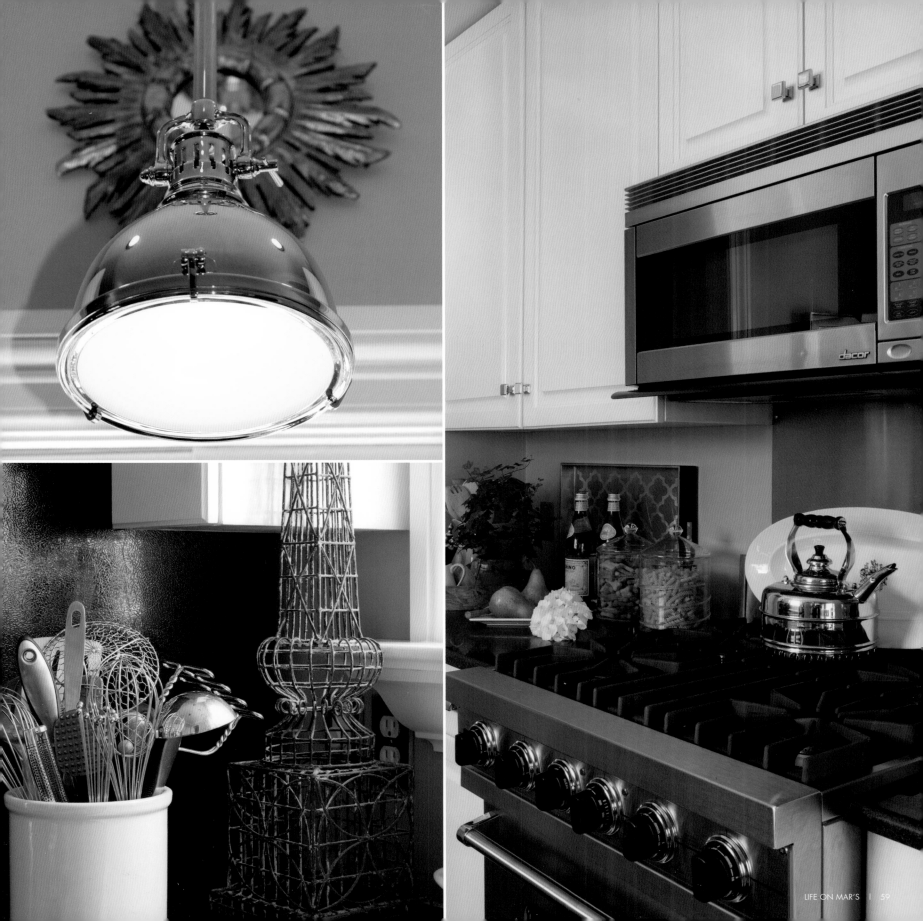

Dos and Don'ts

Define the space—
and make space.
Don't try to make
a small kitchen
serve too many
functions. Eliminate
or remove the "junk"
drawer: relocate it,
for example, to an
accessible basket in
a closet. Refrain from
using the kitchen as
an office for bills,
junk mail, homework
assignments or odds
and ends. If you do,
make it a point to
take your projects
with you when you
are done. If your
objective is to make
it a cooking center,
concentrate on that
function. If possible,
allow seating, even if
it's just a stool pulled
up to a counter for
guests; few of us like
to cook alone.

Stainless steel appliances are the premium standard, so I knew they would be a big part of the budget. When dealing with small spaces it is important to remember how sounds travels to adjacent rooms. This was a deciding factor in the choice of appliances. Natural gas was already running into the house so I splurged on a Viking stove for it's masculine, industrial lines. A Miele dishwater replaced the previous "builders' special" dishwasher, which cleaned well but sounded like sneakers tumbling around in a dryer.

I'm sure you have heard the expression "One man's trash is another man's treasure." Well, whenever appliances or fixtures are still in good working order, consider donating them to a local charity and receiving a generous tax receipt on top of the benefit of knowing they are helping someone else's budget and not going into a landfill.

The kitchen cabinets were soon painted a high-gloss, white lacquer. The cabinetry needed to reflect light, but also be easy to clean. This color choice contrasts with the black granite countertops and makes a big visual impact. The existing gold knobs and pulls were switched out for polished chrome, providing a modern, distinctive look. The knobs and pulls, named Dillon and Duluth, respectively, were found at Restoration Hardware. A Waterworks faucet adds glamour to the sink area, while an elegant, mini industrial-looking hanging pendant light has a retro vibe with a modern touch. Lighting over the sink is a must in any well-appointed kitchen design; if you don't have it in your own kitchen then it is worth the small investment for the electrician.

One of the best ideas was to replace the original inside windowsill over the sink with a deeper, more decorative one. This five-inch-deep sill is now the perfect place for setting down watches while washing up, but also for flowers or potted plants year-round—and with the garden studio not far away there is a never-ending supply. At the sink I really enjoy using interesting glass jars for storing hand or dishwashing soap and love my repurposed vintage bottle for dish soap, capped by an old champagne cork.

In doing these smaller upgrades I realized that something as small in scale as a faucet, knob or windowsill provided an easy update that makes any kitchen a more luxurious experience.

In spite of these updates, one major challenge remained: I was separated from my guests while cooking. I put up with this—and with friends milling about in the kitchen—for over a year. And then I had an epiphany. Rather than renovate to remove the wall and create an open kitchen concept, I decided to rethink how to use the existing space.

This was a great opportunity to forgo the traditional use of an eat-in kitchen, bidding farewell to the table and chairs and creating a cozy seating area for two. This immediately became the perfect place for visiting guests to relax, have a glass of wine and nibble on some hors d'oeuvres while I prepared a meal. No one wants to be in a kitchen alone, so creating this intimate and sophisticated area off the kitchen was an attainable alternative. Truthfully, it was rather easy once I

decided what I really needed in my kitchen was company!

Two upholstered, armless chairs, each accented with a zebra pillow by Dransfield & Ross, are accompanied by two tables: a small, wrought iron, glass topped demilune table against the window, and a modern side table—the right size and scale to be used as a coffee table. I found it at a local tag sale for twenty dollars. Its white marble top sits on a brushed nickel base; the marble's white links the color of the cabinetry to the seating area. On the demilune table sits a Simon Pearce lamp that combines a pottery body with a glass base, and topped with a rectangular shade. Also nestled in the space is an old barn wood armoire. It is

"Eat, drink, and be MARry!"

repurposed to hold stemware, serving dishes, and less frequently used small appliances—all out of sight.

This area of the kitchen has beautiful garden views, offers a wonderful place to sit and a new place to enjoy morning coffee and afternoon tea. It works perfectly and whenever not in use it looks great. Why go with a traditional

approach when it does not work for your lifestyle?

By rethinking the layout of this space there was no need to renovate. The key to designing any room is to identify how you use the space and how then to maximize it for efficiency, convenience and your lifestyle. Keep in mind that you can make a room appear larger by simply keeping it light, airy, limiting the furnishings, and keeping it free of clutter.

Today this kitchen is a well-appointed, functional one that connects with both the outdoors and my guests. I've been told it sparkles with both efficiency and style. Any kitchen may present design challenges, but they can also be a model of stylish and functional design when done correctly.

sMARt tip

Appliance Scale
Major appliances are now available in many sizes for even the most difficult design challenges. Just because you want a large refrigerator does not mean you have the room for it. Consider all the options and what works best for function and lifestyle.

sMARt tip

Maximize Seating
If your small space has to accommodate lots of people on a daily basis, avoid the obvious: don't pack it with lots of small-scale seating. One or two large pieces, such as upholstered banquettes or a pair of loveseats, can provide plenty of storage and seating. The trick is to use every inch of space and make any "dead" corners work overtime.

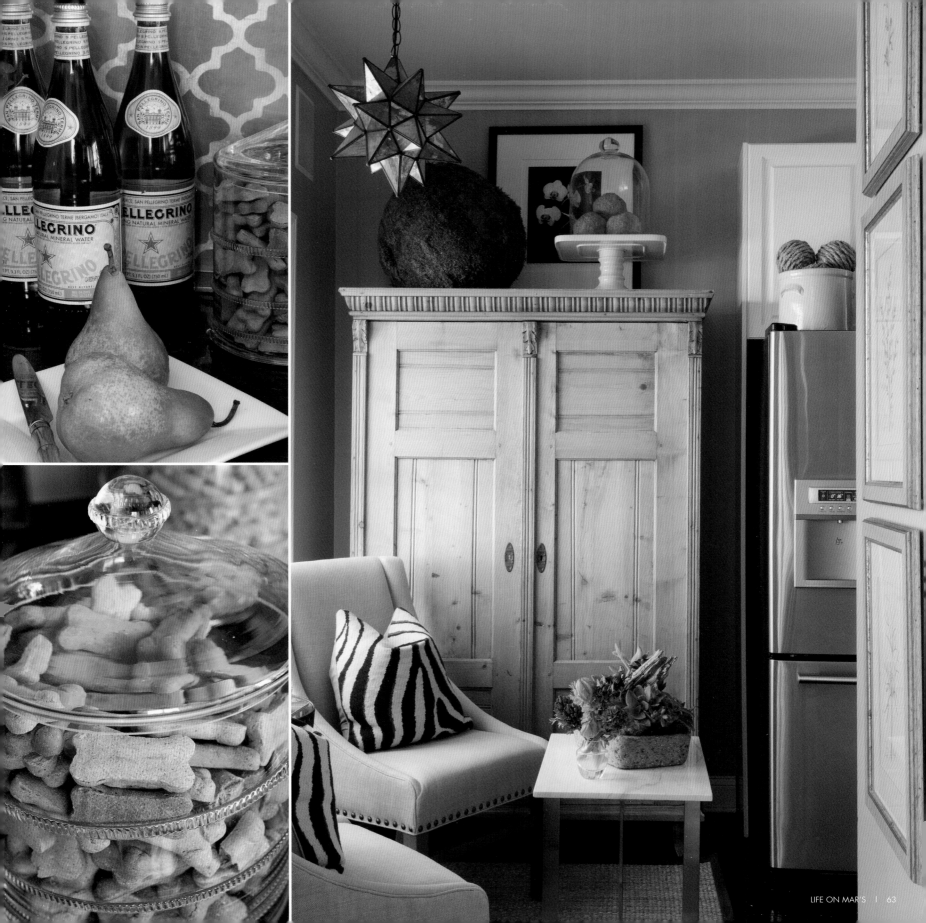

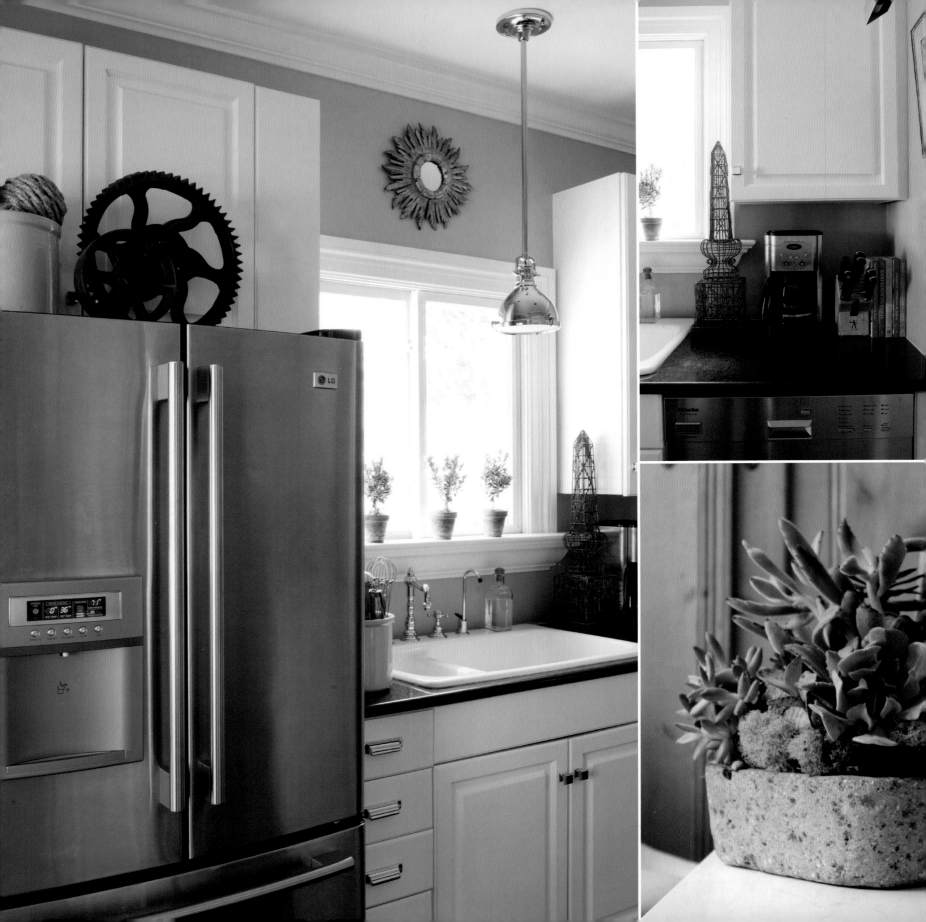

> **Casual Luxury** means having Mother Nature on speed dial. Don't put her on hold.

Chapter Seven
Cloakroom

Why do I call this the cloakroom?

After all, bathrooms are referred to by many names: toilet, loo, powder room, little girls' room, the gents', commode, lavatory, privy or washroom. Because my gardens are inspired by the grounds of English homes, I like to reflect the Anglo sensibility inside as well. Unlike the North American use of "powder room" as a polite euphemism for an extra downstairs toilet in a house, the British English equivalent is "cloakroom," so that's what I call mine.

> **How** you are reflected in a mirror is one type of truth; how you are reflected in your home is more telling.

Having three floors of living space has some challenges, but having a bathroom on each floor is not one of them. On the first floor the cloakroom is located right off a small hall next to the kitchen, making it accessible from both the dining room and living room.

Bathrooms are personal and private spaces, not to mention frequently used, with the cloakroom being most popular. This is yet another great space in which to put your best decorative touches to work. Since it will not be used the same way as a full bath—considering that those who use it do not spend as much time there—it can be more decorative than rigorously functional. Be creative with fabrics, tiles, vanities, paint colors and wallpapers.

Without style, bathrooms have no personality. Does your cloakroom have any? If not, time to refresh it. I like to take inspiration from nature, but in design, there is never one right or wrong way. For example, you personally may be more inspired by modernity or antiques. Take your time and don't rush into anything. Little changes can make a huge difference in an old, tired bathroom. Here is how I gave mine personality and created design cohesion with the rest of the house.

My cloakroom, just like a typical clothes closet, lacks a window. Because it is not located on an outside wall, adding one was not an option. With only a toilet and a sink to work with, I directed my attention to the details, making this space feel private and intimate. Although the smallest room in the house, it was going to be used the most.

Nine-foot ceilings
4x5
Paint
Benjamin Moore
Coventry Gray

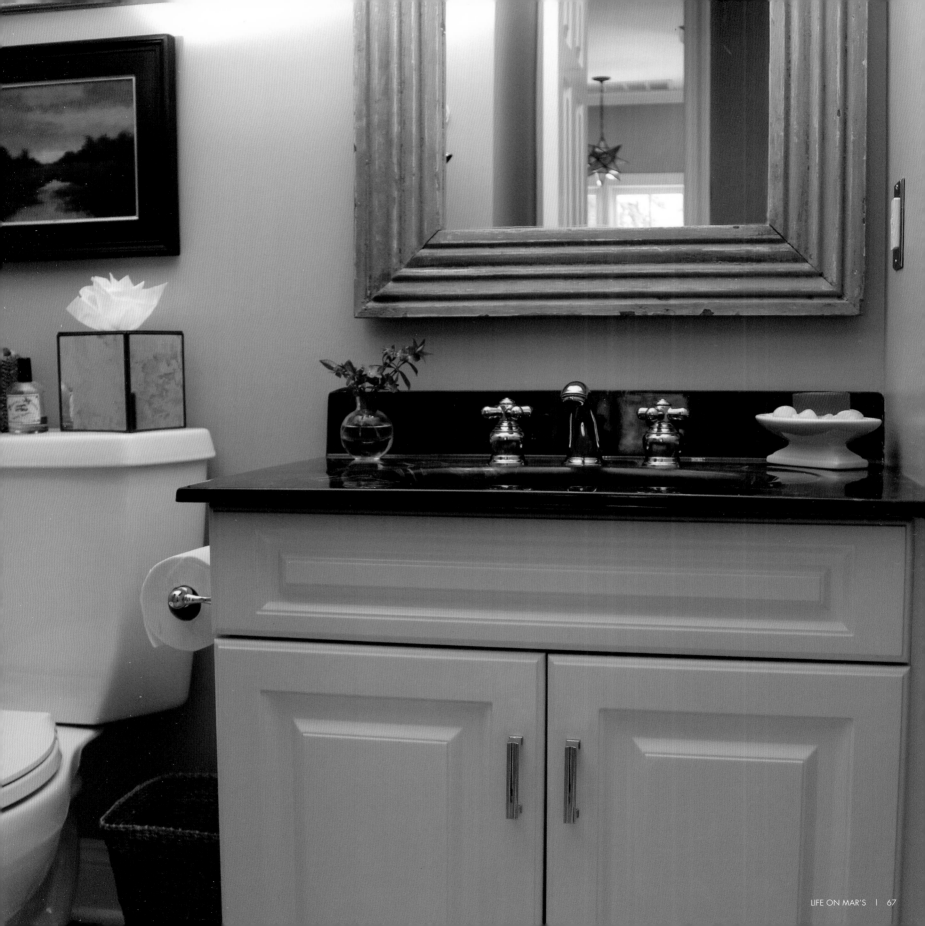

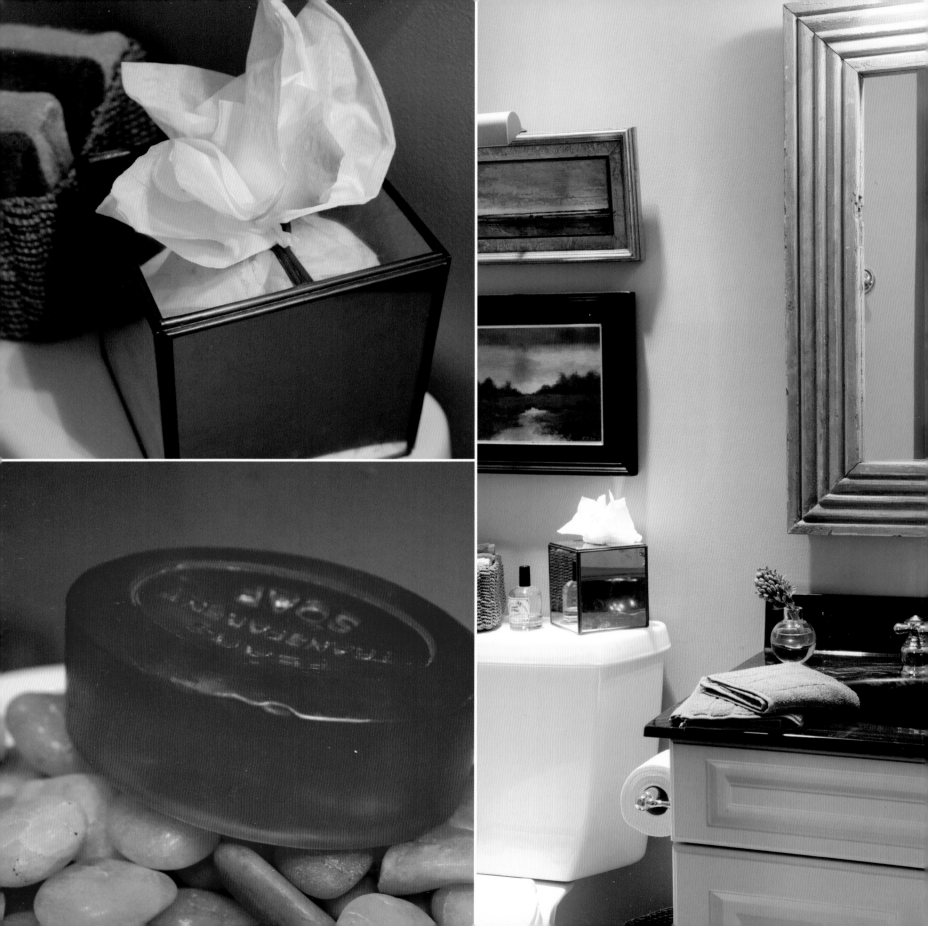

The wall color is the same as the kitchen. This color complements the grey and black marble flooring. What this room lacks in natural light is compensated for by two small, well-appointed landscape paintings: one gold-framed, the other in a black frame that is gold-trimmed. They are not identical, but harmoniously work together as a focal point.

Lighting dimmers are perfect in any room, so why not here, too? The overhead light has a dimmer, while the art light is on the same control that regulates the rest of the art on this main floor.

What would I still love to add? A chandelier. If you have the ceiling space go for it! Any bathroom can benefit from such an interesting and elaborate lighting source. This type of whimsy offers the unexpected detail that a powder room may lack. In fact, design conventions have evolved to the point that you can add a chandelier to virtually any room in the house.

One thing to keep in mind for guests was to assure that the cloakroom had a place upon which to set handbags and purses, and a hook behind the door. If you have a pedestal sink most do not offer enough counter space, so get creative by adding the perfect perch: a wall shelf or a decorative and functional piece of freestanding furniture. Even a chair or low ottoman placed nearby can work just as effectively. Keep this need in mind when selecting cloakroom furnishings.

To maximize the overall cloakroom experience, I like to think of ways to

gently scent the air. Fresh flowers, candles or even fragrance room diffusers are the three best options. Of these, fresh flowers are the best as they are visually appealing as well. With so many choices, it's easy to make scent part of your overall design scheme.

There are many ways to reference Mother Nature in a cloakroom, including incorporating pebbles, stones and rocks; their neutral palette goes with just about everything. One simple idea I use: add an element of surprise to guest soap dishes by using river rocks as a bed instead of a soap drainer. It's clever, functional, and always a conversation-starter.

Storage in a powder room is a must, so below my vanity you will find all the appropriate bathroom necessities on hand. The black, veined marble sink balances the white cabinetry while coordinating with the black picture frames and marble flooring. Easy access is also important—for example, the additional toilet tissue should be within reach while seated. If there is insufficient space to keep several rolls hidden, keep them in a beautiful basket on the floor, which can also contain towels or other useful items.

Remember that a cloakroom that is actively used by guests can reveal a great deal about its owner. Keep your personal products hidden from view.

Consider updating standard-issue water faucets to create a new, modern and trendy look. From nostalgic reproductions to architecturally inspired designs, there are many styles to choose from. Find the look that fits

Small Room, Big Function

A cloakroom offers smaller spaces in which to create design. Because you do not spend a lot time in them you can afford to be more bold, fun and whimsical than in other bathrooms. Keep it clean, keep it fresh and keep it up with great style.

Because a cloakroom must be welcoming to guests, make sure there is ledge space for purses and such. If the sink installed has a narrow vanity, find ways to add surface area—chairs, ottomans or shelving units work wonders to make these spaces feel more inviting.

with your overall design concept and spend a little extra money here as everyone will see and feel the difference.

> **Your** home is a reflection of your life. Embrace your spaces, share it with the ones you love, and leave your personal stamp for tomorrow.

While the space and layout of your cloakroom may have been decided for you during construction, color and the overall mood is totally in your control. A color can make or break the room. Think twice about defaulting to your favorite color. It doesn't mean it is a good choice for a bathroom. Paint may be inexpensive for do-it-yourselfers, but it's not a fun project to do twice, so be sure you love the color. Because small paint samples are readily available, try several side by side on a wall—then leave them there for a few days. Living with the color is the best way to ensure your choice. Although *Casual Luxury* includes a wide range of colors from nature, I prefer neutral earth tones for my bathrooms.

Whether you are a renter or a homeowner, the following tip is for you: replace your toilet seat. No matter where I have lived, a fresh, new toilet seat has been part of the move-in project list. This is the most used and abused item in the bathroom, so why would you not want to update it? Today the range of available options has come a long way and is an important part of any bathroom design. Seats now come in many finishes, but the hardware is standard, meaning that they can be fastened to most toilet bowls. I have a strong preference for the models that resist slamming shut as they add to the overall serenity of the space.

Every bathroom needs a mirror, and if storage is not a concern, forgo the medicine cabinet route. Don't limit yourself to traditional bathroom mirror styles that are found everywhere. There are endless possibilities for creating an interesting look. For example, the frame can be an important part of your overall design scheme. The cloakroom mirror came from an antique flea market with the wood already distressed by time.

Ventilation is important. The original exhaust fan in the cloakroom also offered a dim extra light source; a very common and practical style. Over the years I noticed it began to make more and more noise—imagine a dishwasher agitating broken glasses. I ignored the problem by simply never using it. However, its switch is located next to the one for the light, and often guests would flip the fan instead. Rather than being discreet it became an announcement. To make things worse, when my mother visited she would forget to switch it off again. You can tell I was not a "fan" of that fan! If drove me so crazy I vowed to replace it before her next visit.

That decision led to replacing the other two in the home at the same time, as all were the same age and beginning to register the sounds of wear and tear. Today's exhaust fans provide even more ventilation and circulate more air than older models, thus keeping your bathroom fresh and quiet. They also feature much better lighting options than in years past.

Any well-appointed cloakroom—or any bathroom for that matter—should offer a cohesive design with the rest of your home and pass three simple rules: It should be inviting and clean, it should have a fresh scent and it should be depersonalized with no signs of daily toiletries. If you've achieved this, then your guests will be impressed that even this smallest of rooms has style and personality, too.

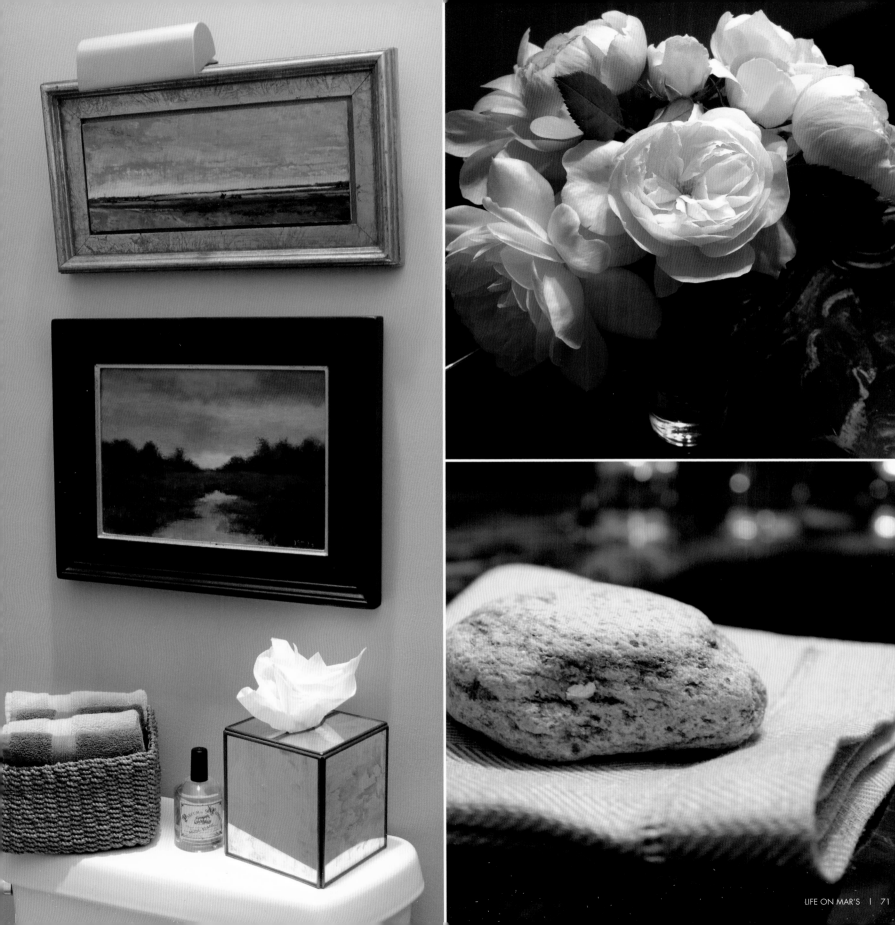

Chapter Eight
Overhauling the Hall

Transitioning up to the second floor living spaces, you ascend fourteen steps to reach the second floor landing.

From this six-foot-by-seven-foot space, a large window offers direct views of the garden studio and pergola below. The area is flooded with unobstructed northeastern light. Off this landing are the media room, guest bathroom and the hallway to the guest bedroom, office, and the laundry room.

One of my most vivid memories of my first visit to this house was walking up the stairs from the main floor and encountering a solid wall on my left, closing off the views of the hall and doorways. There was no banister or post at the landing, and the entire area—including the stairs—was covered by wall-to-wall carpet. That was 1996, and when asking

the builder why this particular wall was left solid he shook his head and wondered, "Hmm, I'm not sure why it wasn't opened up, it was not a weight-bearing wall." That was a green light to begin dreaming of changing it.

Later, a weekend trip to the Hamptons helped provide inspiration for this renovation. I was visiting a gorgeous home named Blue Haven in Southampton and saw a banister cutout treatment that seemed perfect. Ten years after buying the home and talking about opening this area up, I was ready to finalize my design plans and begin the process to transform not just the wall but the entire landing. The timing could not have been more perfect: I was working from home and available to supervise the project. I allocated my budget and focused on the renovation as the perfect opportunity to also introduce quality details that were more representative of my overall *Casual Luxury* design aesthetic. I addressed this space by not only opening up the wall but also adding hardwood floors, a banister, spindles, crown molding, fresh paint, and recessed halogen lighting.

Homeowners are always looking to improve their property values with minimal cost... getting more bang for the buck as it were. I'm no different. I negotiated, and acted as supervisor every step of the way, and created a custom look for a lot less.

New handrails were installed and stained to match stair treads. Risers and spindles were finished in a high-gloss, oil-based white paint, creating a high contrast with the dark stain.

Stairs and Second
Floor Hallway
Eight-foot ceilings
Paint
Benjamin Moore
Van Courtland Blue

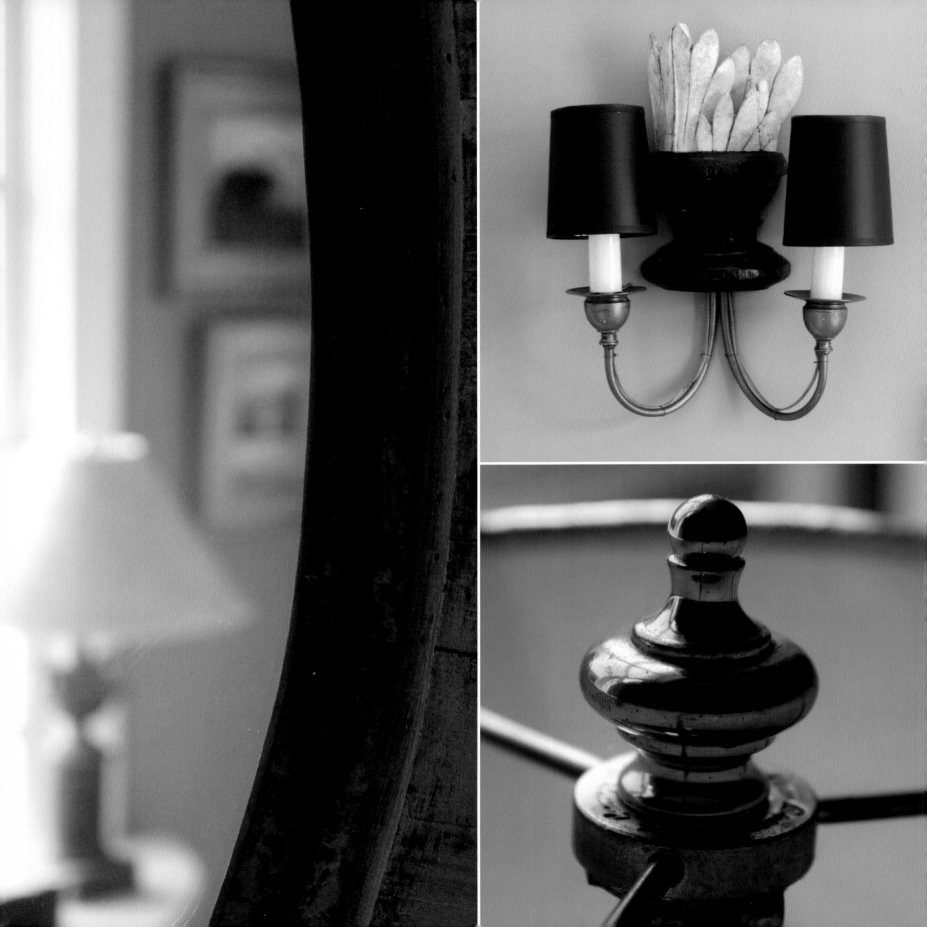

Trims were also replaced in the hallway. Wall trim is normally under scale, so I prefer high baseboards, wider door casings and a good-sized crown molding. Money well spent to get a grand look in your home.

While the walls were being opened up, I took the opportunity to run wiring for music to the second and third floors. Speakers and controls could now easily be installed and connected to one master control board, which was located in a closet off the kitchen.

This would have been a much more costly expense to do later on its own, so even if you're not going to install speakers right away, when you have such opportunity you should get the wiring done for the future.

This renovation experience was also documented for others to discover in the future. I have always believed in leaving a personal "**MAR**k" on homes. This can come in the form of gardens that were created, wallpaper that was hung or in this case a love letter hidden inside the walls.

It's hard to imagine a more personal way to learn about a home's history than by discovering the written words of those who once lived there. Whenever you have a renovation I would encourage you to write a special note somewhere inconspicuous. When I added a new window in my Garden Studio, I took that opportunity to write on the inside of the window jamb: "Designed by Mar Jennings 2002— I love this space!"

For the landing renovation, a time capsule was created to mark the date and included information about the home—including the name Rosebrook Gardens. This was actually the second time capsule hidden during a renovation. The first is under the stone landing off the dining room. The letters included always start the same way: "Wow, how did you manage to find me?" Followed by the reason it was placed there, the date, and some words to convey my connection to the home. Over the years I have encouraged friends to do the same whenever they have the opportunity.

I feel strongly that we never really own our homes, we merely take care of them. Yes, we make mortgage payments and they provide us with shelter, warmth, and spaces to enjoy, but eventually we will have to say goodbye. This is why I recommend leaving your personal mark behind, giving the discoverers the story of the homeowner and the people who once lived there. Each home should tell its own story, always respecting the past while adding to its future. What a wonderful gift for the next generation to discover.

Back to the renovation! The time capsule was placed, the walls were sheetrocked, and it was time to focus on the fun stuff: furniture, lighting, artwork and carpeting.

Putting a runner on stairs is not only a good idea for visual appeal but for safety as well. Right after the new hardwood floors were installed—and stained the same ebony color to match the first floor—the final result was so

perfect that I wanted to show it off. So I left the stairs and hallway bare. One morning, running to answer the door in my stockinged feet, I slipped. Luckily, being a former competitive skater, I landed safely as if I fell after a double axel on the ice—but I knew the next person wouldn't be as fortunate. That afternoon I was out ordering matching runners for the two staircases as well as the hall.

This actually helped the design continuity by using a familiar pattern and material on two floors. The sisal carpet with chocolate trim was the best way to get a continuous flow from the stairs to the hall and up the second flight of stairs as well. The installers managed to cut it in one piece so there would be no seams to break the design.

Because the entire area was renovated I introduced softer, more aged touches as a way to balance the hallway between new and old. A larger, antique Swedish demilune table complements the smaller one at the bottom of the stairs, without appearing too perfectly matched. To anchor items on this table I chose an antique urn lamp, discovered in France, that was brought back and rewired. A wall sconce was added for ambient lighting and a touch of historical integrity, and tonally balanced by a 19th century-inspired architectural oval wood mirror.

Another star-shaped antique bronze lighting fixture hangs over the landing. (Keeping score? That is the third I have mentioned—the others are in the kitchen and the foyer.) Repeating this design connects the décor visually with the first floor. Reintroducing and repeating design elements whenever possible is a principle of *Casual Luxury*, and creates continuity. Although unique from each another, the star lamps are similar enough to be connected because the naked eye first recognizes the essentials of shapes and colors. This trick afforded me the luxury of purchasing them at different times and developing the theme gradually.

The wall sconce—mentioned earlier—was added to help light the way for any overnight guests. Just as the sconces in the dining room, it was once a garden

finial. Its origins provide wonderful grey color tones and beautiful architectural details. The bronze detail in it connects to the hanging star light, thus linking their relationship as harmoniously as nature intended.

Hallways are many times missed opportunities in homes and should be celebrated as extending focal points to rooms; the hallways can have a purpose rather than seeming like an afterthought. This hallway is not just a means to travel from room to room, but a simplified version of a beautiful gallery of art and collectables to enjoy and ponder. The two paintings are from contemporary artists and repeat the living room's theme of landscapes while infusing the hallway with deep, rich organic colors.

Casual Luxury touches and design principles quickly elevate this space beyond simply a landing at the top of the stairs. It is a transition space to the rooms beyond the main floor, and continues to welcome visitors further into my home.

sMARt challenge

How many *Casual Luxury* design principles can you spot in this photo?

How did you do? In fact, there are examples of all six.

1. **Represent Mother Nature:** terrarium, bud vase, art work
2. **Embrace Light and Reflection:** unobstructed light, reflection off glass terrarium
3. **Natural Materials and Colors**: wall color, table, wooden box
4. **Repurpose**: iron urn as lamp base
5. **Repeat Shapes and Patterns**: circular shape of demilune table, lamp shade
6. **Consider Size and Scale**: two paintings versus one large one

With practice, seeing *Casual Luxury* cues becomes obvious, doesn't it?

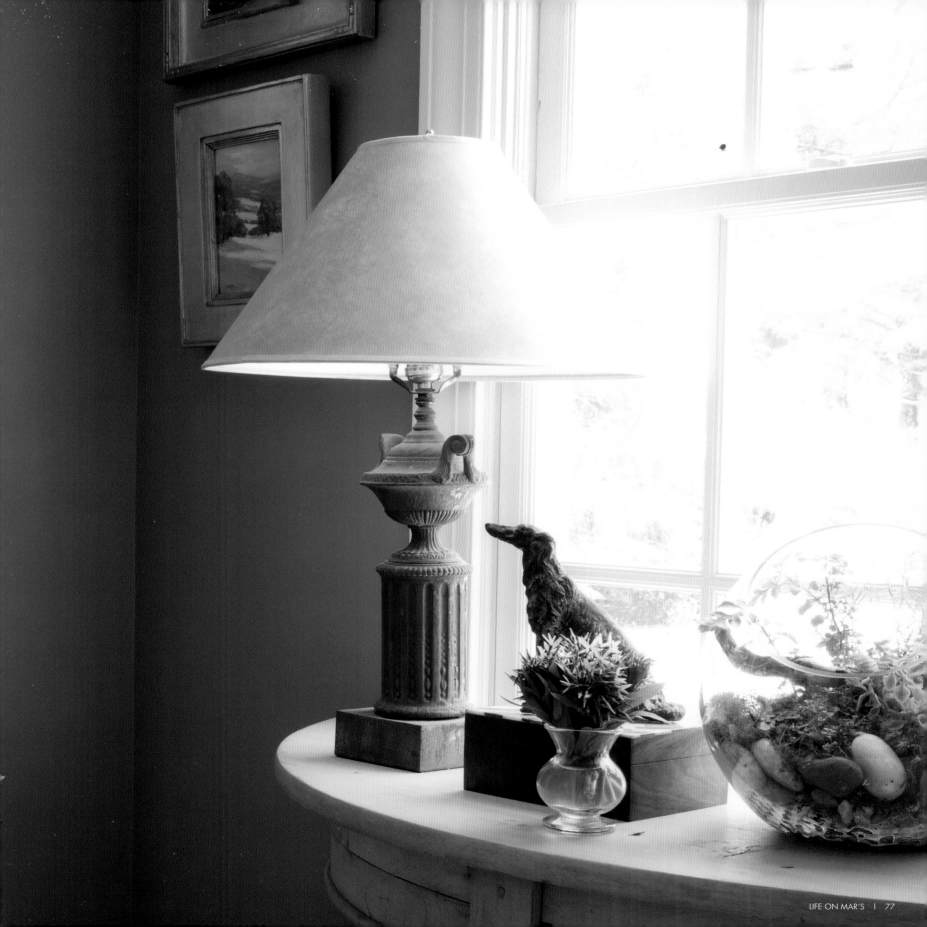

Chapter Nine
Media Room

This is one of my favorite rooms in the house, due to the amazing light it gets from three oversized windows.

This room also overlooks the side parterre garden as well as the outdoor living room. These garden views are grand and you can appreciate the extensive landscape from a bird's eye view.

Although now referred to as the Media Room, this room was originally designed as a bedroom and came complete with a good-sized closet and close proximity to the guest bathroom. This is the first room you encounter when you reach the second floor. Rather than turning it into the guest room, I decided to keep it for my own use and enjoy the light and the views. Realizing it would make a

perfect, casual television room, it became the media room. Since I knew it would be used more than my living room, it was the perfect place to have an oversized sofa that could quickly become a fainting couch as well. But let's not jump ahead. The decorating of this room began by installing custom shutters.

As you already know, I embrace as much of Mother Nature's natural light as possible. But when you want to take a nap or watch a movie in this room, the blinding light would have spoiled the fun, so window treatments were a must. Shutters were the perfect solution, and although they can be a big expense initially (around five hundred dollars per window), I feel the long-term benefits have paid for themselves over time because they also add a strong design element. Before the room was even painted, the shutters were on order and the look and feel of the room was established. Shutters offer the best control of light, whether you want to completely flood a room with it, filter it, or block it out altogether.

Although I'm not opposed to the traditional rods and curtains, I believe that there are other great choices for privacy which offer cleaner lines.

Whether you call it a media room or family room or great room, it should still look polished while being family-friendly. A busy, active room may become the place to collect clutter, so it is imperative to incorporate plenty of storage places into your overall design for this room.

Eight-foot ceilings
12x11
Paint
Farrow & Ball No.
38 Biscuit

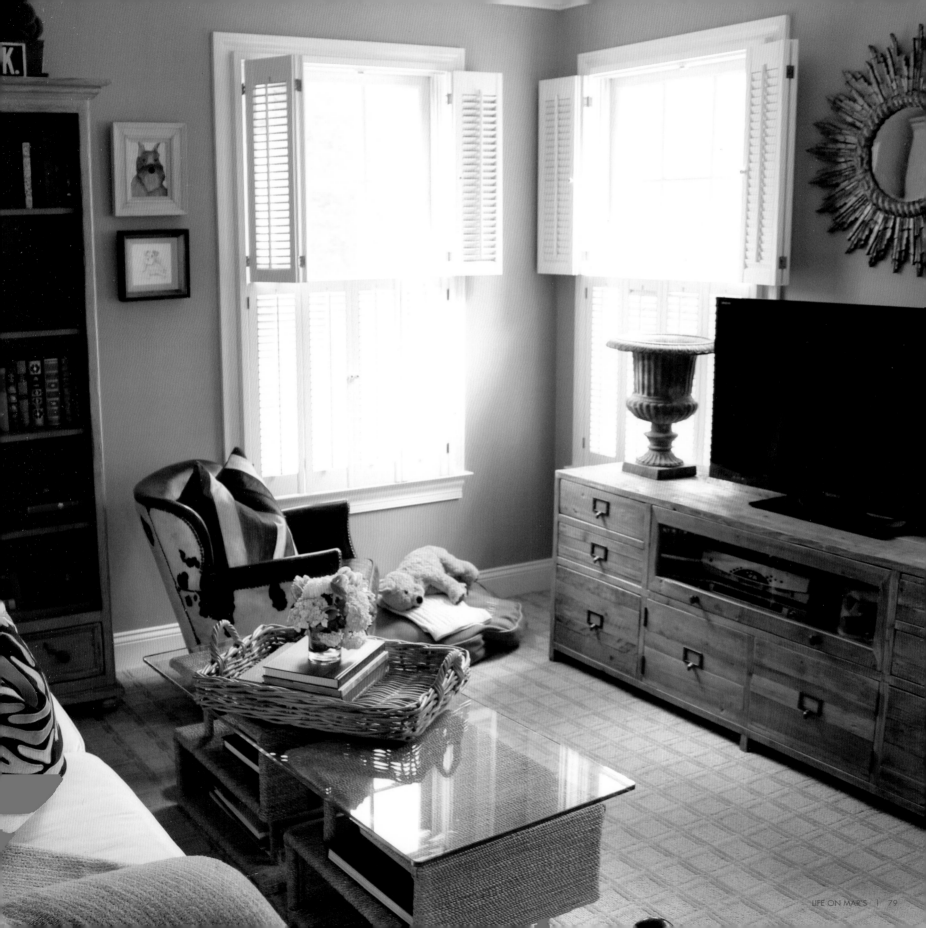

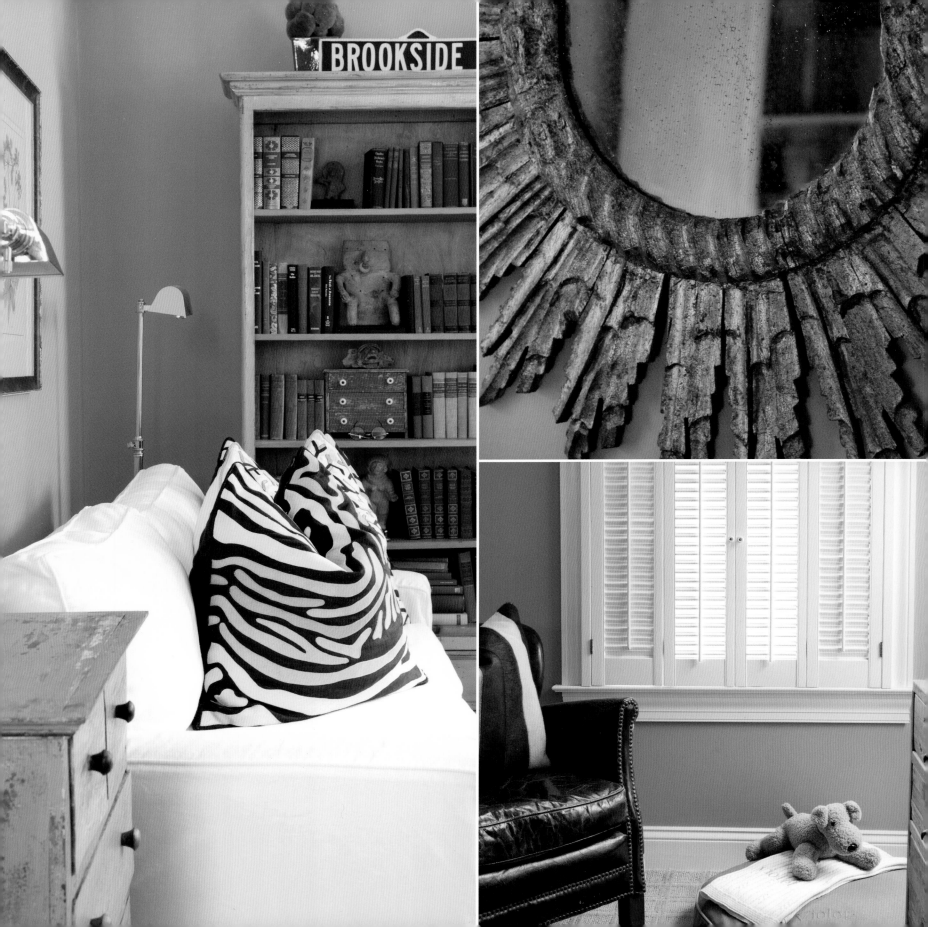

BROOKSIDE

Wall-to-wall carpeting in bedrooms does provide a great look. Although no longer a bedroom, it also worked for this space. The 100% wool carpet offers a repeating square pattern in a light wheat color with just a hint of sage. It contrasts with the texture and materials used in the hallway's sisal runner, and the two floor coverings are unified by their color and easily transition from one space to the other.

A few tips about neutral carpets. Neutral carpet is a builder's favorite, as it was for most of my rooms. Because of this you may feel that showing individual style means shying away from neutrals themselves. But neutral carpet doesn't have to be monotonous. In fact, a trend for carpet right now is patterned neutrals. Low pile with a subtle texture is another way to bring added life to a neutral carpet. Geometrics, subtle stripes, dots and even vines add interest and texture to carpeting without adding color. Think tone–on–tone. Even more traditional Berber carpets have a subtle dot pattern that adds visual interest. Keeping the color neutral allows these patterns to stand out.

> ## When it comes to great design, there is no status in overpaying.

The goal for any well appointed family room is to maximize the seating area. There is more than one way to achieve this without defaulting to a sectional sofa. The principle regarding size and scale of furniture plays an important role, but equally important is the ability for your furniture to be somewhat modular.

Multiple pieces of furniture are a good way to maximize seating. Try combining pieces like a sofa, fainting couch, loveseat and a matching set of chairs and the result is a grouping that can fit in any room. Combine these with an ottoman or two—the perfect

place for your feet, as well as extra seating and even storage. Together, these pieces of furniture give you the same amount of seating you would get from any oversized sectional, but are more elegant. Plus, they will allow you the flexibility of changing the layout anytime you wish, as well as make it easier to fit them into a new space should you move. When choosing pieces, they shouldn't match exactly: go for visual design interest, appropriate scale and a cohesive look through similar textures, tones or finishes.

When deciding on a palette around which to pull it all together, consider choosing a sofa fabric as your jumping off point—it's an easy way to anchor the space. Don't exactly match color from fabrics and patterns, but look for color tones that complement rather than compete with your fabric choice. The next few paragraphs detail how to build these choices.

The Mitchell Gold + Bob Williams sofa has modern track arms with a loose box back. It is 79" inches wide and although hardly a shocking fashion color it is the largest piece of furniture here. The white denim fabric was chosen because it came as a slip cover—for flexibility and easy cleaning—unlike other upholstered pieces in my home. Slipcovers are the best way to keep busy spaces fresh and clean. The media room is an active one, often filled with people, pets, snacks and cocktails. (And a miniature schnauzer who thinks she is a person!) A confession: although home laundering works wonderfully well, about once a season I turn them over to my dry cleaner, who cleans and presses them back to a showroom state better than I ever could.

This sofa has a bright, clean and current look that neither overpowers other pieces nor screams "modern" in the room. Four cushions—two on the back and two on the seat—makes this type of smaller-scale sofa the right fit in just about any home. Three fabulous Ankasa blue and white pillows in a fun coral-inspired design provide the perfect balance to the crisp white.

Two small brown leather chairs with a faux pony back design offer extra seating without overwhelming the room. This is a great example of finding and using

the right scale. The nail head detail adds to the rustic look of the well-used and aged leather. The pony backs have a touch of white to tie in with the sofa. A leather and suede down-filled pillow offers the perfect finishing touch on each. I love this set of chairs and discovered them on vacation one summer in East Hampton. Thank goodness my friends who live in Connecticut were also in town—their Mercedes SUV (I call it their ark!) became the perfect truck alternative. In the years that followed I discovered another set in Norwalk, Connecticut, but unlike this set they did not have the pony backs. I picked them up for a steal and as you continue reading you will discover where they wound up in my home. The best thing is that they can be used as extra seating that is scaled correctly for the room and instantly looks coordinated, too.

When does a coffee table become more than just a coffee table? Two Pier 1 Imports rope-covered ottomans became my version of the perfect coffee table. They were on sale for twenty-five dollars each, and although I did not need another ottoman in the house, I did love the wrapped roping and open shelves. I removed the top cushions that were secured by ties at the corners, ordered an extra thick clear glass rectangle to place on top, and voila! a one-of-a-kind coffee table that quickly fit into this room. The color is neutral enough that it blends into the carpet, but complements the tones in the chairs. And if needed, I can disassemble it and add my own cushions to instantly add even more to the seating suite.

I have always been a firm believer that whatever a room lacks in floor space can be replaced with the vertical resource of a beautifully stacked and styled bookshelf or storage tower. Whether you have a large room or a small-scale space, wall-mounted shelves or a bookcase (either free-standing or built-in) can increase storage while housing collectables in an organized fashion. Both the visual impact and functional purpose make it a staple item in any home, not to mention its versatility and mobility.

Beside the bookshelf hang two charming pieces of art, both of beloved miniature schnauzers. The top one is an expressive oil portrait of the first "lady of the house," Corky, and below it is a remarkably lifelike pencil drawing of Violet. This artwork repeats the dog motif seen elsewhere, while adding a personal touch.

The starburst mirror was the deal of the century. Its unique, carved and gilded wood rays extend from the center of the mirror, and would offer super design details for just about any room in a home. I discovered it in a bedroom closet in a rental home in Southampton, Long Island, and quickly made it known to my landlord that I would be interested in purchasing it. I remember his response: "That old thing?" For seventy-five dollars it became mine and was relocated to Rosebrook Gardens the following

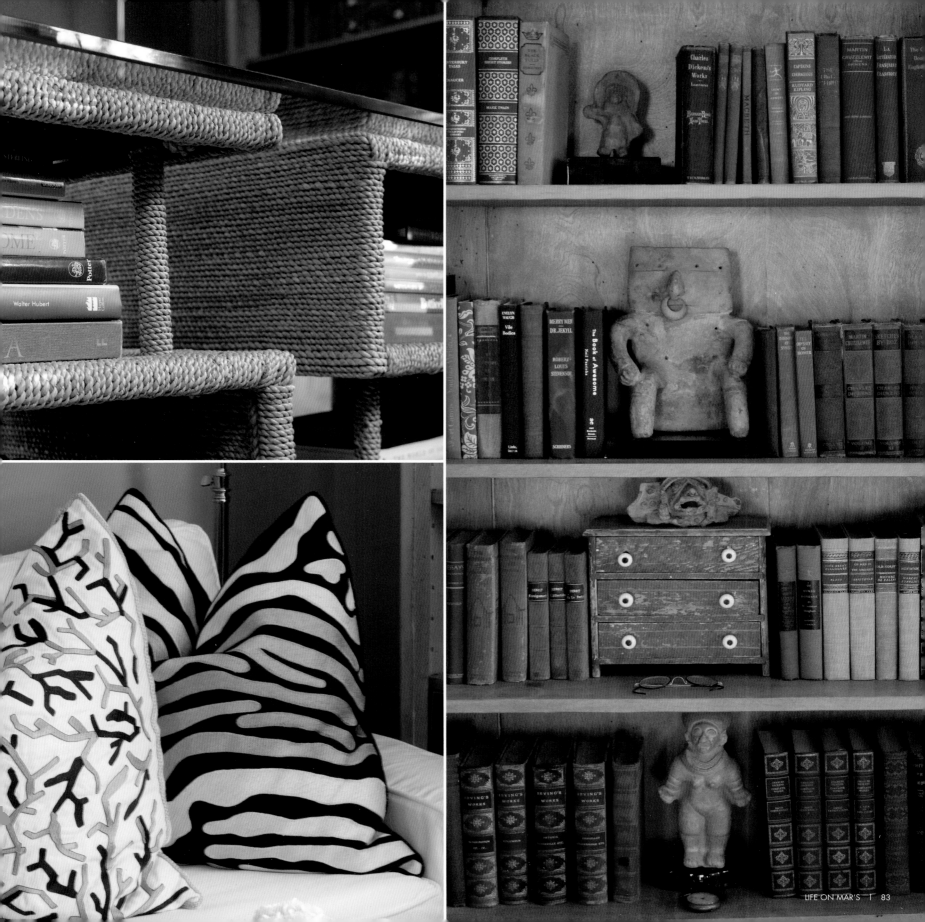

weekend. Starburst mirrors can be extremely expensive to purchase, so when you find a deal you need to jump on it.

Starburst mirror designs are believed to have originated in France and Italy. In the center of this starburst is a convex mirror, a design that can also be found in old paintings from the Venetian Republic. In North America, starbursts reached a pinnacle in the 1940s Hollywood Regency period and again at the turn of this century, when high-end auction houses started to get ecstatic bidders for these jewels. Mainstream companies took notice and began to reinterpret them. Starburst mirrors have been used extensively in more traditional designs in the last few years. Personally, I am fond of the shape, one that I have repeated in various ways throughout the home.

> ## "Mother Nature makes the best roommate."

I enjoy the history and journey of this starburst mirror and how it was saved from being hidden in a closet. No thing—or person!—should ever languish hidden from view, especially when there are so many of us willing to showcase its splendor. The good news is that you don't have to go digging around in people's homes to get the look. Today, starburst mirrors are mass-produced and available at price points that are affordable regardless of budget.

The media console is handcrafted from reclaimed and recycled wood from Southern and Northern China. It was repurposed and sold by the Hughes Collection. The wood from Southern China was

sourced from floor boards in old buildings and the wood gathered from Northern China once served as doors for farmhouses and homes. I gravitated immediately to this piece of furniture as if it was calling my name. The moment I learned about the craftsmanship and materials used I whipped out my credit card and asked if it was ready to take home that day.

It's a great investment piece because it will retain its value and also remain unique in its construction. Something old became something new, and there is no better way to support being green. Not only is this a **MAR**velous media console for the room, but it also supports a company that encourages conservation. After all, *LIFE ON MAR'S* has its roots in connecting with Mother Nature.

From carpeting to furnishings to seating to décor, this room is certainly more functional than keeping it as another bedroom. So whether I am lounging with Violet watching my favorite shows on my DVR or entertaining a crowd for the Super Bowl or Academy Awards, my Media Room is a flexible, comfortable space that always feels a truly inviting and livable part of my *Casual Luxury* home.

sMARt tip

Coffee Table Alternatives
Coffee tables in family rooms are a great opportunity to use your *Casual Luxury* repurposing creativity. Here are some examples of items you can use to create your very own: warehouse crates, vintage suitcases, antique trunks and even tree stumps, to name a few. Keep in mind that the best coffee tables offer storage as well as style and individuality.

Chapter Ten
Guest Bedroom

> ## Wherever I have lived, I have always enjoyed entertaining friends and family as overnight guests.

Overnight guests should always feel welcome and valued, so before I ever had a guest room, I would offer my bedroom to my guest and sleep on the couch. After finally having a real guest room at Rosebook Gardens, I wanted to elevate my guests' experience and fill the guest room with the cozy comforts of a five-star hotel. Today I call this room the "Edwardian Suite" after Edward Smith, a dear friend who was synonymous with the art of entertaining houseguests. People from around the globe have stayed here, and enough rave so that it has become a standing joke that I should have a two-night minimum.

The guest room is equipped with all the necessities that make staying an experience to remember.

Rosebrook Gardens offers the best layout for overnight guests, as the guestroom's location makes privacy and comfort easy. With a laundry room and private bath only steps away, guests are encouraged to unpack and make themselves at home. And that they do. Short or long-term, visitors have plenty of privacy as the master bedroom suite is on the third floor.

When renovating the hallway I wanted to create linking design elements between all the rooms on this floor—the media room, guest room and office. First, the wall color is the same in all three rooms. Second, they also share a six-inch crown molding detail to add an old world charm. The handcrafted millwork of yesteryear all comes at a price today, but each detail added to a home helps it surpass the average cookie-cutter construction. Crown molding is an easy installation and can quickly transform the look and feel of a room.

In the world of guest rooms, neutral carpeting dominates most quarters. While there are some homeowners and decorators who choose to use bold, bright or deep colors for their carpeting and flooring, the majority stick to the practical idea that neutral is best and most universal. However, today's neutral doesn't have to be boring or uninviting. With so many great patterns available, look for simple tone-on-tone or textured styles. You can discover the benefits of a subtle but decorative visual impact. If you need a pop of color, consider an area rug or throw rug over a natural-toned carpet, which will provide both flexibility and appeal.

Eight-foot ceilings
11X11
Paint
Farrow & Ball No.
38 Biscuit

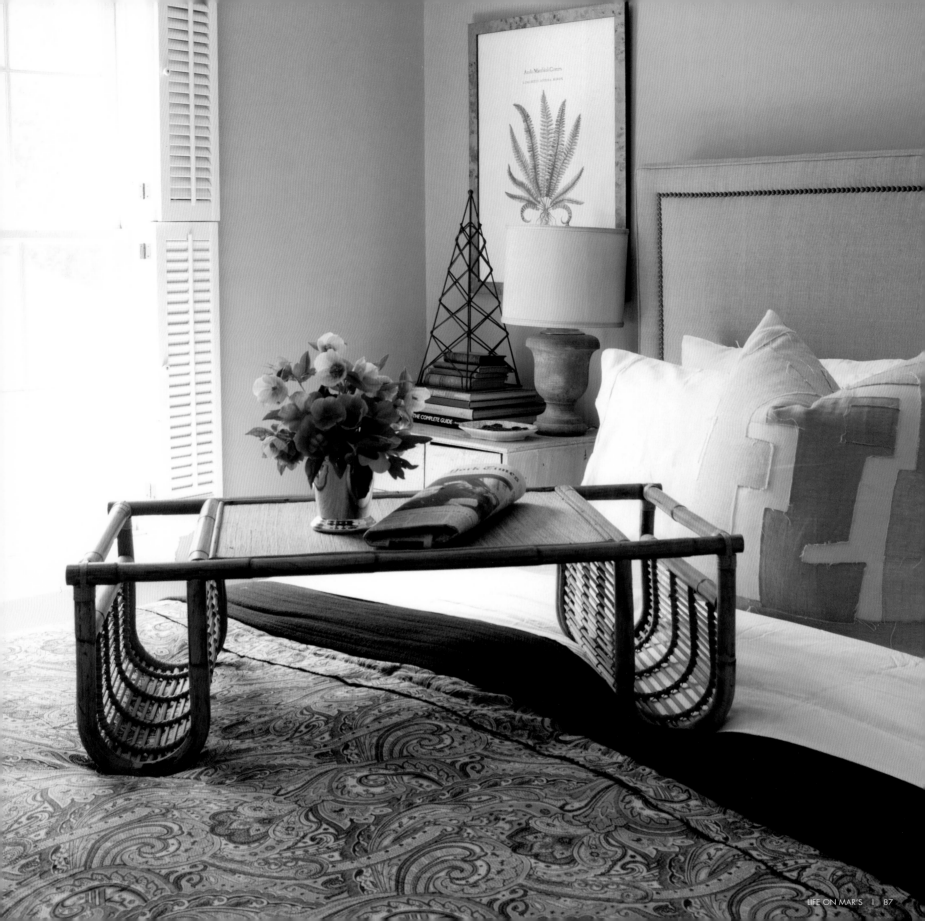

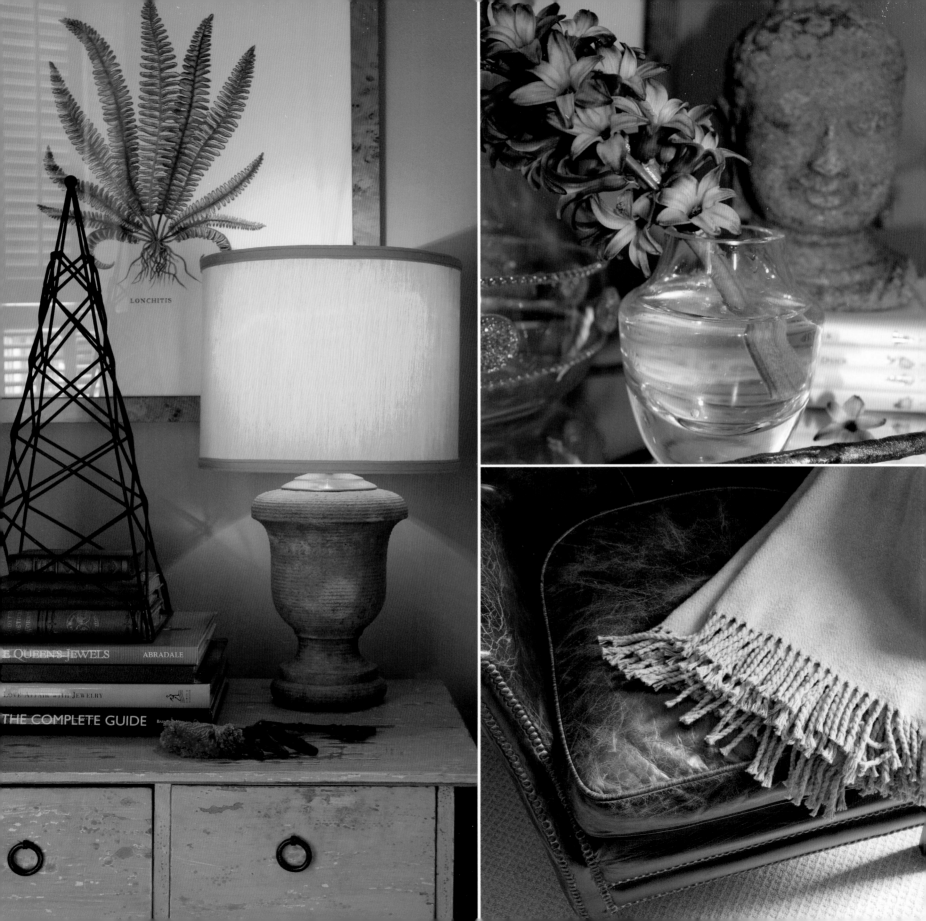

The guest room has a 100% wool, waffle-weave, cream-colored Berber carpet. Wool carpets today can be found starting as low as three dollars per square foot, and when you have a small room, it's best to invest in quality carpeting that can stand the test of time.

A guest bedroom should be very inviting from the first peek, and the best way to achieve this is by a beautifully made bed, with fantastic linens and decorative pillows.

Of course, the true foundation of any bedroom will always be with a good, solid, well-appointed bed; it should not move or squeak. As I am no stranger to hotel rooms, I've adopted a great tip learned from some of the best: a great mattress pad can go a long way to offering guests a more luxurious and restorative sleep. Add some crisp, white, high thread count sheets and a wonderful duvet cover and your guests will think they are sleeping in a heavenly cloud.

To truly evolve your guest bed into something friends will rave about, we must address a few design rules for making it. One rule of thumb is no more than three decorative pillows on a guest room bed. I've seen many different types of beautiful pillows on beds, but the impact can be subconsciously overwhelming if too many are present. When you have a collection of pillows on a bed it simply makes it less inviting for a guest. People love the look but hate the chore of having to remove them all before sleep. Three decorative pillows on a full, queen or even king size bed is all you need. The larger the bed the larger the pillows can be.

Let's not confuse decorative pillows with sleeping pillows. First, I typically place four sleeping pillows on the bed; two laid horizontally with the decorative trim facing out, followed by two more pillows in decorative shams. All should be in a cohesive color scheme. Then decorative pillows: either one large stylish decorative pillow in the center, or two large decorative pillows on each side with one smaller pillow in their center. This creates visual balance and makes it easy for your guest to clear off the bed when they are ready to retreat to sleep.

The idea here is that unlike a bed we would make for ourselves, a guestroom bed should be easier to make and style, thus less intimidating for overnight guests.

My guestroom closet was designed to make it easy for visitors to unpack. They can conveniently hang long garments and coats without hitting the floor. I place an extra blanket in the closet along with two one-size-fits-all fluffy terry robes with slippers to match. This is also the perfect place to store a collapsible luggage rack.

My guest room offers two distinctive nightstands: small scale chests of drawers with plenty of storage. Although they do not match, they are balanced. Nightstand drawers in a guest room should never be filled with personal items. Although you may be tempted, there is nothing worse than opening a guest drawer and discovering someone's else's odds and ends. When your guests arrive they should be encouraged to unpack and make themselves comfortable. Having access to empty drawers will help the process. On one nightstand is a mirrored tray which holds a Juliska water pitcher and something reminiscent of childhood: a collection of Beatrix Potter's bedtime stories—The Tale of Peter Rabbit, The Tale of Jemima Puddle-Duck, The Tale of Mr. Jeremy Fisher and The Tale of Two Bad Mice. A weathered Buddha head garden statue on top of the collection provides an organic touch to the space. The fern botanical prints on each side of the bedside provide the linking elements to the garden theme of the house.

A seasonal bouquet of flowers from the garden can always be found on one night table along with a fragrant soy candle. The two urn-shaped, faux cement table lamps have decorative brass details; they are easily accessible on each side of the bed and can be either turned off by a wall switch or by hand.

The shutter window treatment is consistent with the media room. Guests can completely close the louvers for maximum privacy or adjust for a peek of light.

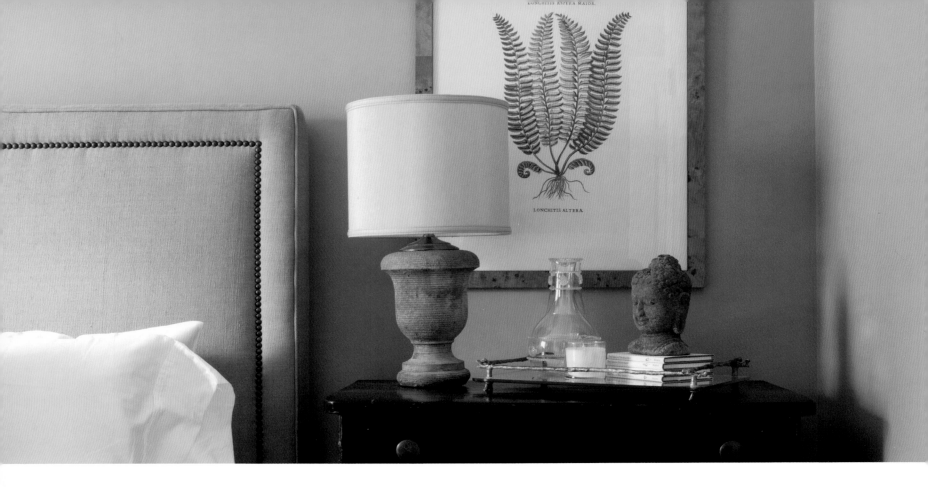

When first moving into the house I wanted to highlight my collection of books, so a second bookcase was placed and filled with unique and fascinating volumes and finds. Books are personal, but also decorative, and are a perfect invitation for my guests to relax with one before sleep.

Every guest room needs a place to sit, other than the bed. The leather chair was chosen for its scale and shape. It is part of a set of two (its twin is in the office), and chosen to visually connect to those in the media room.

A bamboo breakfast tray completes the welcoming look; purchased from an estate sale for forty dollars, it offers something old as something new in the space. In one of its racks are the guestbook and a pen. It is also a great workspace when a desk is not an option. My visitors love using this for computers, magazines and of course the occasional breakfast in bed when my mother comes to town.

I'm drawn to houses and spaces with architectural elements and a sense of history. Faced with neither, I bring my own touches by choosing antique and architectural fragments that represent a classic touch. The shutters, the crown molding, the lamps, breakfast tray and the Buddha head helped to infuse *Casual Luxury* design into this room. With great design and personal touches, your guest bedroom can become the perfect home away from home for those you care about.

sMARt tip

Double Up Hanging Space

If you are going to live a *Casual Luxury* lifestyle, regardless of space you will need to be organized. When it comes to your closet, rather than putting one hook on the center of the back of the door, consider putting two: one on top and the second midway. This trick allows you to double up. Unlike the back of a bathroom door—where you need the hooks side by side for long robes—stacking them doubles the hanging space while still giving access to the closet.

"Rosebrook Gardens' guest room is so popular, friends say I should have a two-night minimum."

Chapter Eleven
Guest Bathroom

A guest bathroom, unlike a powder room or a half bath, presents its own unique needs and challenges.

My guest bathroom needed to work well for visiting overnight guests, but it also had to service all the rooms on this floor: the guest room, the media room and the home office. Because it sees lots of activity throughout the day it needed to be designed and styled with this in mind. This bathroom needed to be both inviting and casual.

However, it had one major faux pas. It was built with no windows! Natural lighting is an essential component for creating a *Casual Luxury* space, and whenever natural lighting is in short supply you should supplement it with lamps, overheard fixtures or recessed lighting. This bathroom is located in the far back right corner of the house and has two exterior walls. When first seeing the bathroom configured like

this it reminded me of a memorable quote from the camp classic Mommie Dearest, starring Faye Dunaway as Joan Crawford. In the movie, while renovating her New York City apartment, she said to her architect: "Tear down that bitch of a bearing wall and put a window where a window oughtta be!" I certainly was not as dramatic, but just about quoted her to my contractor. A month later a new window was indeed installed on the northeast wall, high enough for maximum privacy while still allowing natural light to fill the room. No window treatments are necessary.

How do you know if your windows can dare to go bare? (Bare-windowed without blinds or curtains, that is!) If you can see anyone while looking out the window, then they can see you! If you need to put window treatments in your guest room or bathroom, make them easy to use; your guests shouldn't have to fiddle with them.

Once the window was installed I was ready for painting and set on a textured wall. I chose a two-layered, faux denim look with an eye-catching stenciled stitching detail. Due to the tight space, the toilet was temporarily removed to gain access to the wall. Over a long weekend the casual paint finish was completed that still works in this space today. The cool blue color became the jumping off point for the bathroom's entire design theme. Nothing inspires better than the organic colors that Mother Nature offers, and the denim inspired thoughts of the seashore. Seashells, a wicker wastebasket, and artwork in tones of blue, light gray, taupe and sand complete the look.

Eight-foot ceilings
8x7
Paint
Ralph Lauren
Indigo Denim

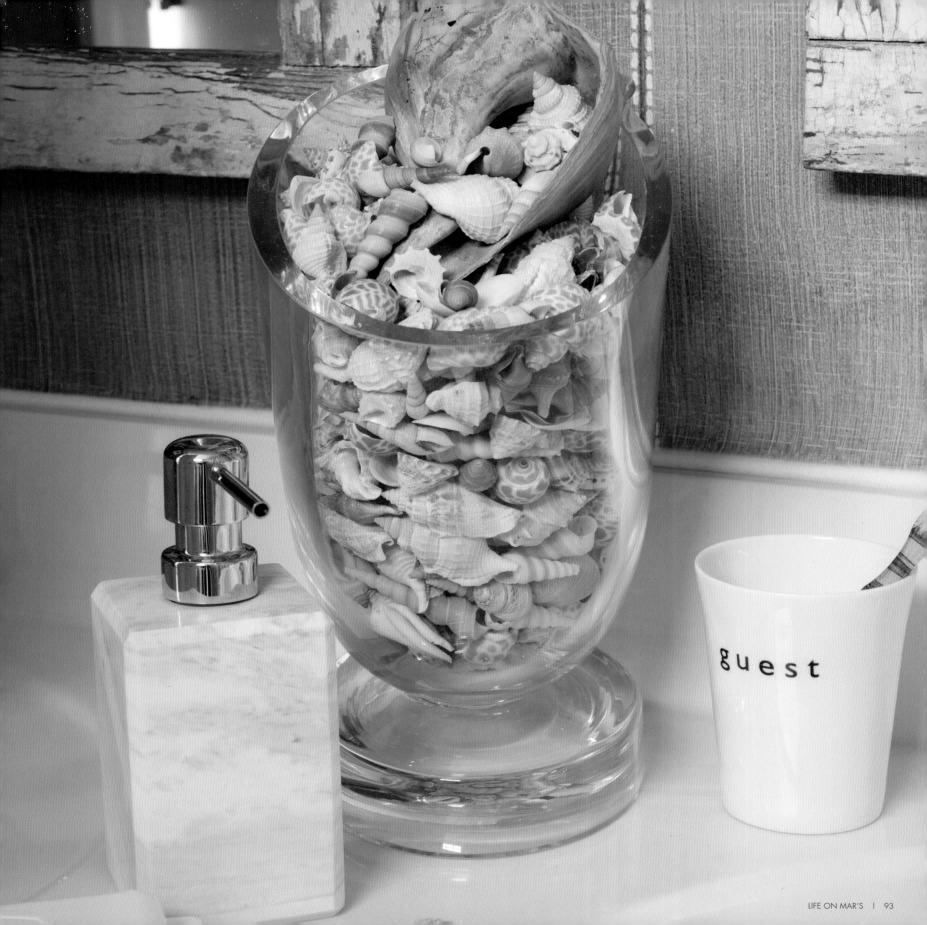

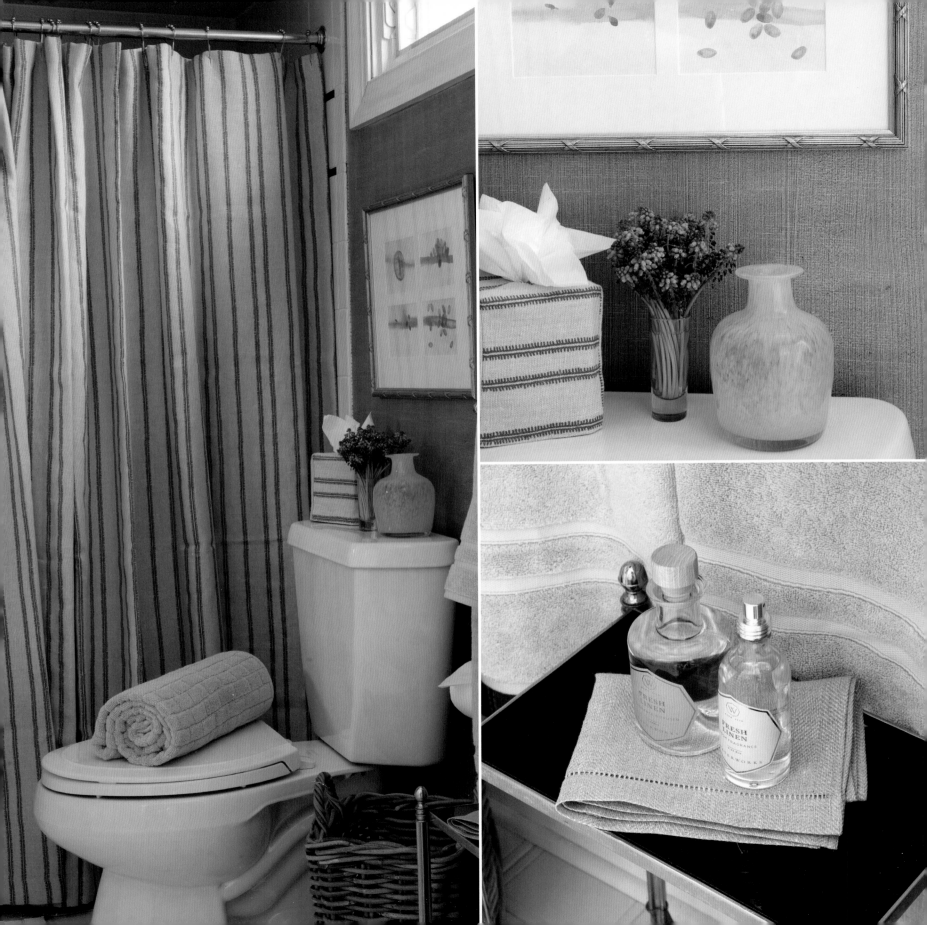

Just like any other room in your home, your bathrooms should also have a design reference to the adjacent rooms. For example, if your home has a more modern or traditional look, then the bathroom should as well. Reference design elements and pull color tones from the resources.

When designing rooms I lean towards fabrics and woods. For a bathroom I prefer natural stone and ceramic. When you can combine all four, you create a formula for great bathroom design. Every room can benefit from the softness that only fabric can bring, so a conscious choice of shower curtain can also become a jumping off point for a bathroom color scheme. Consider upgrading your shower curtain from something drab to something fabulous. In addition to being a major focal point, a shower curtain can hide old tile or even unsightly shower doors. To give your bathroom a really luxurious feel, put two curtains on the rod instead of of one, making for a more custom, professional look. To make a bathroom ceiling appear even higher than it is, hang the shower curtain floor to ceiling; use curtain panels as a shower curtain alternative if you need more height. They are easily found, and give you many more options for colors, styles and fabrics.

Speaking of fabrics, towels are another inexpensive way to change the look of a bathroom without a huge commitment. A change of season is a great time to switch out towels: winter, spring, summer or fall can easily be represented by differing solid bath towels. Steer away from patterns as they can quickly confuse and overwhelm a bathroom space. Keep beach towels for sunbathing, plush towels for bathrooms. Never put personalized monogrammed towels in powder rooms or guest bathrooms. Personally, I never want to dry off after bathing or washing my hands with someone else's monogramed towels. Save those for your own private quarters.

Electrical outlet covers are just as important as any other hardware, so why not complement your design theme with colored covers? This quickly gives a room a cohesive touch by integrating color tones or materials. Simple to do yourself, this adds an instant touch of glamour to a tired bathroom and can make a big visual impact.

No bathroom would be complete without decorative touches and accessories. When it comes to finding accessories, mix items from off-price stores with high-end items for a budget friendly, upscale look. Here, a towering glass vase houses oceanic inspiration while dividing a double sink. The simple white ceramic "Guest" water glass pulls from the white tones of the seashells creating an inviting and cohesive vignette.

A double sink vanity is usually reserved for master bathrooms, but why limit your guests? If space is not an issue in your guest bathroom, consider a larger vanity and gain both the extra storage and counter space.

Bathroom mirrors need not be traditional medicine cabinets if storage is available in a vanity. But decorative mirrors need not be expensive, either. Forgo the expected bathroom mirror and create the unexpected with something custom. Like these two distressed barn windows, found in a Vermont salvage sale. The rusted hinges' locations are still as visible as when the windows were originally discovered. They were quickly transformed into one-of-a-kind mirrors by simply replacing the glass. These custom mirrors have a history, link perfectly with the casual feeling of the denim walls, and their distressed quality lends an air of seashore cottage to them as well.

Wall art in a guest bathroom should be soothing and comforting. Seascapes, mountains or botanicals are

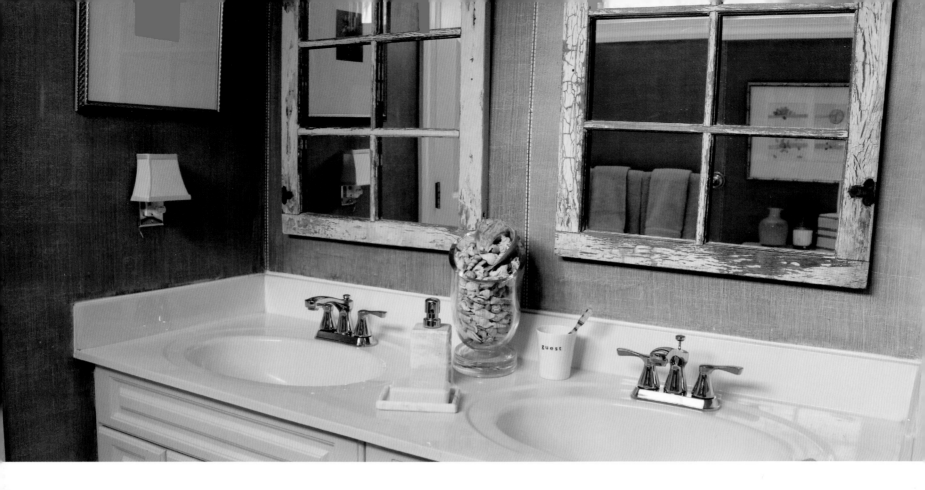

soft choices that can easily be found in compositions to reflect your color tones and personal style. I chose simple subjects that complement each other—both subtly reference petals; a study of lilacs by John Dugdale and an abstract montage by Alexis Rockman.

Your guest bathroom may have to serve your guests only from time to time, but it should serve you and your lifestyle every day. However, avoid personal family portraits in any bathroom. It may be hard to believe, but I have seen this many times over during my career, and find it difficult to use the facilities when someone I know is watching me! If you must hang photographic art in your bathrooms

that has people as subjects, here is a great rule to follow: the subject should never be looking directly out of the picture but to the side or away. Why? Even if your guests don't know the person on the wall, they still deserve their privacy.

When designing your guest bathroom, remember it's rarely for guests only. Make it a practical space for all who use it—friends, business visitors, overnight guests and yourself. A small renovation—adding a window for natural light—plus a welcoming design scheme makes what could have been a small, inconsequential room part of the overall design of this home.

sMARt tip

Be Your Own Guest

Don't turn guest bathrooms into museums! They do not need to be "off limits," awaiting the eventual guest—use the room! Create a warm and comfortable space you want to be in yourself using the six *Casual Luxury* principles, and it can be a working bathroom with style as well. Then simply keep a few guest-only items on hand—fresh towels, bathmat, hand soaps, etc.—to swap out when visitors arrive—and everyone will enjoy this room year-round.

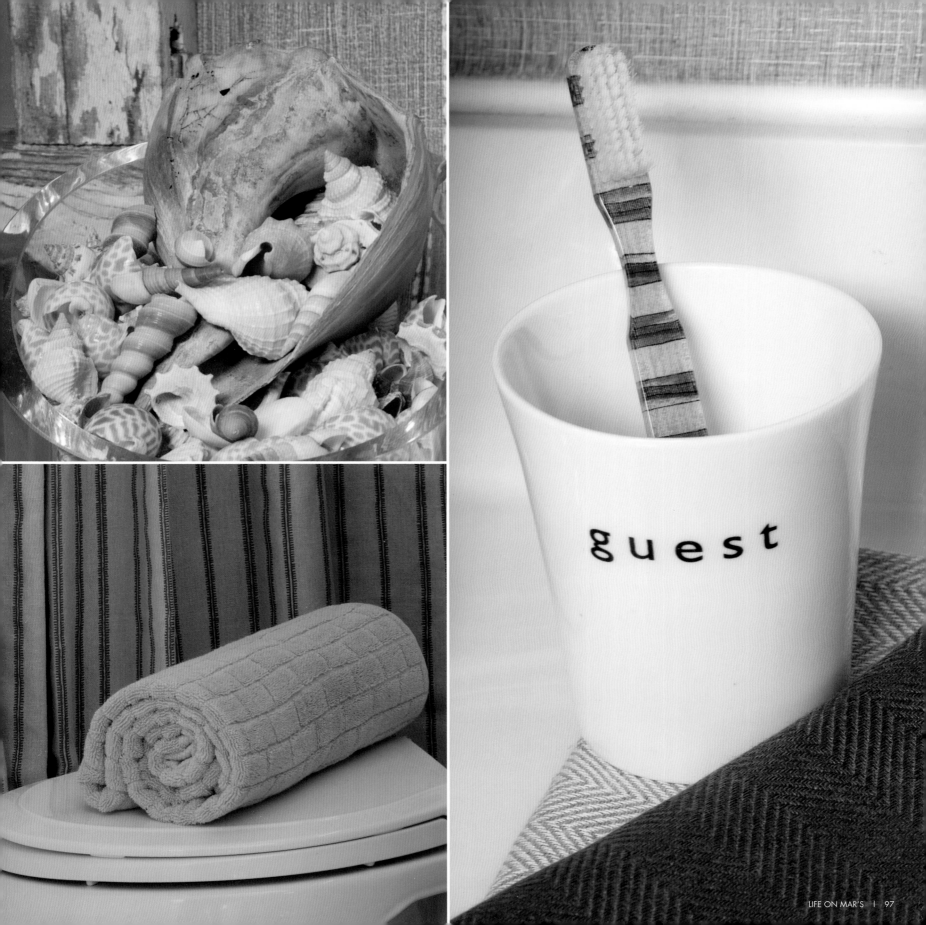

Chapter Twelve
Home Office

As a lifestyle expert and author, I was fortunate to be able to create a dedicated office right in my own home.

Everything I need is here. With views of the garden and a dog basket under my desk. Hours pass and I can remain lost in comfort and creativity.

Nothing stimulates the senses better than a room flooded with natural light. With both southeast as well as southwest exposure, this room has plenty. I find it easy to be inspired working in this room— and so does my staff. I designed it to maximize all of our needs. At any given time, three people can comfortably be working, and as I keep long hours and find the need to write whenever the moment strikes, my home office becomes the hub of my

creativity. Having a home office is a great balance to the garden studio—my "laboratory" where I actually create with my hands—because together they allow me to quickly shift from right-brain to left-brain seamlessly and at any given moment.

Offices are typically expected to be emotionally cold, unattractive, even messy. As a result, our expectations don't demand much when we have a home office. But I believe that a home office should offer the same *Casual Luxury* touches as the rest of your home. Many years ago when I worked in banking I would style my offices and cubicles by infusing them with my own personal touches. For some people this can come by the way of children's drawings or personal photos of family and friends. But I course had to be different and infuse my offices with home accessories such as lamps and framed artwork. Wherever I could add creativity and personality combined with personalized touches, I did. When clients or colleagues visited my offices they would comment on how inviting the space was and how they loved what I had done to it.

Today that spirit continues, as my home office continues to reflect the same need and desire to be surrounded by those things I love, and to make business guests feel comfortable. *Casual Luxury* is about creating spaces that reflect personality, so why dismiss this idea at home or at work? The result is an office that is literally and figuratively "Mar Central," filled with decorative details that bring *Casual Luxury* to an office space.

Eight-foot ceilings
11x11
Paint
Farrow & Ball
No. 38 Biscuit

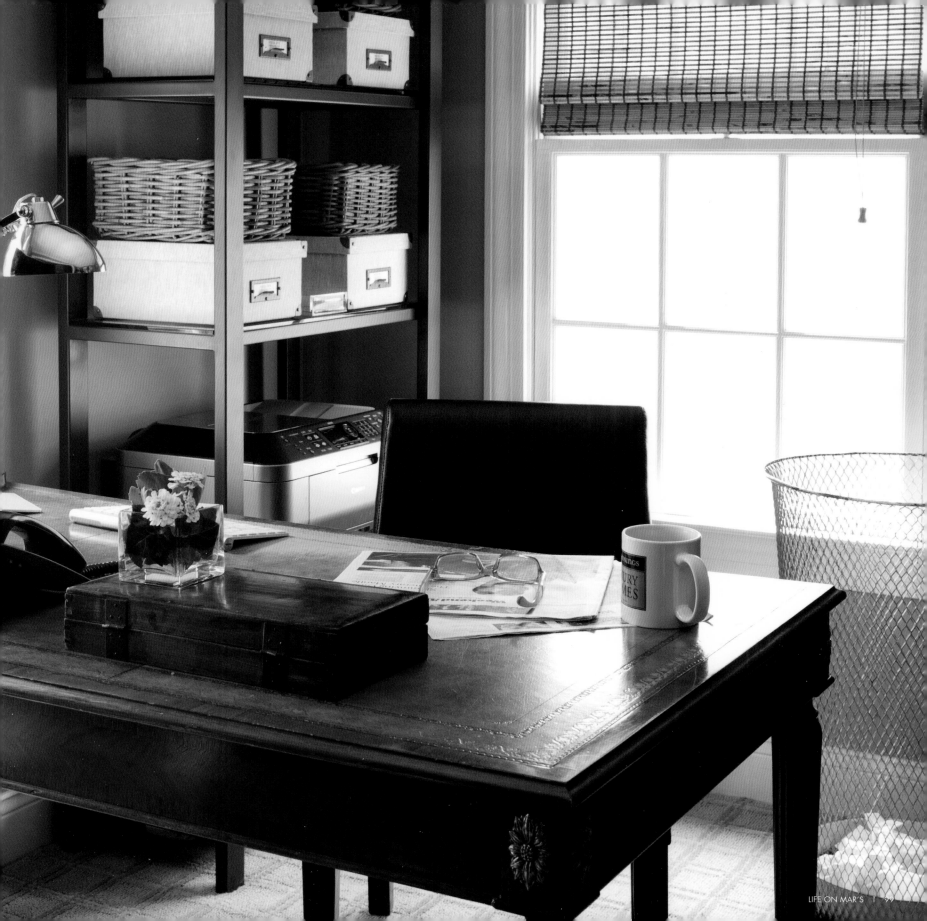

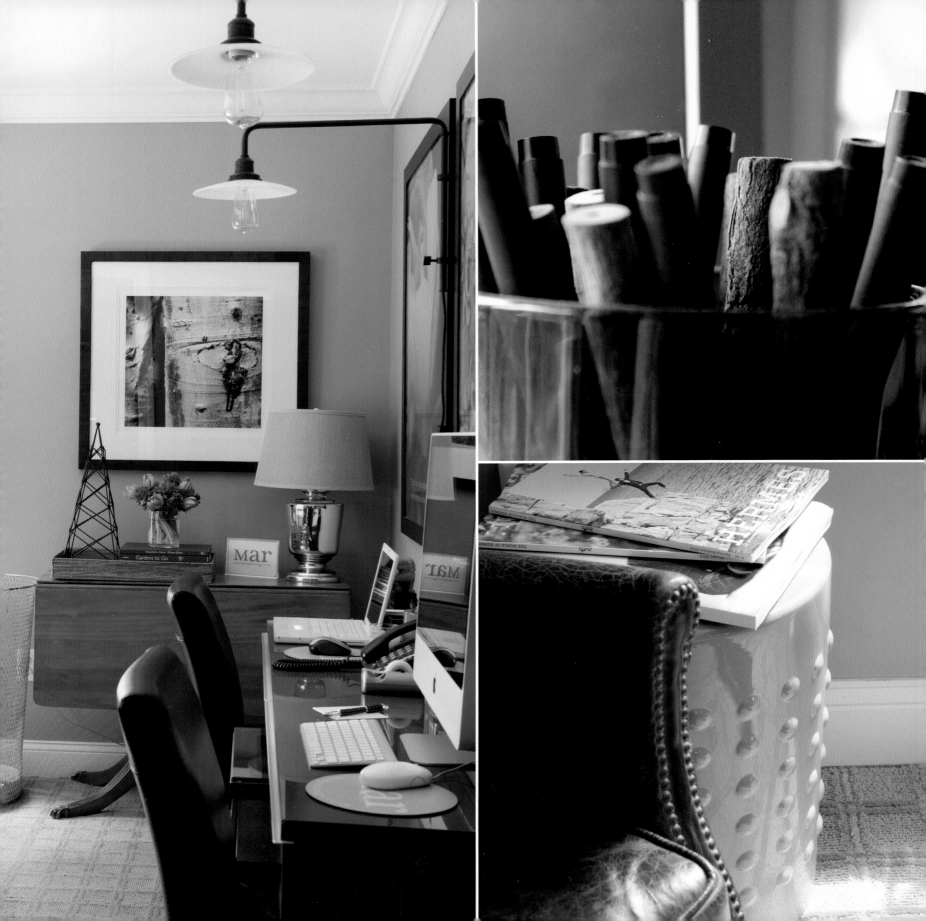

When designing any home office, it is best to go from the ground up. Because all the rooms on this floor were constructed as bedrooms of similar size, I wanted to establish continuity between them by using carpeting. The wall-to-wall carpet for the home office is the same pattern and color of the media room; the guest bedroom is a similar color but a different pattern. This subtly sets each apart, but the overall color and tone of the look unites all three rooms. I further chose to match the wall color in all three rooms to create more harmony and unity. As a result, all the rooms work together but still have their own purpose and place.

My desk, from ABC Carpet & Home, is a French Louis XVI writing table with gold details and leather inlay, a thoughtful housewarming gift from a dear friend who has since passed away, and is extremely special to me. Although an elaborate gift to give, Edward wanted it to serve as divine inspiration upon which for me to discover my inner writing voice. This was in 1997, ten years before my first book. And although I was not much of a writer back then, this unexpected encouragement prompted me to dig deep within myself and discover the voice that would eventually help express my inner creativity. I'm a firm believer that this desk holds continuous motivation, as I write this second book on exactly the same beautiful leather desk top as my first.

Originally it was placed facing the larger front windows, at a right angle to the door. But I quickly grew tired of being spooked every time someone walked up to me, so I redirected the desk to face the door. This writing desk, its surface now covered with all the modern office communication amenities, serves as the perfect place to write, pay bills, do research and also remember the man who provided the "writing" desk that makes it possible.

Due to the bright light, this room actually has window treatments. Can you believe it? Unlike the other rooms on this floor—where window treatments were added for privacy—here they were added because of the direction of the sun. Wanting to install something different from the other rooms, an organic element and something environmentally friendly seemed like the perfect choice. I chose natural bamboo Roman shades which I found at Blinds To Go. Also known as woven wood or matchstick shades, they are the perfect way to be green while staying in the shade. The gorgeously varied tones in each shade link to the hues in wall color and carpeting. For placement on the window, Roman shades are recessed within the window jamb rather than outside the window on the trim, which offers a more professional, custom look at a fraction of the price.

> ❝ Every room has beauty, but not everyone can see it – so put your MAR glasses on! ❞

Since we are addressing the natural light in this room it seems a "natural" time to refer to controlled lighting. Controlled lighting is anything that uses a switch. This room has four sources for light: two wall-mounted train station-style swing arm sconces from Restoration Hardware over the narrow IKEA double desk, a silver table lamp on the drop-leaf table and a silver banker-style desk lamp on the writing desk. Unlike the rest of the house, where dimmers are the norm for lighting, the home office does not offer this feature. When light is needed it is available full-strength, but none of the bulbs needs to be high-wattage because when natural light is

sMARt tip

Retro Bulb Tips
I love the new filament bulbs that look like they have time-travelled from the turn of the century. These are mercury-free and fit any standard socket, so you can easily experience a welcome change from the bright, white light of conventional light bulbs. But when is the right time? Simple: If you can see the bulb you should update it. Even the "big box" hardware chains are beginning to display the many options, so get inspired!

in abundance the blinds are opened as the primary lighting source for the room.

The other furnishings in the home office are practical as well as stylish—and all connected by subtle color cues and connection to Mother Nature. In this room the French writing desk and drop leaf table are both wood and with the same color tones. The fluted leg details connect the pieces through their design similarities. The modern pieces are intergrated by the way of their earthy palette. Both the writing desk and the modern lacquered grey desk are complemented by the repetition of three chocolate leather Crate&Barrel armless chairs.

The other modern piece in the room is the dark gray metal étagère—the French word for stages or levels—and this type of furniture truly helps provide an important resource for a busy home office. Made of glass and steel and also purchased at Crate&Barrel, its industrial touch works well with the swing arm sconces over the double desk as they both offer a perfect level of metal detail. The étagère's squared and tubular frame has a textured graphite coat of paint that introduces a new finish to the room. The matching low filing cabinet serves as a way to divide the narrow desk into two separate working stations.

This étagère offers the same solution for storage as the bookcase in the media room— it creates vertical space. In addition, it directs your eye vertically making the space seem even larger. Unlike the media room bookcase where everything is openly displayed, the étagère provides clean, modern lines balanced with linen-covered Restoration Hardware media boxes. These work well for tucking away items and staying organized. Vintage-looking, very stylish and practical, these decorative storage boxes also provide great looking details with their brass hardware.

The open woven baskets from IKEA offer another clever storage solution; combining the organic nature of the baskets with the metal of the shelves is an example of how *Casual Luxury* can be elegant, too. The baskets and étagère combination is also another example of combining both high and low-priced items, as the best designs come from the "magic of the mix."

You cannot help but notice the custom closets in this home office. They were installed by California Closets. This is truly the best way to maximize storage by using what was intended to be the bedroom closet without sacrificing any additional floor space. Unlike your typical office file cabinets, I needed this design to include wrapping station shelving and double frosted glass door to store fragrant candles, lotions, gifts, and last-minute project supplies. I'm told it looks like something you would find in a retail store. The doors to the former closet were removed to expose the space before the design was installed to maximize functionality. The hardware was upgraded to those with a nickel finish and the same gray baskets used on the étagère were inserted into the shelves to incorporate a mixture of hard and soft surface.

Now let talk trash. Have you ever considered the notion that something as simple as a trashcan could be a home fashion statement? Trash receptacles, whether large or small, are a part of our daily lives. This simple, often overlooked necessity offers endless possibilities to show your personal style while remaining functional and decorative.

Many years ago, when I was still a banker, my colleagues and I were consolidating two branches. An old vault was opened, and inside there was a large wire mesh trashcan, a little worse for wear, about three feet tall, which the workers promptly discarded in the dumpster just outside my office window. Noticing this superb old can laying there, I immediately set out to rescue it. Believe it or not, I climbed up the outside of this dumpster in my suit and jumped in, bringing a whole new meaning to dumpster diving. It was worth it! Today this large industrial trashcan is proudly displayed in my office and embodies resourcefulness and great design. And it was free!

To properly manage a truly full-service multimedia "mini-empire," I needed a professional phone system.

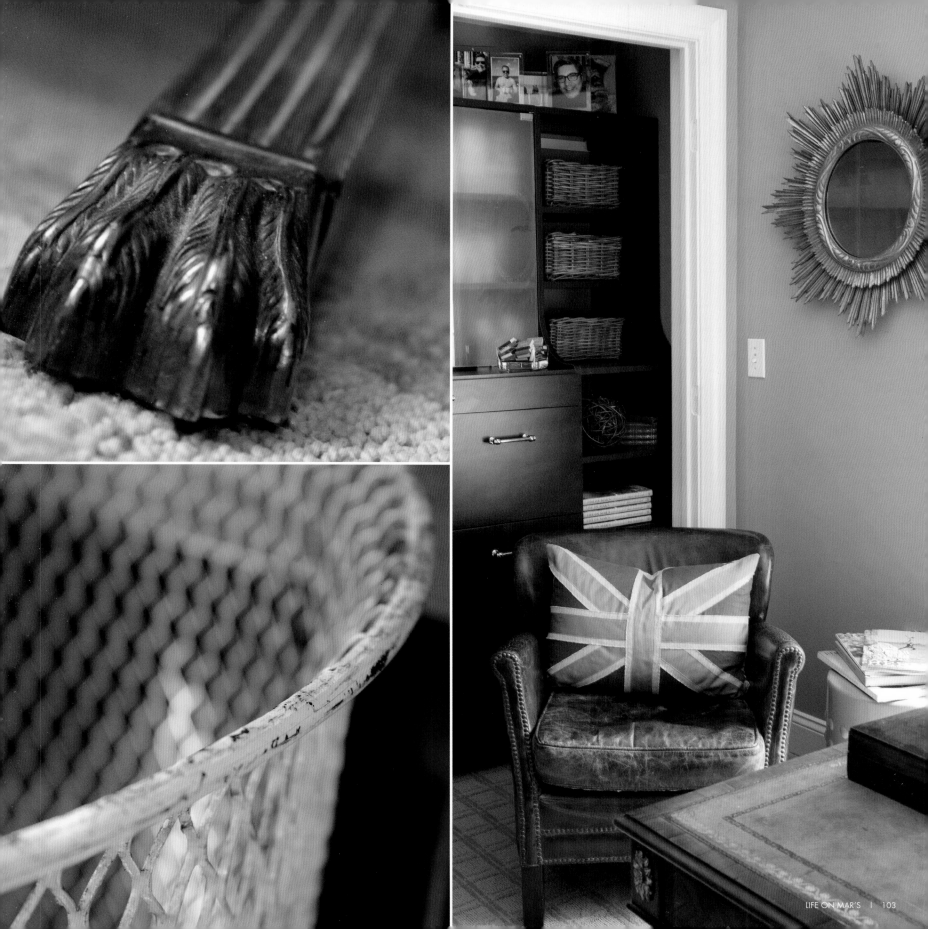

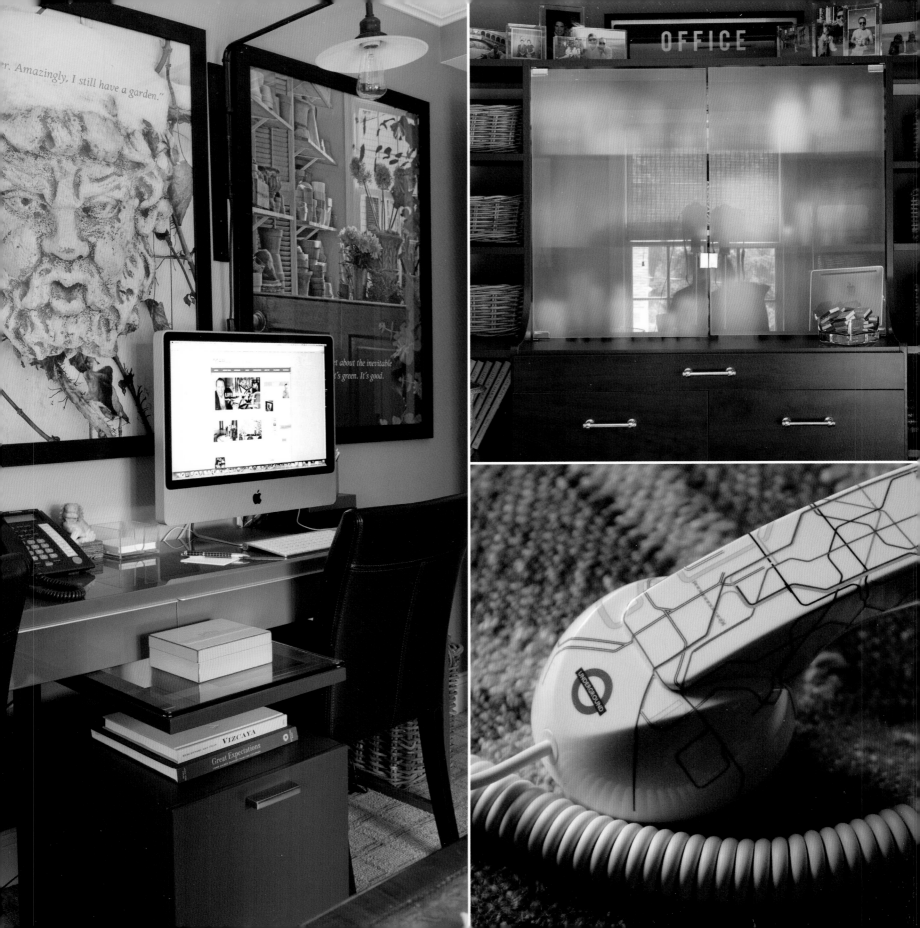

OFFICE

"r. Amazingly, I still have a garden."

about the inevitable
's green. It's good.

VIZCAYA

Great Expectations

UNDERGROUND

Installing one not only gave my staff voicemail, but also helped overcome the need to call up and down the stairs, as from any phone you can press a button to call another room. For example, I may be in my office tweaking the teleprompter notes while my assistant is in the garden studio with producers setting up the segments. When ready, they can simply page me. Just like those old paging systems of yesteryear, my phone system offers a more modern and professional touch with all the added benefits.

No room is complete without decorative and inspiring art. This can come by the way of architectural design prints, family photos or favorite images. In the case of my office, I've hung three oversized, framed pages from my first *LIFE ON MAR'S* book, each chosen because they have a seasonal quote. Also on the wall is a mirror; it's always handy to have one, so why not make it an antique? The starburst mirror offers gold tones that are repeated in the desk hardware and other details,

thus connecting it with something old, something new and something **MAR**velous! The nearly-identical one in the media room is on the exact opposite outside wall of the house. Even if people only notice subconsciously, it creates a great sense of balance.

This room is filled with office resources with which we are all familiar, and believe me, it's really a working office, not something staged. Why doesn't it have the look and feel of an average home office? The difference is that like all the rooms in my home it shares a united design approach. You can do it, too. The first key to successfully creating your own *Casual Luxury* office is not to purchase an office set. Rather, wander throughout the stores and discover the linking elements that can pull your room together with colors, tones, texture, and finishes. Let your eye discover the similarities in designs. This simple trick can quickly become your go-to reference when applied to any room in your home.

Chapter Thirteen
Laundry Room

Today's laundry rooms are no longer tucked away out of sight and mind; they are redesigned as extensions of the living quarters.

Design magazines have come to embrace the laundry room, giving it the much-needed attention it deserves. No longer are we demanding laundry rooms stay in basements. Today, laundry facilities can be found in mudrooms, kitchens, bathroom suites or in designated rooms of their own. In larger homes it is now common to have more than one laundry location. For me, the best placement for a laundry room has always been near the bedrooms—and yet they are so infrequently placed there!

I know that in many metropolitan cities, having laundry in the apartment is a luxury in itself. For most people it's a sterile, fluorescently lit basement laundry room. I did that for a while, until learning I

had the power to successfully redirect my energy to what I could control. In this instance, I found a bunch of terrific, monogrammed laundry bags and vowed to create a great laundry space.

Even a basement laundry facility can be treated with a *Casual Luxury* approach. One key is to multitask while doing laundry. For example, if exercising is your thing, having an exercise machine in your basement is a great way to get in shape while washing your whites.

Rosebook Gardens offered challenges when it came to doing laundry effectively. The original design called for laundry units to be stacked, in a multipurpose pantry and broom closet just off the kitchen.

Not the best setup, as laundry from the bedrooms would need to make the journey down one or two flights of stairs. I don't know about you, but I hate going up and down stairs with a laundry basket (regardless of how fabulous the basket may be). Small piles quickly become big piles that eventual explode out of the closet and onto the kitchen floor where they would have waited in a queue to be washed and dried. Hardly a *Casual Luxury* lifestyle approach! So a better plan was in order.

Within a month of moving into Rosebrook Gardens, my laundry room became part of the "relocation program," and just like the 1970's sitcom family *The Jeffersons* they were "moving on up" to a deluxe location. The new space, originally an open landing on the second floor, served as the perfect place for

Eight-foot ceilings
11x11
Paint
Farrow & Ball
No. 38 Biscuit

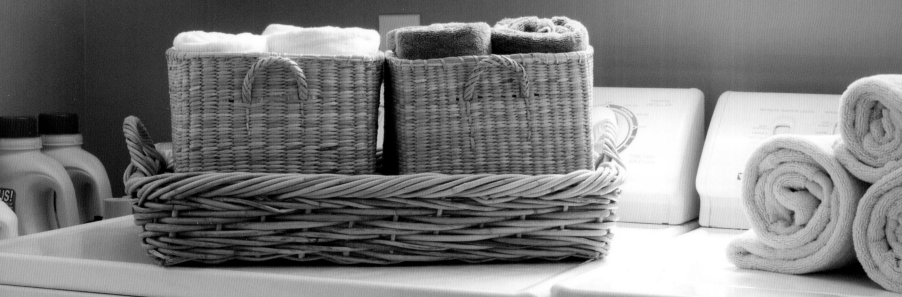

LAUNDRY 15¢

Between Cycles

Fresh Ideas for the Laundry Room:
It's just as easy to banish the gloomy, industrial feeling as it is to banish stains! Here are few sMARt tips for how to spruce up your laundry room for cleaning duty and beyond.
Be fully functional. Add a TV, music player, or phone to your laundry room. Provide a small table so family members can use a laptop or pay bills while waiting for a cycle to finish. No need to rewire, just have a wi-fi system in your home if possible. Now that's a fresh take on the laundry room.

Laundry Lighting

Lighten up. Proper overhead lighting should allow you to see stains clearly, so this is where decorative industrial lighting can make a big hit for form and function. Remember to switch bulbs to white light for the best results. But don't abandon having a softer, traditional lighting source with a regular bulb, such as a table or floor lamp; this provides pleasing light for the rest of the cycle—which will instantly make the space feel less industrial.

a laundry room. A delightful circular window, already in place, offered lots of natural lighting, thus a terrific motivator to wash and dry. Plus, both the home office and media room were nearby, so working on articles or catching an episode of my favorite show are both possible and within a short walking distance.

A plumber and carpenter were called, and a side-by-side, high capacity washer and dryer were installed. Today this little renovation offers the bonus of having a laundry facility that is not shared with mops and brooms—plus the double doors make it feel open.

A laundry room should not just offer the basic elements required to do laundry, so I introduced elements of Mother Nature, just as in other rooms in the home. Because natural light is abundant, the room is a perfect nursery for forcing bulbs, growing orchids, jasmine and succulents.

For consistency of design, the wall color is a continuation from the shade in the other room on this floor, while the hanging light fixture is a clear glass version of the bronze star shape fixture from the landing. Although these lights differ in material and size, they subtly link and create balance from one end of the hallway to the other. This light fixture, too, is on a dimmer, to allow the best control of light.

The window is original to the house, but the starbust design within it was not. It was created to pay homage to the lighting detail, but serves as a decorative detail adding character to the home whether viewed from inside or out. Inspired by a similar detail on an historical home I visited during a

garden tour, I made a mental note, took plenty of photos of its design, and returned home to sketch my own interpretation. You can spend a small fortune upgrading major parts of a home, but often it's the little details —such as this window treatment— that can make the biggest impact to a home.

In need of shelving, a repurposed fireplace mantle painted in high gloss white was installed. A piece of frosted glass was cut to size to add a more sleek, modern look, and to extend the surface area (similar to the mantle in the living room). Three Juliska lidded glass jars provide order and a decorative way to house clothes pins, dryer balls, fabric softeners and found money. Dog-themed bookends with marble bases serve as an unexpected, playful touch to the mantle décor. A reproduction of a traditional school classroom clock—discovered at my local Target—keeps me on schedule, while the "Laundry 15¢" sign that I found at a flea market keeps it fun and playful.

Even a laundry room can offer wall space for interesting touches of personality. Here a set of pressed botanicals in heavy black iron frames and a contemporary painting. This painting captures all the color tones of not just the laundry room but also the entire floor. A great linking feature; even though it is tucked away in the laundry room, I'm surprised by how many people comment about it.

A wicker tray and two baskets filled with rolled up towels are handy and ready when needed. Whenever the laundry room doors are open and the washer and drier are visible, the

baskets also serve to subliminally neutralize their industrial appearance: a quick glance and one sees large surfaces rather than appliances.

Doing laundry may not be your favorite thing, and relocating the appliances somewhere more desirable may not even be an option, but the fact remains that it is a part of life that is not going away. Embrace the laundry room as part of the home, and with a few *Casual Luxury* touches you can easily make it better.

s**MAR**t tip

Stylish Function
What if your laundry area has to remain in the basement, which feels dull and uninspired? What can you do to liven it up? Look for creative storage solutions. Instead of a cluttered jumble of boxes and bottles, create a more cohesive look. Transfer detergents from large boxes and jugs into matching decorative containers, such as apothecary or mason jars. Items such as clothespins, dryer sheets, and dryer balls can be stored this way, too.

> **I hate a wishy-washy laundry room.**
> **Load it up!**
> **Style it up!**
> **Live it up!**

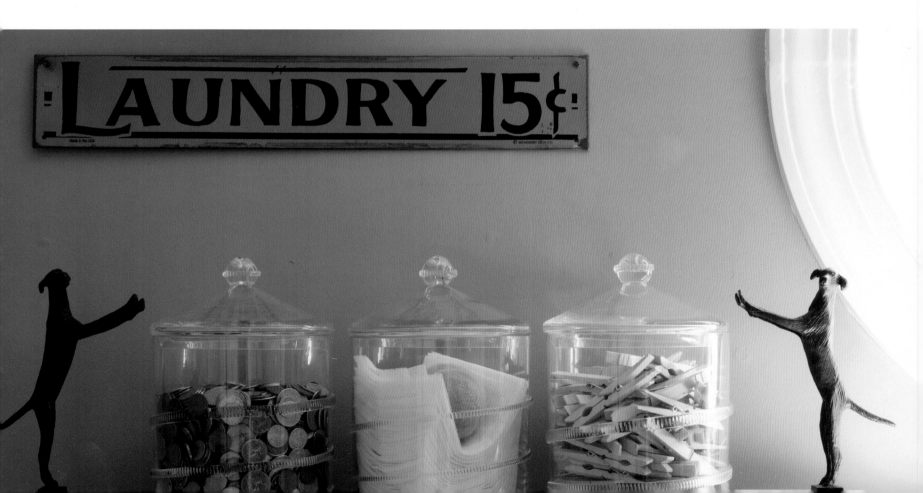

Chapter Fourteen
Master Bedroom

At the end of the second floor hallway, around the corner, lies a door; behind it is my sanctuary.

Travel up a flight of stairs and you'll arrive at the master bedroom suite.

Located on the third floor for maximum privacy, this room feels spacious and bright mostly due to the vaulted ceiling and many windows. An en-suite bathroom is also located here (more details in the next chapter).

A master bedroom should be a refuge for the homeowner, offering the perfect retreat from the rest of the house. A focused use of the *Casual Luxury* principles creates a space that sparkles with great design, perfect furniture scale and placement with all the conveniences and details of a luxury hotel. In particular, I've embraced light, comfortable furniture, fabrics and textures.

Let's begin with the flooring. In bedrooms, I prefer to have a lush, wall-to-wall carpet. Just like the guest bedroom, the master bedroom has the same Wool Berber carpet in a waffle pattern. I did this for two reasons: to create a common connection to the other bedroom in the house, and to subtly identify sleeping quarters.

Placement of your bed in a master bedroom is an important consideration. I prefer to see the bed immediately when I walk into a bedroom. Whenever possible, invite views and light into a space rather than covering them up. However, the layout of your room may demand alternate plans, so it can be perfectly acceptable to put the bed in front of windows, providing your headboard does not block more than fifty percent of the window.

Another option—if the bed is in front of the window—is to use the window treatments to make a statement. Window treatments can become the perfect backdrop, in effect becoming part of the headboard. In fact, a client once requested blackout shades as her headboard, as she required total darkness 24/7. In keeping with the *Casual Luxury* principles, we embraced light in other ways. What was suppressed in great natural lighting was replaced by a grand chandelier, table lamps, and artwork picture lights. (And yes, everything was connected to a dimmer switch.)

In this master bedroom, a set of double windows located on the southwest side of the house dominates the space with breathtaking tree-house-like views. They perfectly frame the majestic

Eight-foot ceilings
12x17
Paint
Benjamin Moore
Pilgrim Haze

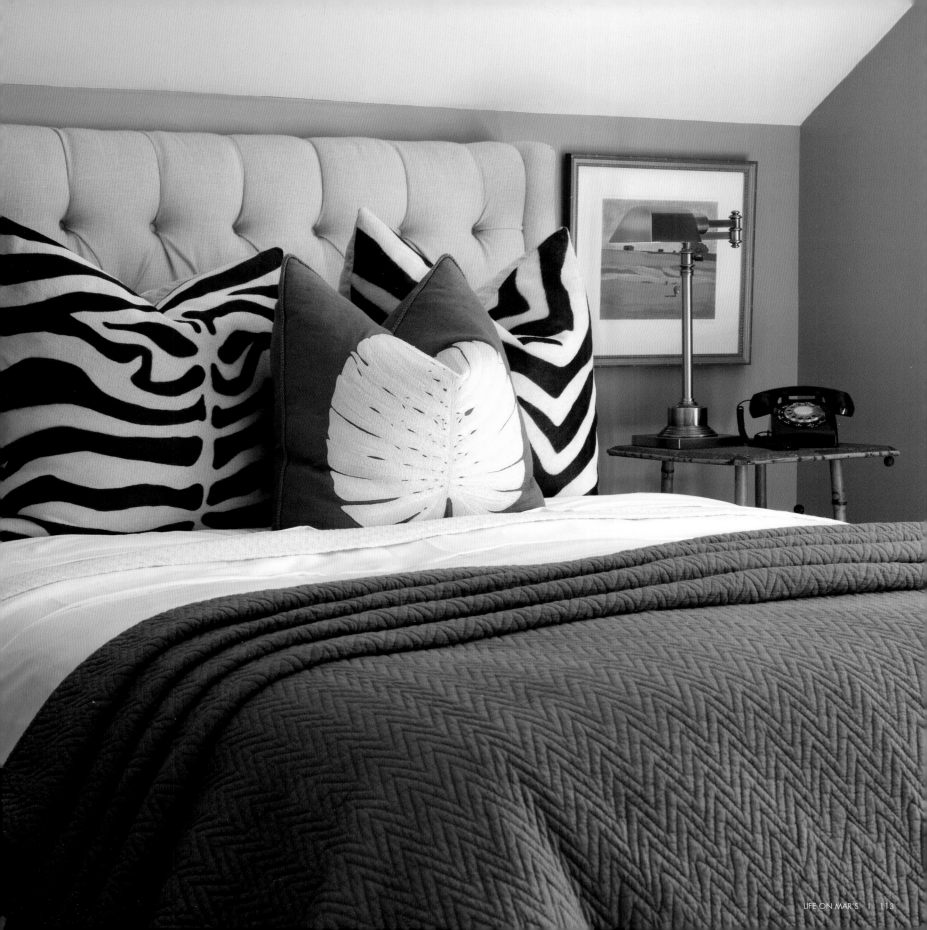

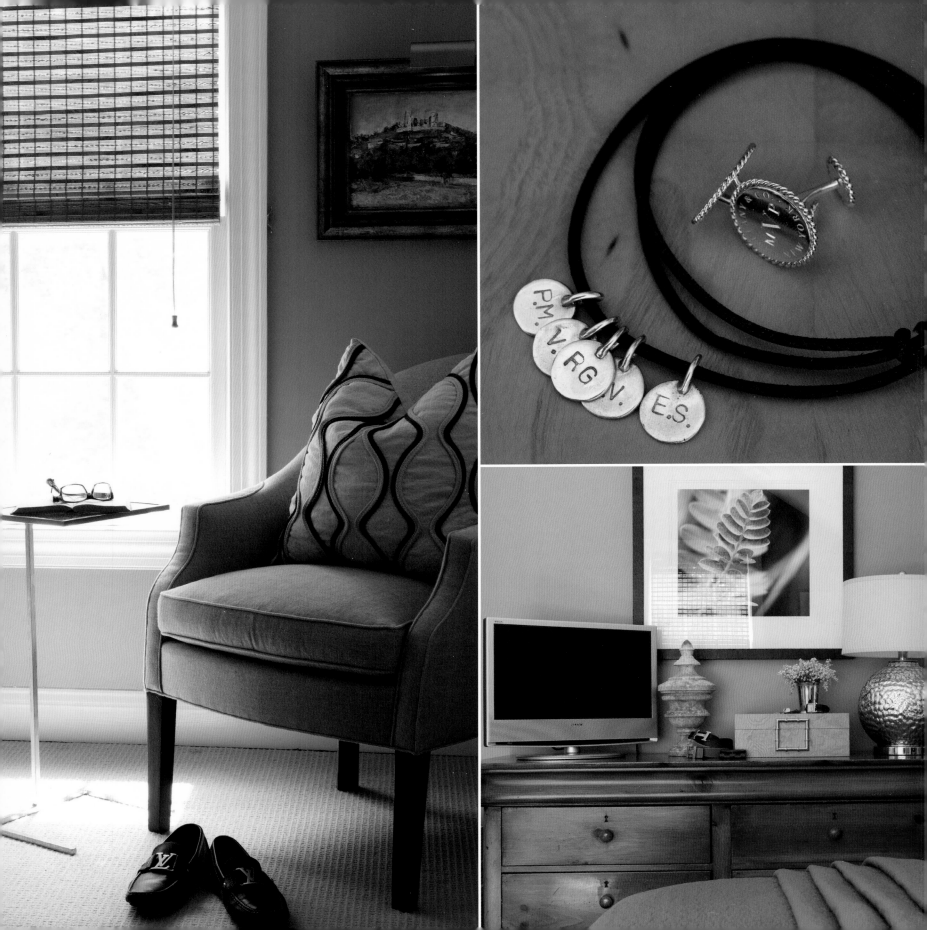

100-year-old oak trees. The trees' seasonally changing glory can be witnessed from the comforts of the bed. Local feathered friends sing from the tree branches while ducks swim in the brook below. The sunsets are spectacular as the ombré shades fill the night's skyline as if calling for a painter to capture its beauty on canvas.

When I selected window treatments and decorative items for the room, life imitated nature: the combination of natural fabrics, botanical prints, and soft colored tones were inspired by this view.

> **Feeling cozy and surrounded by the things you love makes night-night extra special.**

Bamboo window treatments offer serenity and just the right amount of light control. When the sun rises, I want to know about it and when the sun sets, the gentle moonlight is filtered through the slats allowing just the right amount of natural light in. This creates a relaxing ambience, perfect for the sweetest dreams. (The schnauzer loves it, too.)

A round back chair placed in the corner breaks the angular lines of the room and offers a stylish rest. Every bedroom, regardless of size, should offer some seating in the way of a bench, chair or small sofa. Above the chair is an oil painting depicting the mountains and countryside of St. Tropez. It was truly a find and always reminds me of a magical week spent on the Côte d'Azur.

A silver-finished, mirror-top table captures the reflection of light and brings a clean and modern touch to this corner without a huge commitment to modernism. Glass—whether in reflective furniture or accessories—brings life to items in a room and should be used to complement whenever possible.

My upholstered, tufted linen headboard offers great style as well as the perfect decorative backrest for breakfasting in bed, reading magazines or watching an occasional late night movie on television. Linens are always an essential part of a good night's sleep, so it's best to invest in sheets and pillow covers that have a thread count over 500.

When it comes to creating a *Casual Luxury* home you should never sacrifice style or quality. Rather, train your decorative eye to discover the opportunities to create for less. Finding great deals will always be a part of the magic of the hunt and well worth it when one can stretch their dollars. Truth be told, many off-price stores now offer amazing sheet sets at huge discount prices. My go-to place is my local Westport HomeGoods as I can always find name brands for substantially less than other retailers. Once the sheets are on the bed the only difference I notice is the money I saved.

The most sensible thing to put on your bed is a duvet cover because it's versatile and easy to clean. Duvet covers offer such a variety of fabrics and colors and can be easily changed out for the seasons. I get all my duvets and covers at Bed, Bath & Beyond. I prefer the duvet itself to be down as it allows the comforts of a blanket without all the weight. Many people prefer using a duvet the traditional way: the only covering on the bed. Since I use it as a blanket replacement, I still use both a top and bottom sheet—this also lets me use more decorative covers and eliminated the need to change them as frequently.

The bench at the foot of the bed is covered with faux long-hair Hilary zebra. Purchased at the interior furnishings mecca Lillian August, it offers the perfect amount of wildness to the tame room décor. The dark brown wood and nail head detail complement the zebra upholstery. And although they are not a repeat of the pony-back chairs in the media room, there is a similar-enough reference here that they feel connected.

Along the wall, a rustic six drawer tongue-and-groove dresser anchors the space while providing

much needed storage for my endless collection of cashmere sweaters. Orange Hermès boxes also offer a casual and playful way to showcase my collection, established over the last twenty-five years. The items they once contained are distributed throughout the house and my wardrobe, but chosen so as to not garishly stand out. Only here in this room do I poke fun at my collection through my overtly orange pyramid. The boxes also are put to use, to store some seldom-used wardrobe items, like bow ties.

The longest wall has closets running its length, which feature custom, floor-to-ceiling rails, shelves and storage spaces.

The artwork in the master bedroom suite reflects a passion for nature as well as my love for old vintage maps. When does a collection become a focal point? When stacked, layered or grouped. Whether art or other collectables, the best way to feature your passion is by showing the collection in smaller vignettes and distributing them throughout the house. For example, throughout Rosebrook Gardens you will see some consistent art themes: Mother Nature-inspired botanical prints and landscapes are perhaps the most obvious. But man's best friend also shows up in different forms as well: from dog paintings to sculptural designs, reflecting my personality and love for the miniature schnauzer that lives here. I make use of every inch of the space, yet the house remains resolutely uncluttered. That is *Casual Luxury* at its best.

A ceiling fan is a wonderful opportunity to create extra light, add interesting details, plus a cool breeze on demand. I always prefer to install a ceiling fan when ceilings are over eight feet in height. If the fan will hang lower than eight feet it must be installed over a piece of furniture to keep people from walking into its path. This Restoration Hardware ceiling fan has an industrial, sleek modern feel that chimes in with the side table lamps.

Nothing in the master bedroom is part of a set or even from the same collection. Looking at furniture collections in stores can give you great inspiration, but I firmly believe you don't have to buy your whole look from the same designer. Think about the way you buy clothing. When you look at clothing on a mannequin you gain inspiration for a look you love; very, very few people buy the whole look as presented—even if they can afford it all in one go. We look at the individual pieces, consider what we have at home that would fit in or substitute, decide what is the most "must have" item, and then personalize as we build from there. This is not considered a slap in the face to the designer, but rather a compliment. Think the same way when you look at furniture in a gallery: talented people have curated looks designed to inspire you. Furniture can be mixed and matched using both high and low-priced items. Auction houses, salvage stores and consignment centers offer great resources for well-constructed furniture. An attic or basement or even a tag sale will always be my first go to place, as Grandma's pieces can become glamorous with either paint or fabric. The important consideration is to always look for great lines and good solid construction with little to no visible damage—especially to wood.

To create this sanctuary I simply followed the *Casual Luxury* design principles—and the peaceful, restful result is a room that truly tops off this home.

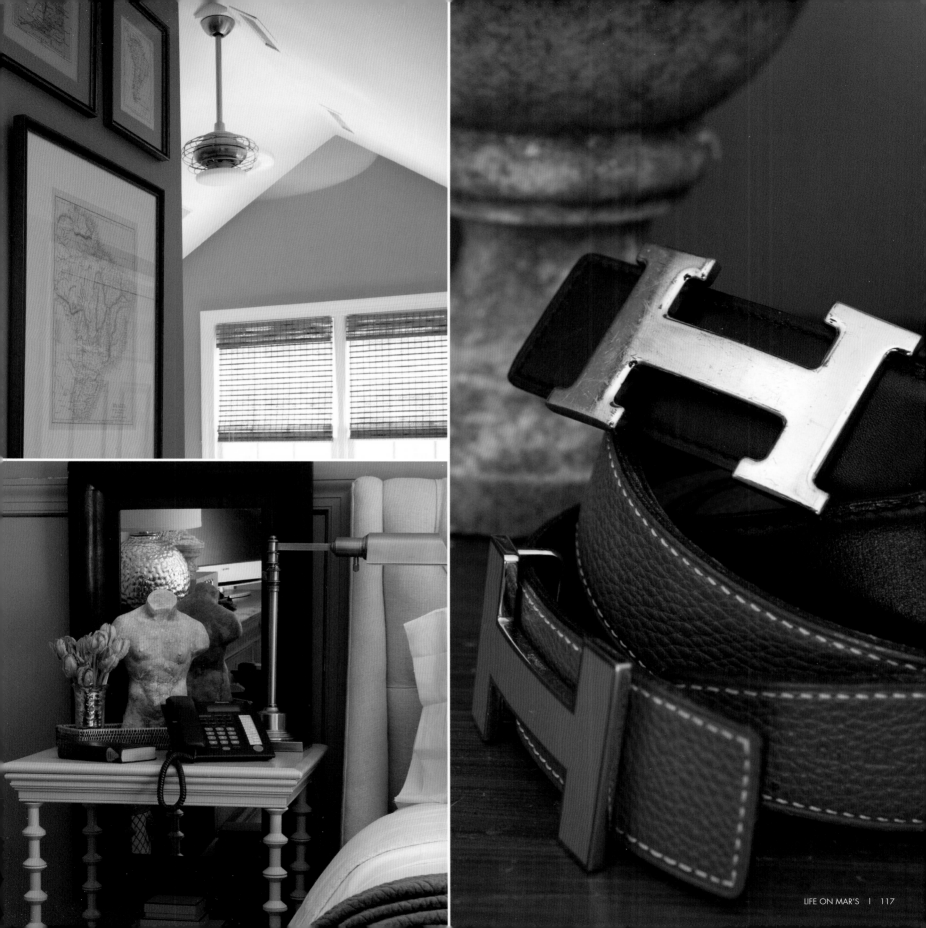

Chapter Fifteen
Master Bathroom

If the master bedroom is my sanctuary, the master bathroom is where all the design principles come together to create a healing room of ritual which both complements and takes advantage of the space.

Although a skylight was on my punch list ever since I moved into Rosebrook Gardens, it was only installed a few years ago. It sits perfectly in the middle of the dormer, and I love the way daylight spills into the room. What I was not expecting were other benefits I have grown to adore. Moonlight floods the room at night, and the gentle drumming of rain during a storm makes even bad weather seem cozy.

Having a new cedar shingle roof installed provided the motivation as well as the opportunity to install them both at the same time. I love a great skylight and whenever possible I make sure they are part of the overall design plan. Installing skylights correctly should be left to the professionals, as there is nothing more unattractive in a room than a leaking skylight. Installing this one proved to be challenging as the pitch of the roof did not allow proper water flow, so the decision was made to make the entire dormer copper.

In every room there is a place to save and there is a place to splurge. That said, I would normally have budgeted the majority of my bathroom dollars into natural stone flooring, trading off for less expensive ceramic tiles for walls and the shower area.

However, the marble flooring was original to the house, and newly installed when I moved in. The builder had an extra supply from a prior project and whatever was left over was installed here. Although I would not have chosen it myself, it was excellent quality, and so I decorated around it, finding another way to repurpose! It is in excellent shape even today. Although the pattern is not my first choice, I embraced select colors of black, shades of grey and white. I avoided the shades of green—although you would think, as an avid gardener, I would be attracted to it!

This room distracts your eye from the flooring by using its selected colors as accents—such as the seating and the plush bathroom mat from

Nine-foot ceilings
with skylight
11x5
Paint
Benjamin Moore
Metallic Silver

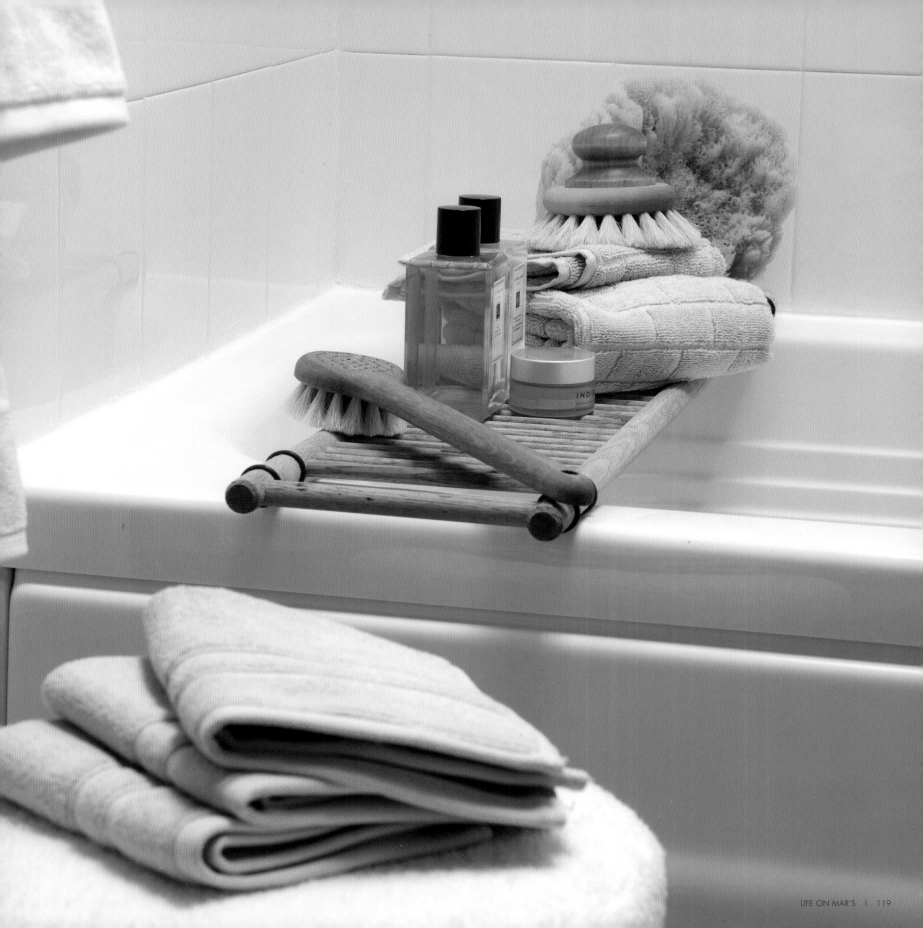

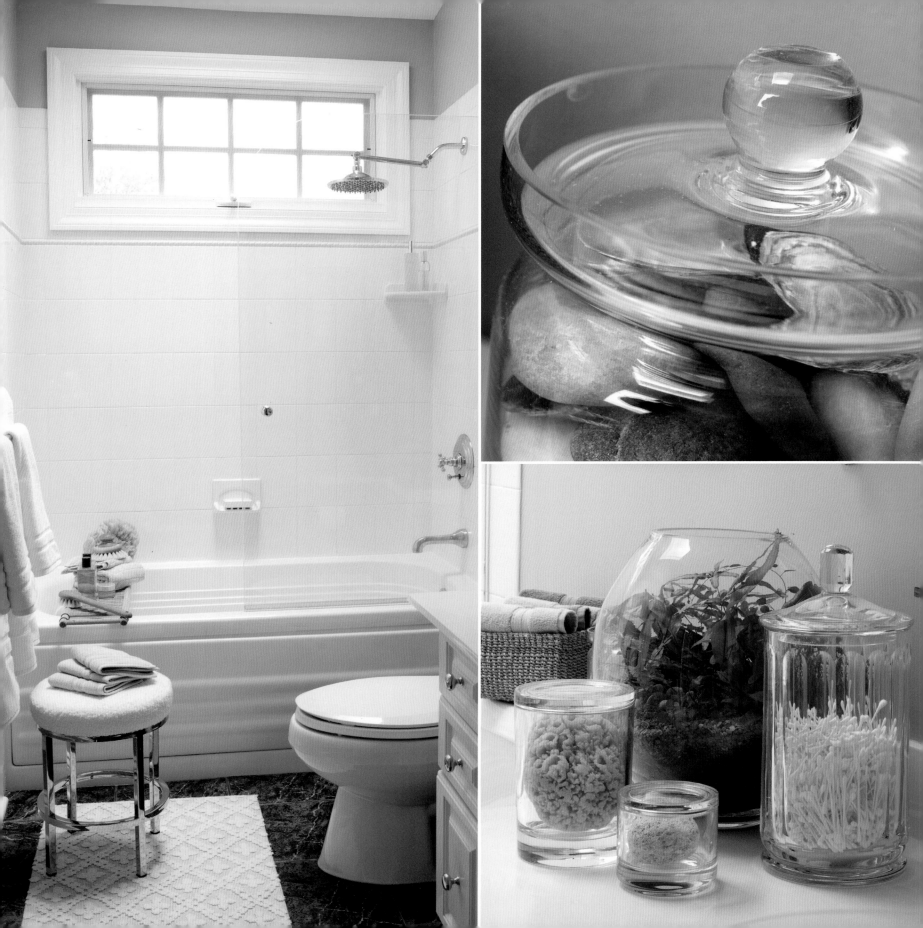

Waterworks. Another way to diffuse the flooring was to use a lighter paint color on the walls and divert the viewer's eye to the incredible black and white photography in high gloss black wood frames. It contrasts with the wall color, but is in theme with the color tones of the flooring, creating that important linking element.

The tiles are subway style. There are many cost-effective ways to tile large surfaces. Ceramic wall tiles can be complemented with multiple textures of tiles. For example, different materials such as glass tiles can be incorporated into a less expensive ceramic tile to create a high-end designer look with little upgrade dollars. Don't focus on all one material or shape as the best looks can come from the magic of the mix.

The bright feeling created by the simple white tiles in the shower is complemented by the openness of the curved-top glass half shower door. An extra deep, multi-jet whirlpool bathtub completes the bathing

oasis. It is the perfect spa-like retreat after tending to the garden. The rain shower head is another way to bring the outdoors inside, making even the quickest shower a luxurious experience.

A bead board trim runs around the bathroom. When tile or bead boarding is not an option, consider adding a chair rail and shadow boxes. Trim molding can be installed on sheetrock creating a layered effect. Trim can be painted to create contrast on the wall. To create the effect of custom paneling, paint the wall above the chair rail one color, and below it another complementary color. If you do decide to install decorative bead board or tile a chair rail, make sure you know the hight of the vanity. You want to make sure the rail is about six inches above the counter, creating an alluded backsplash.

Although the master bathroom does not require a window treatment, I recognize that bathroom windows can provide an opportunity to personalize a bathroom—and with less of a commitment than in other rooms, simply because you need less fabric. As you know, I prefer to only address window treatments when privacy is an issue, but consider the alternative of a frosted window if you want a more modern, clean look without the distraction of window treatments.

Each day is busy from dawn till dusk, but this master bathroom starts and ends my day in perfect *Casual Luxury*.

sMARt tip

Artwork Options

An alternative to expensive artwork is black and white photography. It can even be created yourself, as most digital cameras offer a Black and White feature so you can quickly see the exposure and the contrast allowing you to easily convert them. Mass-produced frames can be customized with cut-to-size matting. This is an inexpensive way to get an expensive look in a room for a lot less.

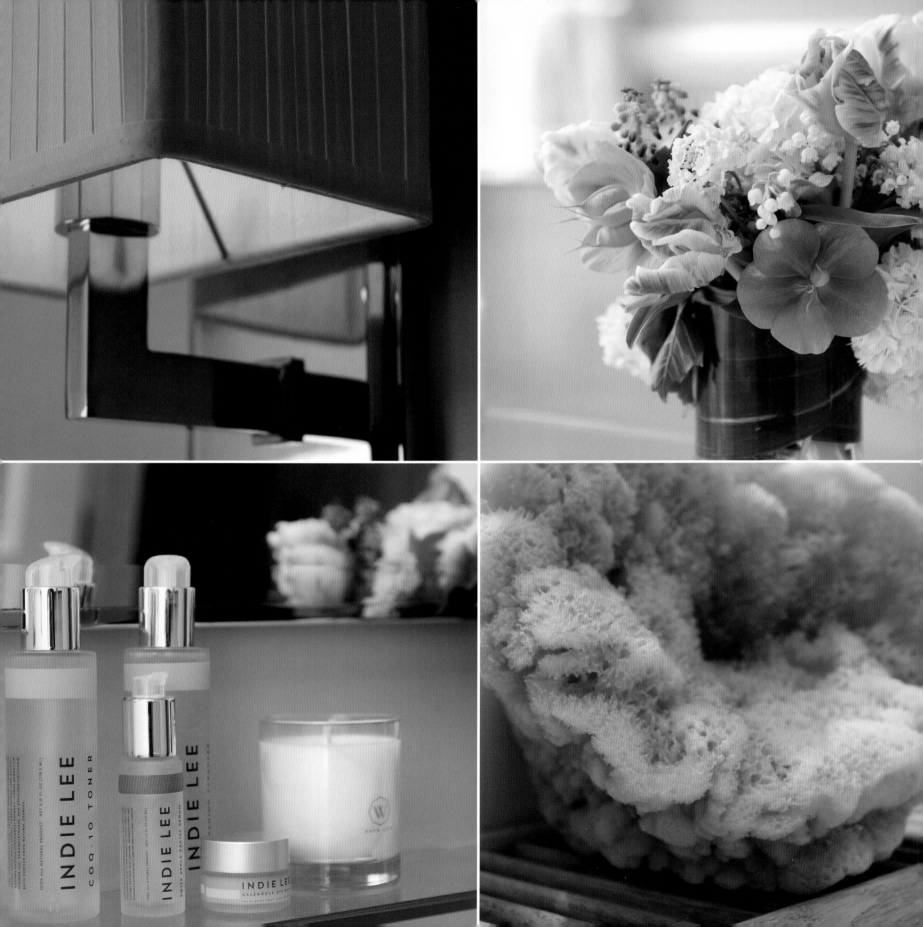

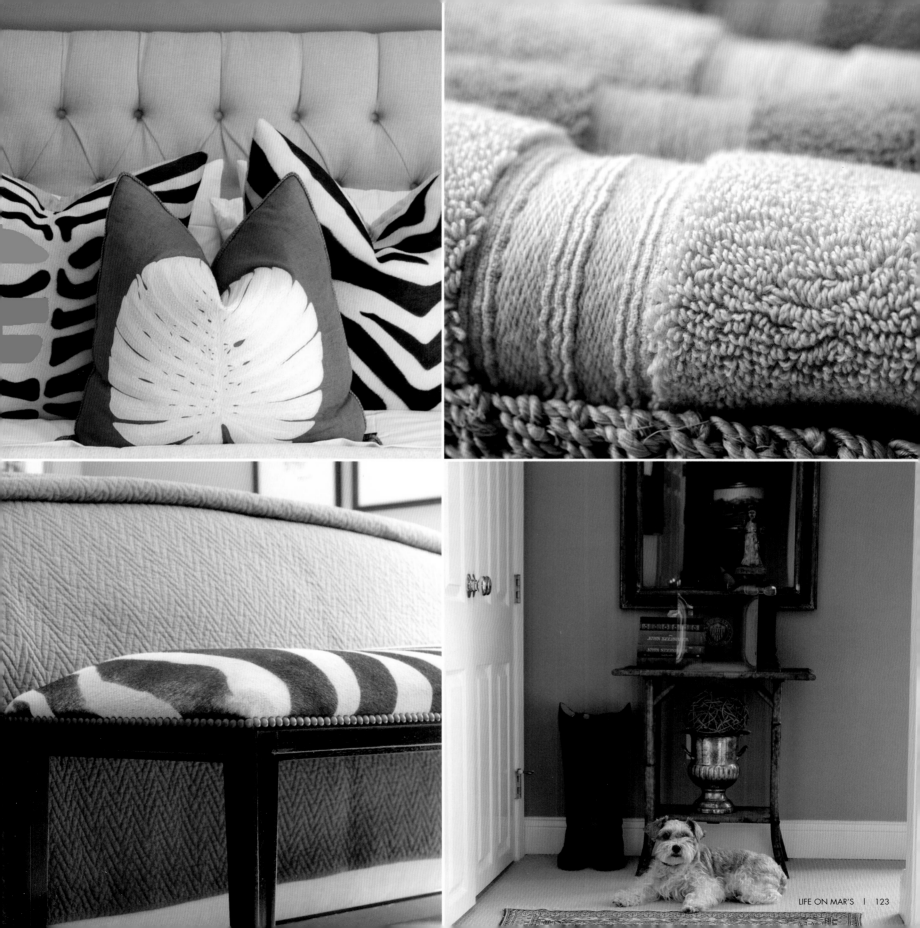

The Outdoor Rooms

An avid gardener, I love being outdoors. No matter what I'm doing, I always take a moment to look up at the blue sky or stars, no matter the season.

Then I turn my attention to the beauty of the gardens.

During the last 10 years I've been focused on giving garden tours and lectures, always emphasizing my garden design philosophy of using color, texture and interest throughout the year. This was also the focus of my first book. Now it's time to give you a tour of my outdoor spaces, or outdoor rooms as I like to call them. Then I'll share with you three additional planning guidelines that will set you up for success in your own outdoor spaces.

The simplest way to understand my approach

Outdoor rooms should follow indoor design principles. These outdoor spaces are an extension of the indoor spaces. No matter where you look, color and texture play a leading role just as they would indoors. The six *Casual Luxury* principles apply here as well, creating an explosion of eye candy to blur the lines between outdoor and indoor living spaces.

So let's begin as if you're on a garden tour and visiting my home. You'll notice two matching Adirondack chairs in the front yard, for taking in the cool morning air or resting. Each chair, painted in an orange inspired by Hermès, holds an oversized brown and white pillow to complete the look and make the space even more inviting. Once through the side rose-and-parterre garden you enter the privacy of the backyard. I've mirrored the front yard tableau under my Bradford Pear tree with two teak chaise lounges that invite you to relax and enjoy the views of the wisteria and honeysuckle-covered garden studio. This is the perfect place to come for shade during the afternoon sun.

Just off the back French door—which leads from the dining room—spills a pebble and slate patio lined with Belgian blocks. An all-weather wicker loveseat, made from two sectional end pieces, is just the right size and scale. A limestone console table shows off small planters of succulents with reflective globes to capture the light. A teak coffee table is the perfect place to display weather-tolerant collectibles such as beach rocks and driftwood. An extra large pair of chairs completes the design.

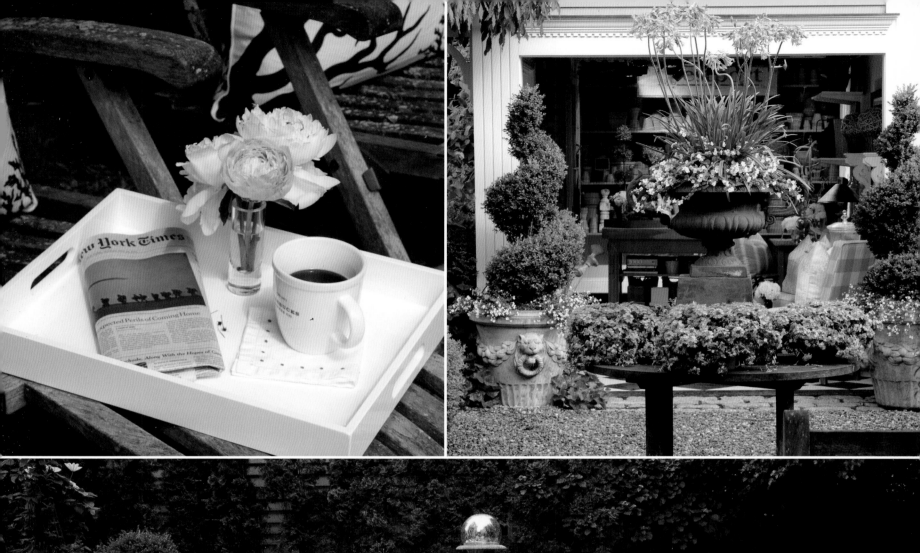

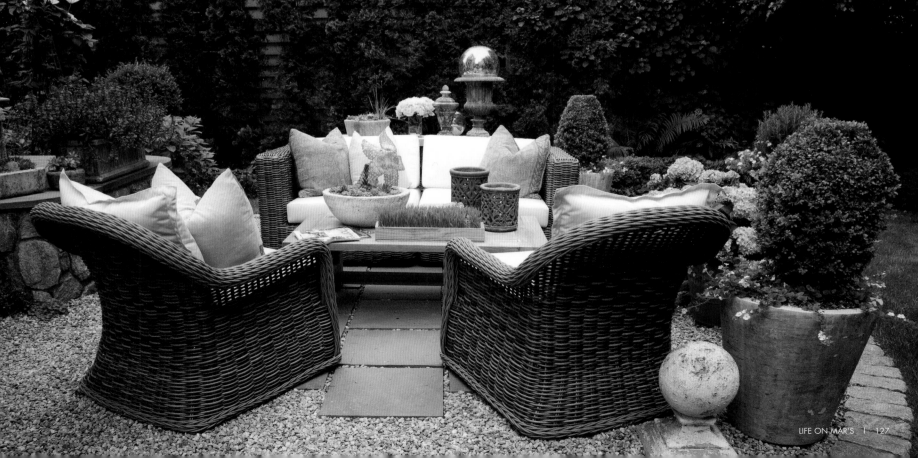

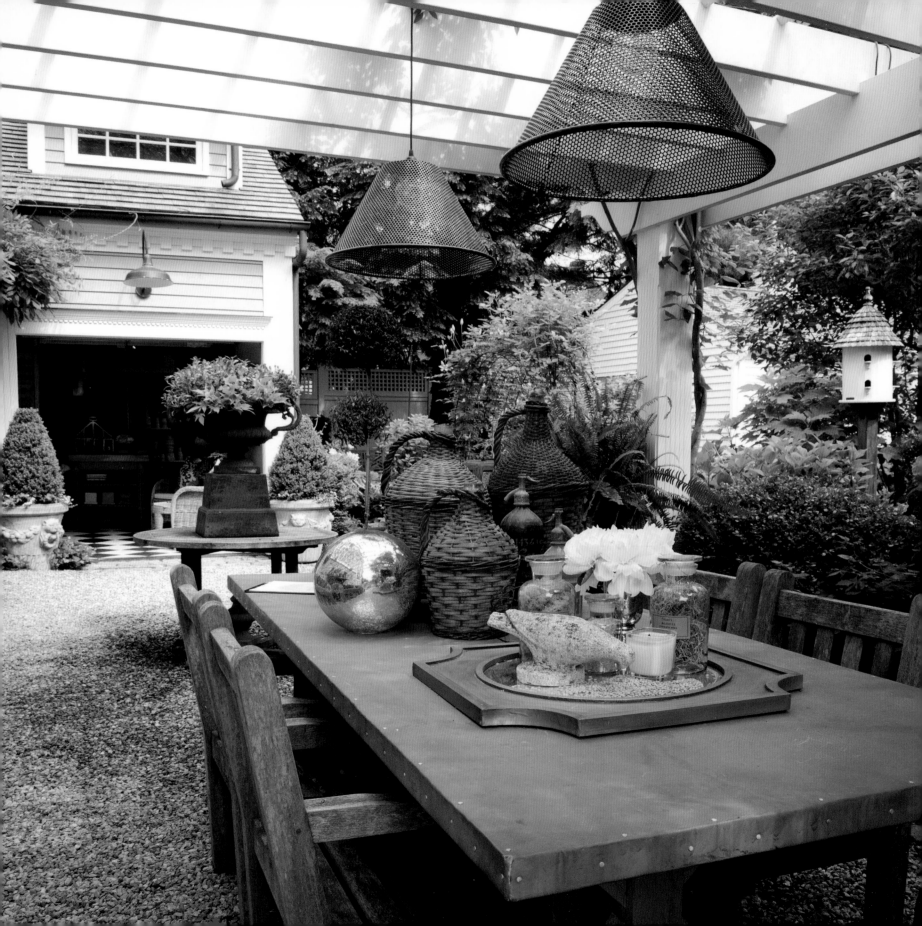

A burst of blue from hydrangeas in oversized containers is complemented by the lush texture of boxwoods. An antique black urn—usually with a rosemary plant, and home to a metallic sphere when not in season—is both decorative and functional.

The Garden Studio (the former single car garage, happily repurposed to be a year-round hub of activity) is the central part of my garden design. Here you can sit, protected from the sun or inclement weather. For large gatherings this becomes the heart of the adjacent outdoor rooms and is where the bar or buffet table are located.

Breakfast, lunch and dinner can be served under the pergola; the rectangular table offers plenty of seating. Covered in zinc, the sturdy table is all-weather, as are the four teak side chairs and the two wicker armchairs.

Nothing is sadder than an empty table! When not dining, a garden-inspired tableau rests on the table, changing throughout the year to match the season. I've also turned a mirror into a tray to reflect light and to frame and highlight garden ornaments—in this case, a stone dove.

At the front of the property is the shed—in the spirit of this English inspired garden I call it my Folly. This custom-built shed by Kloter Farms plays a functional and decorative role in the outdoor room design. Garden tools are stored in this eight-foot-by-eight-foot space. Shelves are lined with vases and candles. The shed doubles as a garden office where I tuck myself away to write about the most recent garden

activities in my journal. This is also where visitors are greeted for garden tours. The pitched cedar shingle roof offers a bonus space for hanging and storing trays and baskets that are used for outdoor entertaining.

How to Plan Your Own

As promised at the beginning of this chapter, now that you've had your tour of my outdoor rooms, let's focus on how you can use these design principles to create your own outdoor rooms. I like to call these outdoor planning guidelines the "power of three."

Reason, Design and Style

REASON: Always begin with what you need the space to do. Over the years I have designed many outdoor rooms for clients all over the country, and no matter how big or small a property might be, the outdoor room concept is attainable. Even an apartment terrace can be transformed through great design. Most of our time outdoors is spent with our families and entertaining friends. But big outdoor spaces can end up unused if the whole family is not present. That's why I find the most intimate spaces can be the most rewarding to design.

You should always begin by identifying each zone. Understanding the zones helps you tackle vast properties by turning large spaces into a sequence of smaller spaces. Smaller spaces can seem roomier when you discover the real reason for having them and design accordingly—funny how that works. Regardless of your reasons or the size of the space there is one important "rule" you should always live by: Never, ever design a space for one person unless you want to stay single for the

sMARt tip

Flowerless Bouquets

One of the many pleasures of nurturing and cultivating a garden is the reward of having resources for creating flower arrangements for my home. But no flowers, no problem: the textures of seasonal greenery can star, too. Mix and match sprays of evergreens, ferns, and tall grasses for a fresh effect. Leafy branches add casual drama, especially in spring and fall. A bunch of variegated hosta leaves in a simple low glass vase can even become the perfect centerpiece for a coffee table. Or consider a grouping of succulents in a low planter for something longer lasting. And all from your outdoor "flower shop," steps from your door.

rest of your life. Two chairs, two chaises or even a hammock for two will do. The whole idea is to make the space inviting for you and someone else.

DESIGN: Designing an outdoor room is easy when you focus on three important details.

1. Sunlight

2. Flooring

3. Furniture and Accessories

Lighting

Plan around the sun. For example, if you're looking for a place to rest, find a space where you get shade; if you're looking for an area to entertain, find a bright area that is protected from the full sun but has filtered light. For the best dining area look for a cool, well-lighted space that provides respite during meals.

My outdoor dining space was once in the backyard with easy access from the dining room and kitchen. I eventually realized that in the morning it was too cool as the house cast shade. At lunchtime it was too hot. Only after 6 pm was it just right. So the space was redesigned and moved under the pergola. The pergola, with vines of wisteria intertwined with clematis, offers a bright yet filtered light all day.

Flooring

Just like any well-appointed room you must design from the ground up. Carpet, tiles or wood surfaces are the norm indoors and the choices for an outdoor space can be even more exciting. Consider cobblestone, Belgian blocks, pebbles, brick and slate.

These materials offer durability and drainage. Mix them for greater effect. This outdoor living room combines three materials: Belgian block borders, pebbles and slate. The slate design mimics a throw carpet under the coffee table, which if not completely fooling the eye does send a subconscious signal of familiarity about the arrangement.

Furniture and Accessories

One of the best things about designing an outdoor space is that you can be bold and use larger pieces that might be off-scale inside. Create boundaries with furniture or shrubs, allowing the openness to take center stage. A good outdoor design motto could be "No walls? No borders? No problem!" You can create spaces, from an intimate set of chairs for coffee on the lawn to a dining space under an old oak tree. With the "no wall" concept there are no limitations.

STYLE: Decide on your decorative style and stick to it. This will help you make choices about everything from furnishings to shapes. The art of mixing and matching comes easily when you pull from visual patterns, textures and layers found in nature. Following furniture lines and shapes as we did inside is a clever way to extend design schemes from room to room. A circular table can benefit from a round chair. Round decorative items in the adjacent outdoor room results in visual continuity. The same is true of color. Tone-on-tones are fantastic indoors when you incorporate different textures such as faux fur, cable knit, linen and cotton. Duplicate these principles outdoors: all-season, all-weather materials can benefit when mixed together, from canvas to cotton to linen.

Another way to add a touch of luxury to a casual space is to use fabrics as you would indoors, such as tossing a light blanket over a sectional. (You'll have to bring the blanket in each night to protect it from the elements, but you will love the look.)

Never, ever buy your furniture as a set unless you want your home to look like a showroom. Instead, mix and match, letting a color or texture be your guide. Iron can be mixed with teak and all-weather wicker can be blended with limestone. Your outdoor room will look and feel organic, not like something that was shipped and installed.

In addition to Reason, Design and Style, outdoor rooms need definition by day and night. You achieve this through focal points and evening lighting.

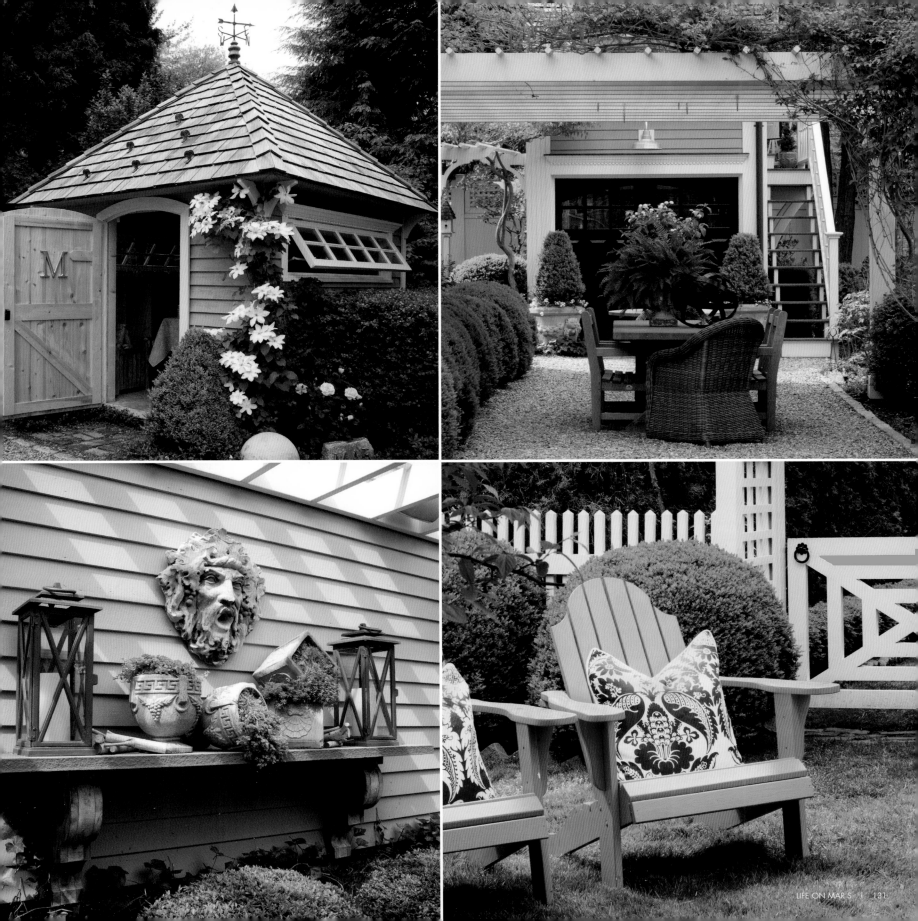

> **Every spring and summer my roses remind me that good design stands the test of time.**

Focal Points

Focal points are just as important outside as they are inside because they dictate the flow of your space. Each outdoor space should have a least one area to focus on. It could be as simple as a view of the garden, pool or lawn. Either embrace an existing view or create one just as you would inside your home.

For example: Do you want to look at the neighbor's garage or your garden? Hopefully your garden! Always arrange rooms to direct attention to vistas that you can control and away from anything unpleasant. I've made sure in this home that you are looking at something interesting—the Garden Studio, an outdoor mantel, a garden bed, a grove of trees—rather than a fence, a driveway or a road.

Evening Lighting

Daylight hours are no problem, but night needs some help. Candlelight is best—and most practical—when it's an accent, never as your only source. If you'll be entertaining most often at night I strongly suggest up-lighting or spotlighting parts of your garden or home in addition to the outdoor room itself. This ensures your views and focal points do not disappear. In fact, spotlighting might allow you to create a focal point at night where none exists during the day—for example, up-lighting tree trunks can create instant drama. The best way to find these focal points is to walk your property at night with a powerful hand-held flashlight. Place the light where you'd consider a spotlight, step back and observe. Consider up-lighting for trees and your home's standout architectural details, like staircases or outbuildings. Reserve low lighting for walkways and steps. Carefully choose your lighting hardware (including a timer/power source), and consider wiring options. Just like icing on a cake, I recommend doing this last. Design the accent lighting around the space, not the space around the lighting.

Following indoor design principles is the simplest primer for creating your own outdoor rooms that will give you the feeling of *Casual Luxury*—no matter how much space you have.

Chapter Seventeen
Decoding Your Design Dilemmas

Got a design dilemma and feel stuck?

I am here to help! Most people I've met and worked with feel like their rooms are "almost there" but can't quite put their finger on what might be missing or needs to be changed.

Design dilemmas are easily identified by how well they match up to the absence of a specific *Casual Luxury* principle. Whether you are stuck figuring out what to change in one room or the whole house, this quick checklist will help you decode what is causing the dilemma.

Start by thinking about your room. On the left side of the checklist are descriptions of how rooms can look or feel. Simply find the description on that side which seems to match your room's dilemma most closely. (Be honest, now!) Across from the descriptions are their missing principles. To create the cure, start adding elements from that principle to balance the dilemma, and you'll be on your way!

Find more than one description on the left that matches your room? You have more than one dilemma, so simply add elements from more than one of the principles.

Don't forget to repeat this for each room as needed!

sMARt tip

It's not always easy to choose descriptions from this list. Here are three things to keep in mind:

1. Ask a friend to help; they can be more impartial.
2. The words on the left are extremes, for contrast; your room might not completely reflect them. First, look for words that pop out at you, then imagine if a less severe word might apply.
3. If you even consider checking off a word, your room might benefit—treat it as a dilemma!

Design dilemmas

My room looks or feels...

Design dilemma cures

Use these *Casual Luxury* principles to create solutions

} Represent Mother Nature

☐ Not cozy
☐ Stuffy, airless
☐ Overly masculine
☐ Sterile

} Embrace Light and Reflection

☐ Cold
☐ Dingy, dark
☐ Uninspiring
☐ Corporate

} Use Natural Materials and Colors

☐ Minimalist, modernist
☐ Industrial, stark
☐ Cold, uninviting
☐ Plastic, prefabricated

} Repurpose

☐ Lacks charm
☐ Like a showroom or catalogue
☐ Impersonal
☐ Unimaginative

} Repeat Shapes and Patterns

☐ Disjointed
☐ Uncoordinated
☐ Thrown together
☐ Collegiate

} Consider Size and Scale

☐ Feels crowded or empty
☐ Uncomfortable
☐ Does not allow multi-use
☐ No flow through room

Chapter Eighteen

Developing Your *CASUAL LUXURY* Eye For Detail, Room By Room

What follows is a **Plan of Action** worksheet that you can use to track exactly how you want to bring *Casual Luxury* to life in a way that is personalized for your own home. On the first part of the worksheet you will see the six principles, some questions to think about, examples of each listed from various rooms in my home, and then space for you to list how you want to bring it to life in your own home.

On the last page of the worksheet I have added three bonus questions; important things I ask clients to think about before designing their rooms, along with some sample answers. I've added these because they might give you an extra "aha!" moment, as they've done for some of my clients and friends.

Do not mistake this as a simple checklist for how to duplicate my home. It is meant to inspire personalization. For example, the shapes and patterns I chose to repeat may be a good jumping off point, but only you know what will make sense for your home.

My favorite thing about this process is the discovery it usually prompts. Something interesting happens when a client walks through a home and discusses this worksheet: it becomes clear very quickly

where they can transform their home. For example, if they cannot identify a shape or pattern they want to repeat, once we decide upon one they find their rooms start to come together quickly. Or if everything in a certain room is brand new, it becomes easy to imagine the charm or warmth a repurposed item could lend. Or if every room hosts a different type of collectible, their home begins to look less cluttered once they decide how they truly want to express their personality. I invite you to try it yourself with an open mind and see what you discover.

Advice Before Getting Started

Because the best rooms are built over time, make copies of these pages—one set for each room—and make as many notations on them as you'd like. Keep them in your personal design files, refer back to them as often as needed for inspiration, and feel free to add information as you go.

I'm proudly sharing this process with you—it's in your hands to create *Casual Luxury* on your own. Have fun with this Plan of Action worksheet. Use it and the Decoding checklist to review what your rooms already have—and what they might need. Remember, these are worksheets, not a rulebook, so use them to spark your own ideas. I was fortunate to have been inspired by others throughout my journey, and so I hope my principles of *Casual Luxury* will help you create your own personal style.

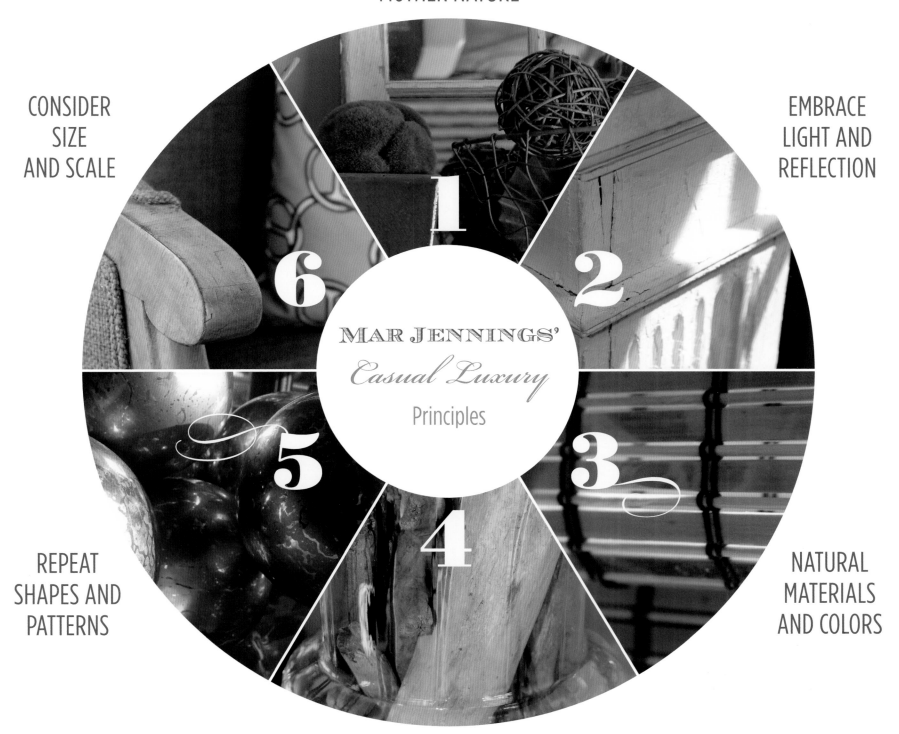

REPRESENT
MOTHER NATURE

EMBRACE
LIGHT AND
REFLECTION

NATURAL
MATERIALS
AND COLORS

REPURPOSE

REPEAT
SHAPES AND
PATTERNS

CONSIDER
SIZE
AND SCALE

MAR JENNINGS'
Casual Luxury
Principles

1

2

3

4

5

6

Plan of Action *Casual Luxury* Worksheet

Six Design Principles	Examples seen in Rosebrook Gardens	Ideas for how to incorporate in my room

1 Represent Mother Nature

- How is Mother Nature represented in your room?

- What could you add or change to incorporate?

☐ Flowers and plants
☐ Landscape paintings
☐ Moss balls
☐ Birch logs
☐ Wicker
☐ Botanical prints
☐ Terrariums

2 Embrace Light and Reflection

- How have you embraced natural light and/or added reflection to your room?

- What could you add or change to incorporate?

☐ No window treatments
☐ Mirrored surfaces
☐ Glass vessels
☐ Lucite
☐ Lacquer surfaces
☐ Lights on dimmer switches
☐ "Zero space" furnishings
☐ Silver, gilt, gold and brass finishes and hardware

COLORS: Shades inspired by what is visible outside
☐ Clean Whites
☐ Soothing Greens
☐ Calming Blues
☐ Earthy Browns
☐ Natural Stones
☐ Accents and pops of color: inspired by flowers and fruit, from pastel to vibrant

Go to marjennings.com for more design inspiration

3 Natural Materials and Colors

- How are natural materials and colors represented in your room?

- What could you add or change to incorporate?

MATERIALS
☐ Sisal carpet
☐ Leather
☐ Bamboo
☐ Metals
☐ Stone
☐ Linen
☐ Wood grain
☐ Sea grass

Six Design Principles	Examples seen in Rosebrook Gardens	Ideas for how to incorporate in my room

4 Repurpose

- What items have been repurposed, reused or redesigned for your room?

- What could you add or change to incorporate?

☐ Kitchen armoire
☐ Demilune tables
☐ Star lights
☐ Sconces
☐ Starburst mirrors
☐ Chest of drawers
☐ Media console
☐ Bathroom mirrors

5 Repeat Shapes and Patterns

- What shapes and patterns are consistent throughout the house?

- What shapes and patterns give unity to this room?

- What could you add or change to incorporate?

☐ Stars, as in lighting fixtures, starburst mirrors and candle holders
☐ Circles and half circles, as in demilune tables, iron work, decorative spheres
☐ Union Jack
☐ Coral
☐ Nail heads
☐ Grid pattern

Don't miss the latest sMARt tips— follow Mar on Facebook, Twitter & Pinterest

6 Consider Size and Scale

- Is there an equal mix of large and small furnishings in your room?

- Does the room feel crowded or empty?

- What could you add or change to incorporate?

☐ Full-size focal point pieces: armoire, desk, bed, media console
☐ Smaller-than-expected pieces: club chairs, love seats, dining table, kitchen seating group, office furniture

Additional Design Considerations	Mar's choices for Rosebrook Gardens	Ideas for how to incorporate in my room

What do you love about the room?

- Including the architecture and the way it is currently decorated

How do you want to express your personality in the room?

The themes I choose to express through decorative items are:

1. _____

2. _____

3. _____

- What could you add or change to incorporate?

- Botanical prints, landscapes
- Dogs: figures, drawings, etc.
- Favorite books

To download a printable version of this worksheet visit marjennings.com and search 'Worksheet'

What is non-negotiable? Architectural or furniture restrictions you must work around?

"Acknowledge it, own it, and move on."

(Examples: Kitchen needs new appliances; landlord will not allow me to paint; bureau has been in family for years; etc.)

- Believe that if you design well, the ugly can disappear! Trick your eye to see the beauty instead.

- What could you add or change to incorporate?

- Small cloakroom
- Existing bathroom flooring
- Windowless guest bathroom
- Office desk style

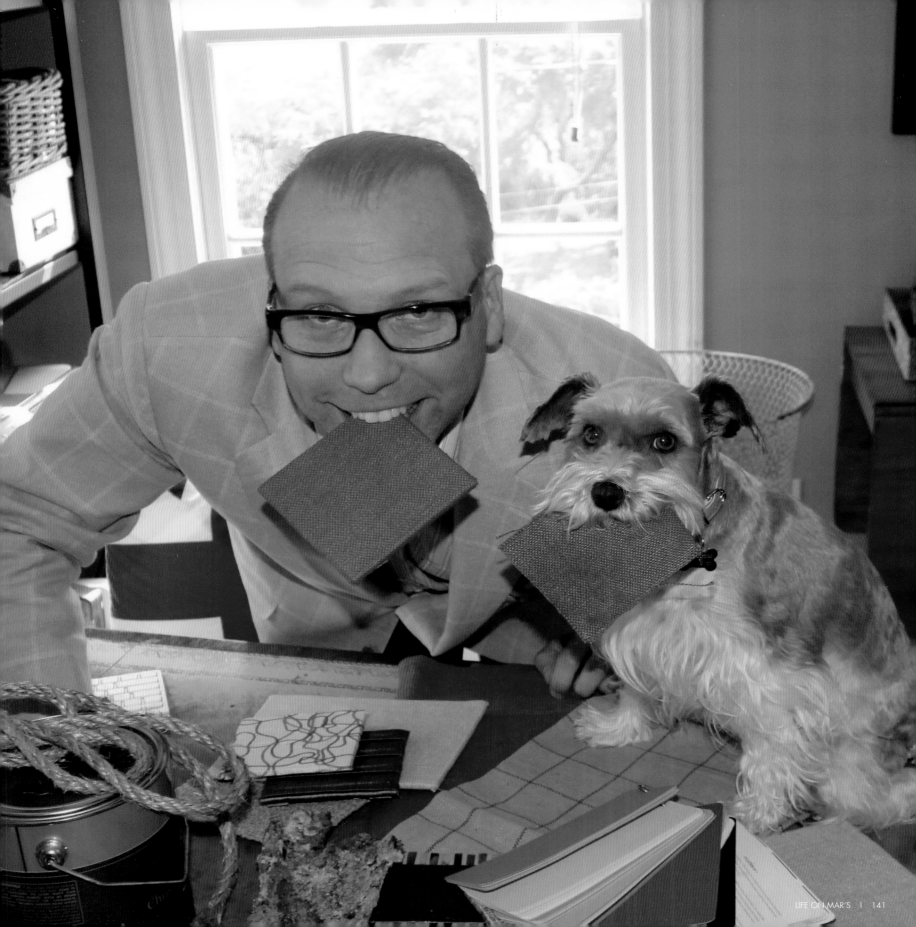

Epilogue

The universe is filled with many creative design ideas; thank you for choosing *LIFE ON MAR'S*.

I'm delighted you were able to come on this private tour of my home, Rosebrook Gardens. I hope I have inspired you to introduce *Casual Luxury* into your life. I truly believe that it is the cure for all design dilemmas. My six principles will work in your home regardless of its size, your personal style, and in any room. *Casual Luxury* has no boundaries.

Designing your own *Casual Luxury* home is as easy as knowing the right combinations of ingredients. Like following a recipe, these six principles are the ingredients, and the worksheets help you know how much of each you need. No degrees or experience required, just the desire to embrace this philosophy.

That said, just like cooks inject their own favorite flavors and seasonings to any basic recipe, I expect you to personalize *Casual Luxury* as your confidence grows. Soon you'll be serving up your own *Casual Luxury* home in no time. It's that simple.

Learn, have fun, and pass it on. So stay in touch, share your results and photos—I cannot wait to see what you accomplish!

And there you have it.

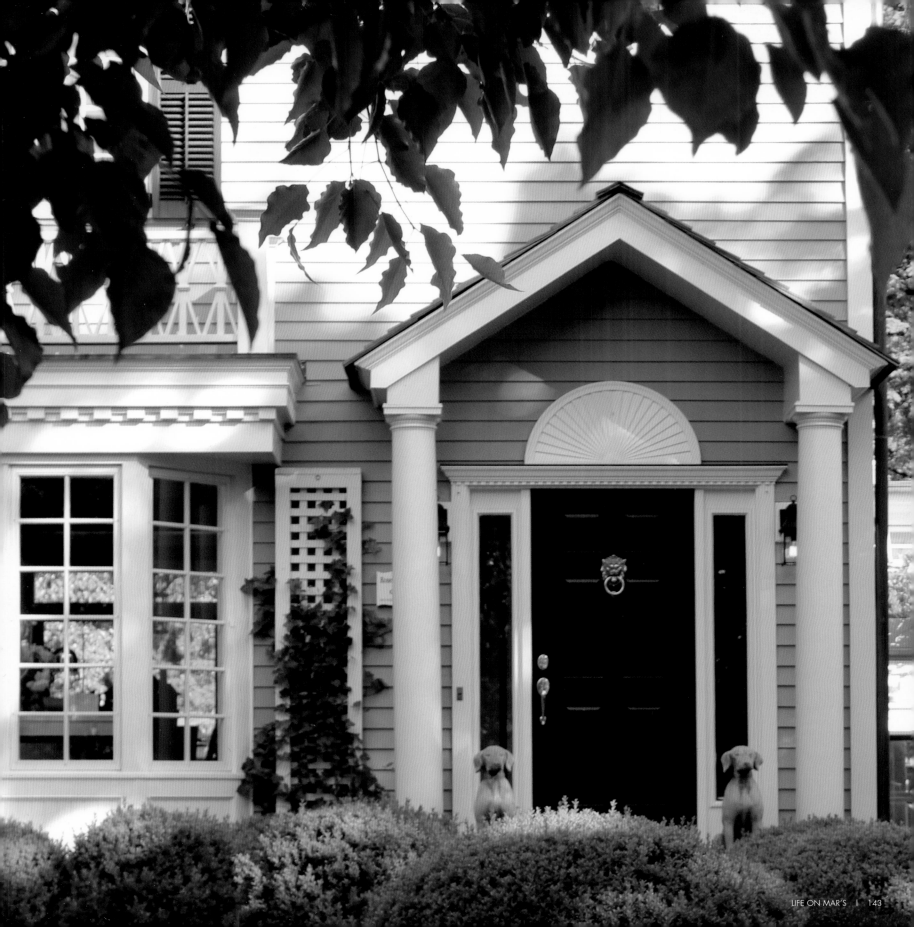

LIFE ON MAR'S *A Four Season Gard*

LIFE ON MAR'S *A Four Season G*

LIFE ON MAR'S

Thank you

Laura Baker, Rick Benson, Robert Bernarduci, Mario Bosquez, Mary & Julian Brooks, Cacilda Camilo-Ramos, Barbara Carpenter, Tony Colapietro, Donna Craft, J.C. DeVilla, Rick DiCecca, Lori, Jason, Sophie & Reilly Dodd, Jocelyn Fenyn, Angela, Mark & Harrison Graham, Aurora Hynson, Jacqueline Johnson, Debbie & Beau Karch, Indie Lee, Audra Lowe, Frank Martinez, Trish Maskell, Barbara Mathias, Paul Mitchell, Russ & Raemar Mitchell, Chris Panton, Rob Pearson, Matt Coles, Audrey Janvier, Jason Dodd & the team at Peppercomm, Kerry A. Petr, Louis Plante, Christine Pompa, Patricia Rodriguez, Derede Samuel-Whitlock, Carol Sheldon, Kenna Smoyer, Martha Spiegel, Philip Tracy, Rebecca & Jason Whiting, Katie Wood, and Geri Zatcoff.

To my neighbors for their encouragement and generosity of spirit, and to the town of Westport, CT, and its residents for their ongoing support.

To the local and national garden clubs, Home Shows, and Design Expos that embrace my *Casual Luxury* style and invite me to share my expertise. To Barnes & Noble, Amazon.com, and the local bookstores that helped make my first book *LIFE ON MAR'S: A Four Season Garden* a best seller.

To the many local and national media outlets that have taken my passion for design and made it available for others to discover. Special acknowledgements to: Tracy Langer Chevrier and all my friends at the Better Show; Dina Stavola, Jane Dee and my pals at CT1 Media, FOX Connecticut and Hartford Magazine; Michele Leone, Janice Lieberman and the inspiring Today Show team; WTNH Good Morning Connecticut; Sean De Simone and the professionals at QVC; HGTV's White Room Challenge and Flea Market Flip.

To my "fur baby," the wonderful Violet Annabelle Rose Von Schnorkenheimer.

To my fans and followers for your belief in me; I love my **MAR**tians!

Special thanks to the a**MAR**zing Stacy Bass for photographing Rosebrook Gardens and bringing this home to life.

TO ORDER, VISIT US AT WWW.MARJENNINGS.COM
A DIVISION OF S&J MULTIMEDIA LLC, WESTPORT, CT 06880

EDITED BY PAUL DARCY MITCHELL
PRINTED IN CHINA

Resources & photo credits

Furnishings & Accessories

ABC Carpet & Home www.abchome.com
Anthropologie www.anthropologie.com
Apple www.apple.com
Artistic Upholstery 203-849-8907
Bed, Bath & Beyond www.bedbathandbeyond.com
Bel Mondo Westport www.belmondowestport.com
Blinds To Go www.blindstogo.com
Brimfield Antique Show www.brimfieldshow.com
Bungalow 203-227-4406
California Closets www.californiaclosets.com
Carol Pearce Fine Art 301-385-0733
Crate&Barrel www.crateandbarrel.com
Cuisinart www.cuisinart.com
Deborah Herbertson for Terrain www.shopterrain.com
Dovecote www.dovecote-westport.com
Dualit www.dualit.com
Elephant Trunk Flea Market www.etflea.com
Furniture on Consignment www.fine2consign.com
Hermès www.hermes.com
HomeGoods www.homegoods.com
IKEA www.ikea.com
Indee Lee www.indeelee.com
J. Pocker www.jpocker.com
Juliska www.juliska.com
Klaff's www.klaffs.com
LG Electronics www.lg.com/us
Lillian August www.lillianaugust.com
L.L. BEAN www.llbean.com
Marshalls www.marshallsonline.com
Maytag www.maytag.com
Miele www.mieleusa.com
Millie Rae's 203-259-7200
Mitchell Gold + Bob Williams www.mgbwhome.com
Nate Berkus for Target www.target.com
Native Union www.nativeunion.com
P.C. Richard and Son www.pcrichard.com
Pier 1 Imports www.pier1.com
Pottery Barn www.potterybarn.com
Ralph Lauren www.ralphlaurenhome.com
Redi-Cut Carpets & Rugs www.redi-cutcarpets.com
Restoration Hardware www.restorationhardware.com

Simon Pearce www.simonpearce.com
Spruce www.sprucehomeandgarden.com
Staples www.staples.com
Stanton Miles stantonmiles-ct.com
Susan Powell Fine Art www.susanpowellfineart.com
Target www.target.com
Viking www.vikingrange.com
Waterworks www.waterworks.com
Williams-Sonoma www.williams-sonoma.com

Outdoor Living

Ethan Currier www.ethancurrier.com
Gault Stone www.gaultstone.com
Kloter Farms www.kloterfarms.com
Marvin Gardens www.marvingardensusa.com
Scooter Centrale www.scootercentrale.com
Teed & Brown Lawn Care www.teedandbrown.com

Professional Services & Supplies

Aitoro www.aitoro.com
Connecticut Arborists, Inc. www.connecticutarborists.com
Custom Phone www.customphone.com
Dobson Irrigation www.dobsonirrigation.com
Enviro Designs www.envirodesignsllc.com
H2O/Peppercomm www.peppercomm.com
Home Depot www.homedepot.com
R. B. Benson & Company, Inc. www.bensonfinehomes.com
Rebekka Seale Illustrations www.rebekkaseale.com
Ring's End www.ringsend.com
Straight Line Landscaping 203-650-2261
Tanah Kalb Jewelry www.tanahkalbjewelry.com
Trish Maskell, Literary Consulting
Van Witt Fine Art Conservation LLC www.vanwittart.com
Westport Glass www.westportglass.com

Photo Credits

Principal photography:
Stacy Bass Photography
www.stacybassphotography.com

Secondary photography:
Mar Jennings and Paul Darcy Mitchell
Page 148-149: Stonegate Studios www.stonegatestudios.com

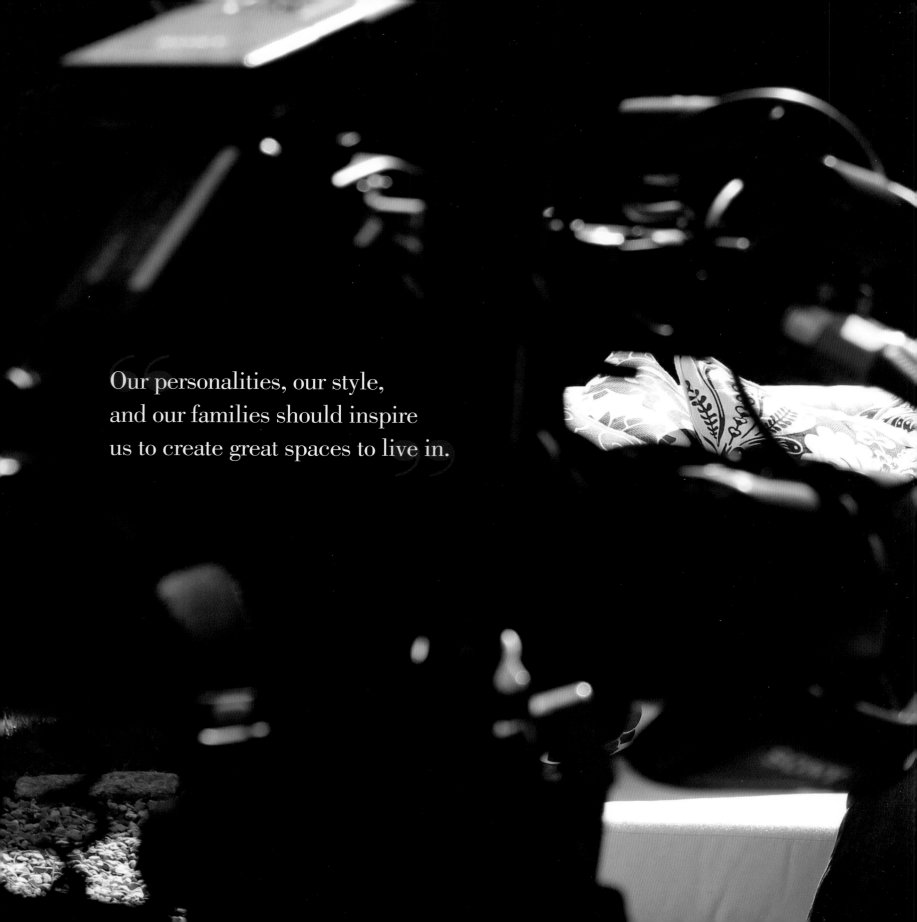

"Our personalities, our style,
and our families should inspire
us to create great spaces to live in."